LILLA CABOT PERRY
An American Impressionist

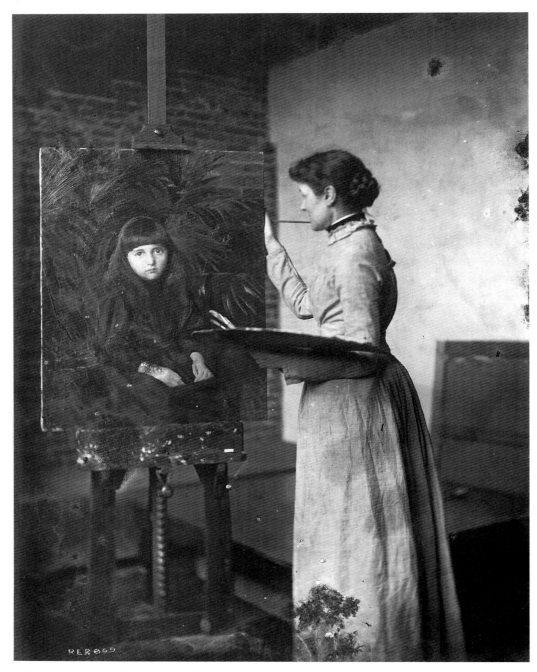

"The genuine artist has the impulse to communicate to others one's own consciousness of the innate beauty that lies in emotion."

— Lilla Cabot Perry, Painting and Poetry" (Unpublished manuscript, Perry Family Archives)

LILLA CABOT PERRY

An American Impressionist

Meredith Martindale

with the assistance of Pamela Moffat

Including an essay by

Nancy Mowll Mathews

The National Museum of Women in the Arts
Washington, D.C.
1990

This exhibition was made possible by AT&T.

Library of Congress Catalog Card No.: 90-061820
ISBN 0-940979-14-4

Cover illustration: *Young Bicyclist* [Alice Perry], *ca.* 1894-95. Collection Alice Lyon.

Frontispiece: Lilla Cabot Perry with portrait of Phyllis Robbins, daughter of
Mr. and Mrs. Royal Robbins.

CONTENTS

Foreword
9

Acknowledgments
11

Lilla Cabot Perry: A Study in Contrasts
Meredith Martindale
15

**American Women Artists at the Turn of
the Century: Opportunities and Choices**
Nancy Mowll Mathews
105

Reminiscences of Claude Monet from 1889 to 1909
Lilla Cabot Perry
115

Family Recollections of Lilla Cabot Perry
Lilla Levitt, Anita English and Elizabeth (Elsie) Lyon
123

Memoirs and Correspondence
129

Exhibition Checklist
141

Selected Bibliography
159

Foreword

Lilla Cabot Perry began her art studies in the twilight of a century but the dawn of a new age. As art was about to expand her outlook, technology was about to unalterably transform the shape and character of American life.

Perry's first art class came ten years after Alexander Graham Bell's first successful telephone message. His move would release us from the tether of time and distance. Hers would place her in the vortex of artistic and cultural change that would upend the traditional order.

Born into a patrician family firmly rooted in its past, Perry nonetheless emerged as a stalwart modernist in the arts. It is on that facet of her life that this exhibition centers. Her proper Boston upbringing is evidenced in works that adhere to the academic style. Yet her openness to change erupts in Impressionist detail and the unusual perspectives of Japanese art.

Like her art, Perry's life was multifaceted. A magnet for the artistic and literary lights of her time, she is perhaps best known for her friendship with Claude Monet, one of the most dedicated of the French Impressionists. Monet's influence is revealed not only in Perry's work but also in her published reminiscences of the summers she spent at Giverny, which are an integral part of this catalogue. They are meant to color this collection, not overshadow it, however.

This exhibition, after all, serves to illuminate the gift of a group too often overlooked. In sponsoring the work of women artists, the people of AT&T hope to help all of us gain a clearer perspective on the role women have and will play in the arts.

Robert E. Allen
Chairman and Chief Executive Officer
AT&T

Acknowledgments

It has been a privilege to organize the first major exhibition of Lilla Cabot Perry's paintings in over twenty years, and we are grateful to both Wilhelmina Cole Holladay, founder and President of the National Museum of Women in the Arts, and Anne-Imelda Radice, former Director of the museum, for entrusting us with this challenge. We also extend our sincere appreciation to all of those at AT&T whose enthusiasm and support have made this project possible and particularly to Gerald M. Lowrie, Senior Vice-President for Federal Government Affairs, R. Z. Manna, Director for Corporate Advertising and Events Marketing, and Michael P. Tarpey, Director of Public Affairs. Without the wholehearted cooperation from the artist's three granddaughters, however, there would be no Perry exhibition. We are therefore particularly indebted to Lilla Cabot Levitt, Elizabeth (Elsie) Sturgis Lyon and Anita Grew English, who not only have contributed a fascinating study of their grandmother but also have shared with us so generously for this occasion the wealth of Perry art and memorabilia in their possession.

Nancy Mowll Mathews, Prendergast Curator at the Williams College Museum of Art, kindly agreed to submit a most informative essay for the catalogue. Lilien Robinson, Chairman of the Department of Art, George Washington University, graciously served as our advisor in the final selection of Perry paintings for the exhibition. To both of these distinguished scholars we express our gratitude. We also extend a special note of recognition to Lilla Cabot Lyon, the artist's great-granddaughter, and John Bovey, author and diplomat. Their initial Perry research several years ago helped pave the way for the present exhibition. In more recent months Peter M. Brown was our dedicated assistant for the Boston area and merits our warm thanks.

Response from the numerous museums, art galleries and private collectors has been overwhelmingly positive. To all the many lenders, and of course this includes those who prefer to remain anonymous, we are indeed deeply appreciative.

The following eminent library directors have generously made available a wealth of rare documents for this exhibition: Walter Kaiser, Director, and Fiorella Superbi Gioffredi, Associate Director, the Bernard Berenson Foundation, The Harvard Center for Italian Renaissance Studies, Villa I Tatti, (Florence, Italy); Rodney Armstrong, Director and Librarian, and Donald C. Kelley, Assistant Librarian, The Boston Athenaeum; Patience-Anne W. Lenk, Associate Curator, Special Collections, Miller Library, Colby College; Rodney Dennis, Curator of Manuscripts, The Houghton Library, Harvard University; and Maureen Melton, Archivist, The Museum of Fine Arts, Boston.

Hirschl & Adler Galleries, Inc., handles the paintings in the Perry estate. We wish to extend here our sincere appreciation to Stuart P. Feld, President, plus a special note of thanks to M. P. Naud, Director of the Department of American Art, who has gone far beyond the call of duty to respond to our numerous requests.

The staff at the National Museum of Women in the Arts has been most cooperative at every level. We owe particular gratitude to Krystyna Wasserman, Director of the Library and Research Center, who facilitated our research, not only by making available the extensive Perry archives at the museum but also sharing with us her exceptional knowledge of women artists in general. It has been a pleasure to work with Brett Topping, Director of Publications, Nancy Lutz, Assistant Editor, and Stephanie Stitt, Registrar. They have our esteem and certainly deserve extra credit for their patience and good humor in the face of the countless corrections and addenda that landed on their desks.

For a project of this scope, it is impossible to cite every individual from art, academic and other circles who gave support. We would like however to express special notes of thanks to: Rebecca Phillips Abbott, Mary Ashton, Bruce Bachman, Robert W. Bacon, James R. Bakker, Diane Biarrios, Lilla Bingham, Susan

Blanchard, Edgar Peters Bowron, Jane and John M. Bradley, Morton Bradley, Eleanor Cabot Bradley, Charlotte Brailsford, May Brawley Hill, Jeffrey R. Brown, Robert F. Brown, Elizabeth Lewis Cabot, Carroll and John G. L. Cabot, Mary Ellen and Louis W. Cabot, Michèle Camus, Carolyn K. Carr, Jacquelyn Casey, Ellen Conant, J. Fraser Cocks, Gilles Daziano, Margaret Di Salvi, Penelope and Joseph G. English, Robin and David M. Evans, Leslie Fayard, Deborah Force, Barbara Ford, Wendy Foulke, Lois Frankenberger, Faith Fuller, Wayne Furman, Harold Goder, George Haigh, Hannah and J. Welles Henderson, Frederick D. Hill, Colleen Hennessy, Patricia Hills, Marilyn F. Hoffman, James M. B. Holsaert, Ann Hutchinson, A. Everette James, Jr., Jayne Johnson, Adeline Lee Karpiscak, Alma S. King, Donald R. Korst, Sandra Lepore, Norman Leventhal, Steven Z. Levine, Lyn V. Lincoln, Claudette Lindsay, Grace Lippman, Cecil B. Lyon, Thomas S. Mairs, Edith and Lawrence Malkin, Eda Martin, Helen B. Martindale, Henrietta and Wallace S. Martindale III, John J. McDonough, Linda Merrill, Elizabeth Monkman, Meris Morrison, Caroline P. Owens, Patricia L. Pierce, Elizabeth Pierson, Sue Welsh Reed, Anne Schmoll, Rex Scouten, Anne and David Sellin, Colleen Sesco, Sarah B. Sherrill, Deborah Spenser, Edith Spenser, Elizabeth M. Stahl, Cassandra and Edward L. Stone, Kristy Stubbs, Cynthia Sunderland, Lily and H. William Tanaka, Jean-Marie and Claire Toulgouat, Carol Troyen, Abbot Williams Vose, Dean Walker, Lisa Ward, Kimberly G. Wass, Masako Watanabe, Valerie Wingfield and Ann Yonemura.

A final note of gratitude goes to our families, with special mention to Jean M. Brown, Olivier Frapier and Peter Moffat.

Their contribution is truly immeasurable.

— Meredith Martindale, Curator
Pamela Moffat, Assistant Curator

LILLA CABOT PERRY
An American Impressionist

Lilla Cabot Perry, 1848-1933
A Study in Contrasts
Meredith Martindale

"Lilla Cabot Perry's brush practically wrote the history of contemporary art development in America from its earliest indebtedness to the French and German academies to its own flowering."

"No better refutation of the widely accepted theory that an artist goes stale after mid-life can be asked than is found in the luminous, gay palette that marks a number of her recent works."

Albert Franz Cochrane
Boston Evening Transcript
October 28, 1933
(*Memorial Exhibition of Paintings
by Lilla Cabot Perry*, Boston Art Club)

This glowing critical appraisal eloquently summarized Lilla Cabot Perry's outstanding career as one of Boston's most distinguished artists. In many ways Perry was an exception. In an age when successful women artists often did not marry because of the strain of simultaneously managing a home and career, Perry took up painting seriously only *after* she had married and become the mother of three small children. Throughout her career, which spanned half a century, she was acclaimed by critics, and a fairly steady flow of portrait commissions enabled her to provide vital income for her family. Like many of her colleagues, she studied and worked in France and Germany, as well as in Italy and Spain. She was, however, the only American woman artist, and possibly the only woman artist of the Western world of that period, who also lived and painted in Japan. Her works were regularly accepted at the prestigious salons of Paris and also were presented at many major exhibitions throughout Europe and America. Yet, until very recently, her reputation has rested more firmly on her friendship with Claude Monet and her efforts to introduce American audiences to the "new truth" of Impressionism than on the singular qualities of her own art that were appreciated by so many critics of her day.

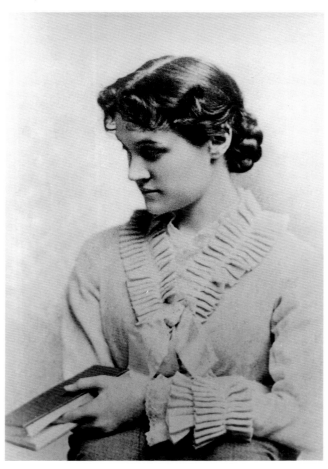

Fig. 1. Lilla Cabot Perry, *ca.* early 1870s.
This photograph was possibly taken at the time of her engagement to Thomas Sergeant Perry.

Boston Beginnings

Lilla Cabot Perry does not sound like the name of a lady who would need to support herself as an artist. Her very signature bestows refinement and gentility. What could be more feminine than Lilla, which blends so easily into the lily-flower, symbol of spiritual purity? Cabot, of course, evokes Boston's elite Brahmin caste, "ennobling" those happy few who speak "only to God."[1] As for Perry, there immediately comes to mind a memorable chapter in America's relationship with Japan. Indeed, before the

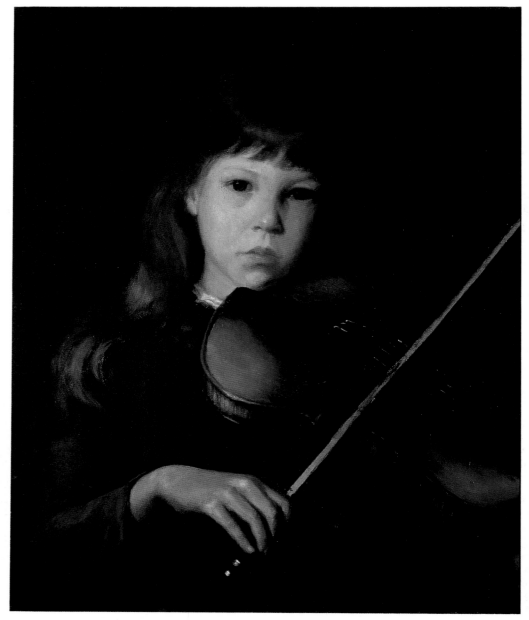

1. *The Beginner* [Margaret Perry]

ca. 1885–86

Oil on canvas, mounted on masonite, 22 1/8 × 18 1/8 in.
Collection of the University of Arizona Museum of Art,
Tucson

Gift of James Holsaert

"I am hard at work painting. I paint every day from 9 until 1 (of course with frequent rests). I have filled up what used to be George's [Pellew?] room as a studio with model stand, etc. and two other women paint with me, and Mr Vonnoh, the head teacher at the Art Museum, comes two mornings a week to criticize. We have a fresh model every week and paint a head in a week generally. I feel that I am improving fast — and that is a delightful feeling! I told Tom the other day that he must not feel offended if I said that I had not been so happy since I was a girl at school! After all a congenial and difficult occupation is the most lasting delight. There is nothing like the pleasure of putting forth one's best powers with tolerable measure of success."

— Lilla Cabot Perry to Mrs. Leonard
Opdycke, January 24 1886 (Special
Collections, Colby College Library)

first stroke of her brush, her name, Lilla Cabot Perry, implies "to the manner born," a lady of leisure out of a novel by Henry James.

Perry was born in Boston on January 13, 1848. She was the oldest of eight children in the family of the distinguished surgeon Dr. Samuel Cabot and his wife, Hannah Lowell Jackson Cabot. Simple living, "high thinking" and service to others — such were the principles that the Cabots taught their children at an early age. Books and sports were favorite pastimes pursued outside of school hours. Perry's childhood memories also included the host of literary giants who poured into the family's front parlor on Park Square. Ralph Waldo Emerson and Louisa May Alcott played "fox and geese" with the Cabot children,[2] for example, and James Russell Lowell was an intimate member of the family circle.

Perry was thirteen years of age when the first shots at Fort Sumter were fired, which announced a turning point in American history. Ardent abolitionists, both Samuel and Hannah Cabot took an active part in the Civil War, assisting the ill and wounded and offering refuge to runaway slaves. Caring for those in need was a Cabot commitment which Perry exhibited all her life.[3]

The war ended when Perry was seventeen. That same year her father purchased a farm called Cherry Hill in nearby Canton, Massachusetts, where, as she later remembered, the family "lived very close to the beauties of nature. . . . From our house on top of the hill, the countryside spread out all around like the large patchwork quilt on my grandmother's bed. Already I had a longing to paint."[4]

Perry was an exceptional student, however, and there were other calls as well as art — literature and languages, poetry and music — which she pursued with a passion far extending the classroom walls.[5] Beethoven brought tears, as did certain lines from Keats or Shelley. Boston in the late 1860s was by no means "the hub of the universe," as Oliver Wendell Holmes once declared, but it was still the intellectual and moral capital of the nation. For Perry and her very select friends, who included Helen Bell[6] and Henry James, the metropolis provided a stimulating and congenial atmosphere.

James grew up in Newport, Rhode Island. His closest childhood friend was Thomas Sergeant Perry, a direct descendent of Benjamin Franklin and the grandnephew of Commodore Matthew C. Perry. Thomas Perry's older sister, Margaret, was married to the artist John La Farge. The delicate simplicity of La Farge's beautiful line drawing of his brother-in-law is indeed a quintessential visual

interpretation of the New England Brahmin in his youthful years: "slender. . . [a man whose] features are regular and of a certain delicacy. . . [and who takes] to his books as a pointer or a setter to his field-work."[7]

Corroborating this description by Holmes, Thomas Perry's passion for books was almost legendary in Boston's prestigious literary circles. A brilliant scholar and linguist, he graduated from Harvard in 1866 and then embarked on the "grand tour" of Europe. Thomas Perry returned to Boston in the late summer of 1868 to take a teaching position at Harvard that fall. According to his biographer, Virginia Harlow, he was introduced to "Miss Cabot" shortly thereafter.[8] It was not until 1871, however, that their correspondence takes on a tone of courtship, which culminated three years later in a quiet wedding at Samuel Cabot's residence in Boston on April 9, 1874.

Although the marriage unquestionably united two families of impeccable lineage and proved to be extremely

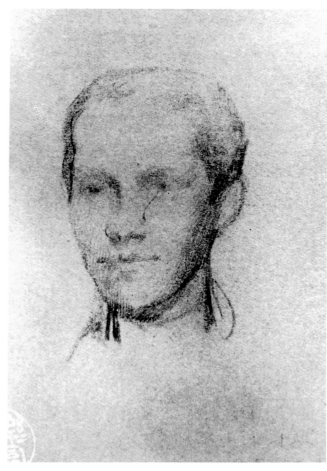

Fig. 2. John La Farge's drawing of Thomas Sergeant Perry, *ca.* 1860. Private collection.

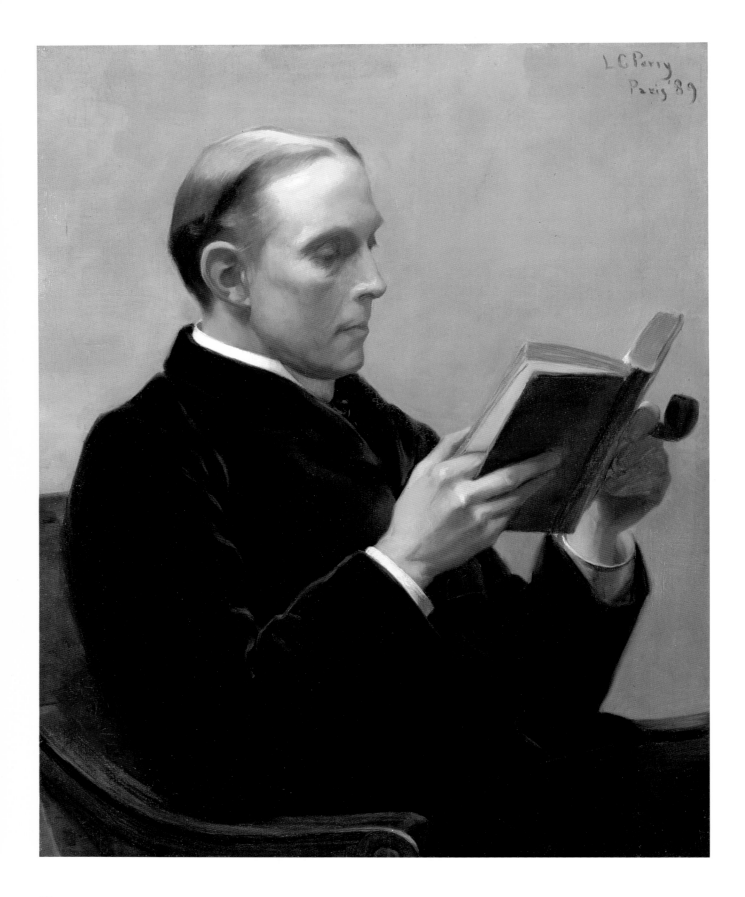

18

2. *Portrait of Thomas Sergeant Perry*
1889
Oil on canvas, 32 × 25 1/2 in.
Collection Mrs. Lilla Cabot Levitt

"[Thomas Perry] had let himself loose in the world of books, pressed and roamed through the most various literatures and the most voluminous authors, with a stride that, as it carried him beyond all view, left me dismayed and helpless at the edge of the forest, where I listened wistfully but unemulously to the far-off crash from within of his felled timber, the clearing of whole spaces or periods shelf by shelf or great tree by tree."

— Henry James, *Notes of a Son & Brother*

close, it was not one that had joined two fortunes.[9] After a very brief teaching career at Harvard came to an abrupt end, Thomas Perry contributed a voluminous amount of literary criticism to *Atlantic Monthly*, the *North American Review* and other prominent periodicals. He also edited several major anthologies of literature which were acclaimed by critics but sadly ignored by the public. Following her father's death in 1885, Perry's inheritance provided a modest income for her family which included her husband and three daughters — Margaret, Edith and Alice, born respectively in 1876, 1880 and 1884. As the years went by the inheritance dwindled. More and more the family also relied on the income from Perry's paintings.

The Emergence of an Artist
The earliest known painting by Perry is a small oil portrait of her daughter Margaret, *Portrait of an Infant* (fig. 3), which dates from early 1878. Scant references allude to informal sketching sessions with friends as early as age eleven.[10] There is no extant documentation, however, that indicates Perry ever received any formal instruction prior to 1884. Presumably her skills were self-taught, resulting from close observation of family and friends, complemented by frequent visits to both the Boston Athenaeum and the art museum. Another source of inspiration was the exceptional collection owned by the Perrys' close friend Quincy Shaw. As Thomas Perry recalled to a friend years later, "Mr. Shaw you know was one of Millet's early admirers & had more of M[illet]'s pictures than one finds elsewhere under one or every roof. I can't say he followed the later movement of

painting [a reference to Impressionism] with equal interest, but he was open to argument & conviction. Besides the Millets, he had many capital Italian pictures & how many I cannot guess for I have never seen them all; there were those on the walls & then he would bring others out from dark places."[11]

In the summer of 1884 Perry received her first professional critiques from Alfred Quentin Collins, once considered "one of America's finest portrait painters of

Fig. 3. *Portrait of an Infant* [Margaret Perry]
ca. 1877–78
Oil on canvas, 8 × 7 1/2 in.
Collection James M. B. Holsaert

the last century, yet totally forgotten today."[12] Like many of his American colleagues, Collins acquired a very sound, vigorous technique at the Académie Julian in Paris. He perfected it at the private studio of Léon Bonnat. Some of Bonnat's other pupils included Thomas Eakins, John Singer Sargent, Walter Gay and Frederic Vinton.

There is a similarity between Perry's portrait of Margaret with her violin, titled *The Beginner, ca.* 1885–86 (pl. 1), and Collins's portrait of young Alexander Wetherill. The serious, intent gaze of each child reflects a strong emphasis on character, accentuated in each work by the dark background tones. Neither portrait is dated, but Perry's was probably painted in 1885. It is an early manifestation of a major theme — children or, more precisely, *her* children. Serious, intent, wistful, soulful, they rarely smile. Her children are carefully posed, almost always by themselves. They often hold a book, sometimes a musical instrument. Solitariness and high moral innuendos go hand in hand throughout Perry's oeuvre.

Just how long Perry continued with Collins is unclear. By the fall of 1885, or possibly early winter, however, she engaged a new critic. "Mr Vonnoh, head teacher at the Art Museum, . . . comes two mornings a week to criticize," she wrote her friend Mrs. Leonard Opdycke in January 1886.[13] Robert Vonnoh was another product of Julian's. The powerful portrait by Vonnoh of John Severinus Conway, which was exhibited at the prestigious Paris Salon in 1883, launched the artist's career as a portrait painter in Boston.

The first weeks of 1886 were exciting ones for Perry, who joyfully confided to Mrs. Opdycke in the same letter, "I am hard at work at painting . . . I feel that I am improving fast and that is a delightful feeling! I told Tom the other day that he must not feel offended if I said that I had not been so happy since I was a girl at school!"[14] This state of contentment came to an abrupt halt when Perry herself and all three daughters became ill in February 1886. Four months later Vonnoh traveled to France, where he developed a new orientation toward plein-air painting as practiced at Grez-sur-Loing.[15] Perry and Vonnoh kept in contact all their lives, and in many ways their careers followed parallel tracks — both artists did much to further Impressionism in America and both produced lovely landscapes as well as strong, insightful portraits.

All roads led to Paris for American artists of the 19th century, and the metropolis attracted many American authors as well. In November 1886 Thomas Perry announced his decision to join his close friend and col-league William Dean Howells in Paris, to which both men would take their respective families for a two-year sojourn. Coming soon after James's self-exile in London, their move illustrates the extent of the cultural hemorrhage which drained Boston at that time, representing as it did the loss of three of the city's most brilliant authors. Perry enthusiastically transmitted news of the move to Mrs. Opdycke. "I like the idea of being in Paris and beginning to study painting there, the headquarters of modern painting."[16]

To prepare herself for the Parisian academies, Perry immediately enrolled in painting classes at the Cowles Art School, which, as an article in the Boston press confirmed, was "the first school in Boston to break away from the conventional methods of teaching and to adopt . . . liberal theories."[17] The article also noted that the school's success dated from 1885, the year Dennis Bunker joined the staff.

Perry herself was extremely impressed by Bunker, as her description of him to Mrs. Opdycke attests, "[Bunker is] a very young artist whose power of drawing is amazing." Commenting on the process of learning art she continued, "I enjoy it very much, partly because it is so difficult. A whole figure is so much more complicated than a head alone, and I have so little experience in charcoal, that I find it much more difficult to use than paint."[18]

Perry chose her instructors wisely from the new crop of young realists temporarily on the Boston scene. Collins, Vonnoh and Bunker represented three exceptional portraitists, all trained in Paris at the Académie Julian. All of them reacted strongly against the insipid "candy-box" images which covered America's walls, "as much like good pictures as 'Mary had a little lamb' or 'Twinkle, twinkle, little star' are like good poetry," to quote Thomas Perry's cynical appraisal of many American paintings of the day.[19]

Paris and the European Scene

Once settled in Paris by the winter of 1887, Perry first enrolled not at Julian's, which had molded her American preceptors, but at the rival Académie Colarossi. It was in some ways an inauspicious choice. Her first impressions of Colarossi gave a rare insight into the teaching methods practiced there by Gustave Courtois and Joseph Blanc.[20]

As one would expect of any woman artist with three small children in tow, Perry's attendance at classes was somewhat sporadic. That first winter in Paris her husband's protégé, Bernard Berenson, often accompanied her to the Louvre, where she spent many hours studying

the Old Masters.[21] Thomas Perry was largely responsible for rallying a group of sponsors, headed by Isabella Stewart Gardner, to send Berenson on a study tour of Europe in 1887.[22]

Travel also occupied much of the Perrys' time. Prior to settling in Paris, they spent a month touring the churches and galleries in London and the neighboring countryside. They then proceeded on a six-week tour of Spain, where Perry spent hours working in the Prado. Thomas Perry recorded her progress in his diaries: "At 1 [P.M.] L[illa] gets permission to copy [at the Prado] & begins on a little prince of Velasquez. . . . She gets additional hours . . . painted the Prince C. [head] and the head of Prince Ferdinand. Began the so-called Sibyl of Ribera . . . and Titian's Mater Dolorosa. L[illa] receives much advice from a German painter, Felix Borchardt, whose acquaintance we made. He boggles over Velasquez's sculptor, but does well with Las Meninas."[23] In spring of 1888 the Perrys marveled at the splendor of Florence and Venice. Several of Perry's paintings from this period recall the Old Masters, particularly *The Red Hat,* 1888, which is reminiscent of Sandro Botticelli, and *La Toilette,* which shows the influence of Jean Baptiste Chardin.

In August 1888, probably at the suggestion of Walter Gay, who served as Perry's mentor in Paris, she and her family went to Munich, where she studied for two months with the German social realist Fritz von Uhde.[24] Once acclaimed, now forgotten, von Uhde certainly merits special mention here because of his influence on Perry's handling of certain subjects and use of color. Furthermore, he appears to have been the first person to speak to her of the charms of Giverny.[25]

Von Uhde's eyes were opened to possibilities inherent in the use of a brighter palette by Max Liebermann in 1880. Traveling to Zandvoort, Holland, in 1882, von Uhde immediately was struck by the "brilliant, silver" sunlight. Thereafter, he always painted in front of a large, open window to let the sunlight illuminate his studio. His canvases, which incorporated "dazzling, daring" colors for the times, created a sensation when they were exhibited in Munich in 1883. They were also warmly praised in Paris, where he was a familiar figure in art circles.[26]

If von Uhde's focus on the miseries of the proletariat, impregnated with Christian symbols, was more akin to the work of Jules Bastien-Lepage, or even several genre scenes by Gay, than to Perry's art, his portraits of children had special appeal for her. *An der Tur,* for example, which depicts a little girl in a bonnet standing quietly by a closed door, may well have inspired Perry's later plein-air series portraying her daughter Alice in Giverny (pl. 11, *Alice in the Lane,* 1891).

Perry returned to Paris from Munich in the fall of 1888. Whether Perry switched from the Académie Colarossi to the Académie Julian before or after Munich is not clear. What is certain is that she studied with Tony Robert-Fleury sometime in 1888 at Julian's annex on the rue de Berri.[27] She may have been in the same class with Cecilia Beaux, who has preserved her impressions of her first introduction to "the master." "'Tony' . . . was to criticise that week, and at the hour entered a young-middle-aged and very handsome man, with a face in which there were deep marks of disappointment; his eyes, grey and deeply set, smoldered with burnt-out fires. How un-American they were! As I observed him [Robert-Fleury] from behind my easel, I felt that I had touched for the first time the confines of that which made France and Paris a place of pilgrimage."[28] It appears that Perry also made a few brief appearances at William Bouguereau's classes at Julian's.[29]

In 1889, presumably while she was still attending classes at the Académie Julian, Perry completed her *Portrait of Thomas Sergeant Perry* (pl. 2). Perry portrays her husband seated in a bold, upright, profile pose, glued to his book, devoid of any trace of sentimentality. "The reader" has always been a popular theme in genre paintings. One of the most sensitive renderings of this theme in France during the late 19th century is Puvis de Chavannes's late portrait of his dear friend, Eugène Benon, completed in 1882. No documents at present confirm that Perry actually saw this painting prior to 1889. It is a fact that she greatly admired Puvis, however, and there is a definite resemblance between his composition and Perry's portrait of her husband.

Walter Gay, who was extremely well-connected in Parisian art circles, was very impressed by Perry's portrait of her husband. He urged her to submit it to the prestigious Salon de la Société des Artistes Français of 1889, along with a portrait of her second daughter, Edith, also with book in hand. To Perry's utter surprise and delight, both paintings were accepted, and that spring her career took wings.

With renewed confidence in her work, Perry was admitted to Alfred Stevens's select Paris studio for ladies (no more than fifteen per class) during the second week in May 1889. Stevens was by then well past his prime, but his reputation as a master of elegant interiors featuring genteel ladies lost in their "reveries" was still intact.

These compositions[30] — forerunners of the entire Boston School of painting — were certainly far more appealing to Perry than the mass productions that poured forth from Julian's over-crowded life classes.

Paris was "abominably full" that spring as thousands of tourists swarmed into the city daily to admire A. G. Eiffel's famous tower and other "bonanzas" that were part of the Paris Exposition. There were no crowds, however, when the Perrys entered Georges Petit's gallery on the rue de Séze, where one hundred and forty-five "impressions" from Claude Monet's brush were presented. This exhibition proved to be the "revelation" of Perry's career. It sparked the Perrys' decision to take up residence that summer in Giverny, where Monet recorded sunlight and air and all the "transient" atmosphere which enveloped the lovely Normandy landscape.

The Giverny Years — Part I

Eighty years later, the memories of that first summer at Giverny were still vivid for Margaret Perry, who described in detail the family's first little house "next to the blacksmith's," recalling that it had "*no* conveniences." She also confirmed that the family took their meals at the Hôtel Baudy, which was filled with American painters.

"Behind the house was a field across which was Monet's place. In the field were the haystacks made famous by him."[31]

Theodore Robinson, John Breck and Theodore Butler headed a small colony of artists at Giverny, mostly Americans, who had already discovered the master of French Impressionism and "were camping on his trail."[32] Of all the Americans, however, it was the Perrys who developed the closest friendship with Monet during the nine summers they were to spend in Giverny over a twenty-year period from 1889 to 1909. Perry's own reminiscences about this time in her life, in the form of "an informal talk," were first recorded in 1894 and then expanded in 1927, after Monet's death. They provide invaluable insight concerning, in her estimation, "the world's greatest landscape artist." The 1927 article, published in *The American Magazine of Art,* is reproduced in this book in extenso, annotated with excerpts from her initial, sometimes more accurate, 1894 observations[33] and other sources.

A radical transformation in Perry's style took place during that first summer at Giverny, as illustrated by her two almost identical compositions which depict the little French peasant Angèle — *Petite Angèle, I* and *Petite*

Fig. 4. The Perrys at Giverny, summer, 1889 (l. to r.: Alice, Lilla Cabot Perry, Edith, Thomas Perry and Margaret). Photograph by Theodore Robinson.

3. *La Petite Angèle, II*
 1889
 Oil on canvas, 25 × 30 in.
 Private collection

"The Listener is heartily glad to see that Mrs. Perry's *Petite Angele,* for which he has already confidently predicted future fame, is to go to Chicago [for the World's Columbian Exposition]; and its artistic importance must certainly have commanded acceptance at the hands of an intelligent jury, even though its model happened to be a little French girl. . . . The art of our city will not suffer at Chicago by comparison with that of any other American city."

— *Boston Evening Transcript,*
January 23, 1893

"I wanted to paint a picture with the sunlight shining through some geraniums..."

— Lilla Cabot Perry, "Informal Talk Given by Mrs. T. S. Perry to the Boston Art Students' Association . . . 1894"

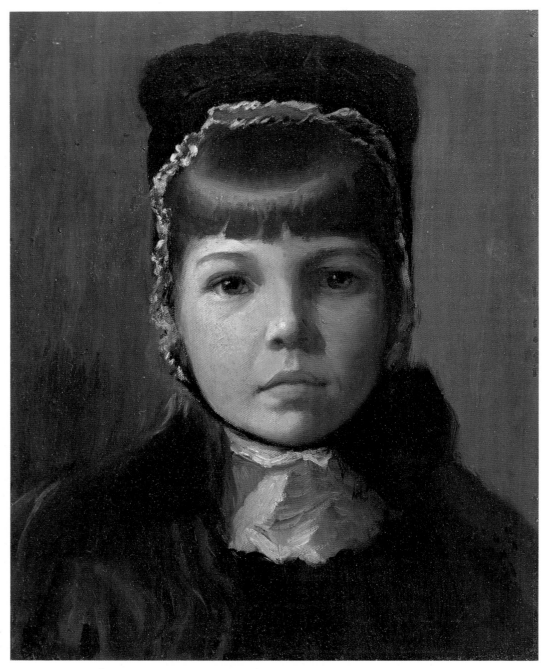

4. *Margaret with a Bonnet* [Margaret Perry]
ca. 1890
Oil on canvas, 16 × 13 in.
Collection Mr. and Mrs. T. Gordon Hutchinson

Fig. 5. Margaret Perry and her violin, Giverny, 1889. Photograph by Theodore Robinson. For his portrait of Margaret, *The Young Violinist,* Theodore Robinson posed her in the garden of the Perrys' first residence in Giverny which they called "The Crooked House." Robinson's portrait of Margaret is now in The Baltimore Museum of Art, Cone Collection.

Angèle, II (pl. 3). Perry employs the Impressionist broken-color technique, applying bright pigments directly onto her canvas, to depict her model. Both the little model and the open window recall von Uhde's themes. The effect of sunlight streaming in the window is heightened here by the bright mustard yellow and spinach green tones of the geranium leaves, contrasted with the vermilion red of the flowers. Angèle's face is interpreted in variegated flesh tones, in contrast to the academic technique of Perry's earlier portraits. Capturing the "sunlight shining through some geraniums" may well have been Perry's main concern here. The overall "impression," however, focuses on Angèle's "wistful" gaze, recalling Emerson's reflections on the quest for sincerity and the manifestation of a spiritual "truth" as seen through a child's innocent eyes and heart.

Both versions of *Petite Angèle* were painted at the Perrys' first residence in Giverny, which they called "the crooked house." Perry depicted the house that summer in a work entitled *Summer Home in Giverny,*[34] along with a number of other canvases for the most part not dated.[35] In the fall of 1889 the Perrys toured Belgium and Holland prior to sailing home in November.

Conservative Bostonians showed little enthusiasm for Monet's view of Etretat which the Perrys had purchased for Thomas Perry's brother-in-law William Pepper, who lived in Philadelphia. Pepper himself was delighted with the work, however, and commissioned a second Monet in 1891. Along with the Monet, Perry brought back from Giverny a collection of John Breck's vibrant landscapes, which she privately exhibited at her residence on Marlborough Street that winter. Prospective patrons were unimpressed, but she was determined to foster this "new truth" in painting. Several colleagues from Boston's art museum also helped Perry organize the first public exhibition of Breck's landscapes in November 1890 at the prestigious St. Botolph Club.

Perry's own paintings from this period reflect the seesaw battle for and against Impressionism being waged in the development of her style. *The Letter* [Alice Perry] (pl. 5), with its russet brown hues and chiaroscuro effects, evokes the Old Masters of Italy far more than the French so-called "avant-garde." On the other hand, *Margaret with a Bonnet* [Margaret Perry], *ca.* 1890 (pl. 4), from the same period combines loose brushwork with strong contours, suggesting a curious blend of Edouard Manet with possible allusions to the recently discovered "Fayoum" portraits from Egypt, the discovery of which was first reported in America by Thomas Perry.[36] Monet's direct influence, albeit subdued, is most manifest in three plein-air compositions[37] all painted at Milton, near Boston, where the Perrys spent the summer of 1890: *An Open Air Concert* [Perry's three daughters]; *Study of Light and Reflection* [Edith Perry]; and *Child in Window* [Edith Perry]. Camille Pissaro's focus on "the inner state of mind" (in the words of his biographer Christopher Lloyd[38]) in several of his solitary figure compositions from the early 1880s also may have inspired Perry here.

Study of Light and Reflection (pl. 7), the title was shortened to *Reflections* in 1893, was highly praised, in the manner of the day, when it was presented in a group show in New York at the Society of American Artists in the spring of 1891, just prior to the Perrys' return to France: "Mrs. Lelia [*sic*] Cabot Perry's work ranks at once with the men."[39]

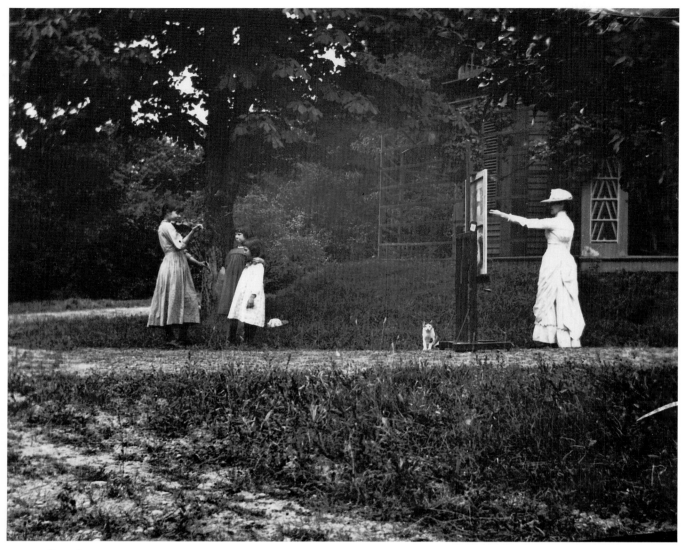

Fig. 6. Lilla Cabot Perry painting her children in Milton, Mass., during the summer of 1890. The ensuing work, *Open Air Concert,* was one of seven paintings by Perry exhibited at the 1893 World's Columbian Exposition in Chicago.

Conversations concerning the recent success of Monet's haystack series were still humming when the Perrys reached Paris in May 1891. Puvis had organized a new Salon (Champ de Mars). Many of the works exhibited at both the "Old Salon" (Champs Elysées) and the "New Salon" reflected "the new tendency toward light," as Thomas Perry reported in an article for the *Boston Post*.[40]

In June 1891 Paul Durand-Ruel, the dealer most committed to promoting Impressionism in America, launched the first major group show of American contemporary artists in Paris. The Perrys were delighted as

two of their close friends from Giverny, Robinson and Philip Hale, were well represented. The favorable response in the French press sparked Thomas Perry's review of that event in the *Boston Post*. He concluded his article with a stirring appeal for "less indifference" on behalf of the American public to the plight of many talented countrymen, who, though stimulated by the Paris art scene, might well face "starvation" on their return home.[41]

Theodore Robinson kindly arranged for the Perrys to have the same accommodations during the summer of

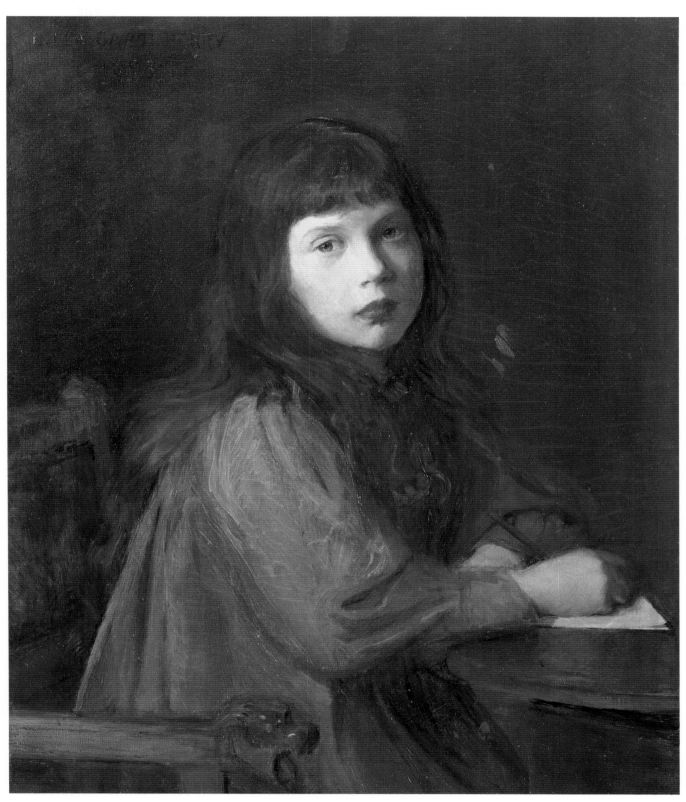

5. *The Letter* [Alice Perry]
1893
Oil on canvas, 23 1/2 × 20 in.
Private collection

6. *Landscape in Normandy*
 1891
 Oil on canvas, 18 × 22 in.
 Collection Newark Museum
 Bequest of Diana Bonnor Lewis

"Mrs. Perry is painting the view out of my window . . . it is a beautiful field which Monet often paints."

— Thomas Sergeant Perry to Hercules Warren
 Fay, August 28, 1891 (Houghton Library,
 Harvard University)

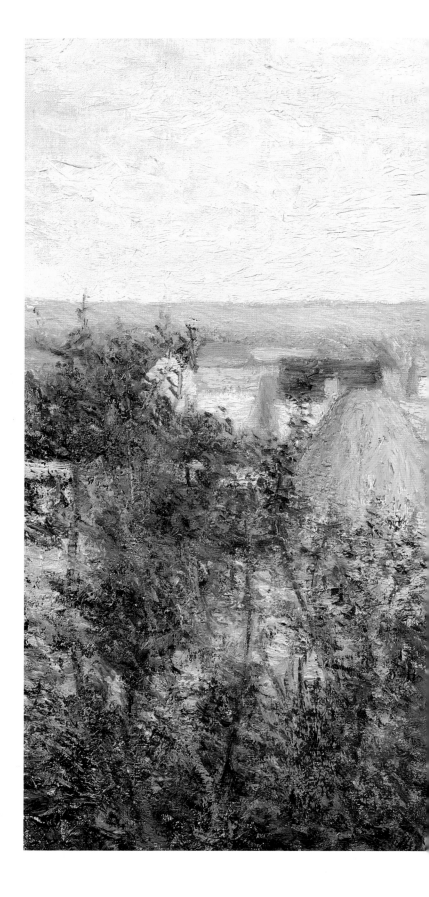

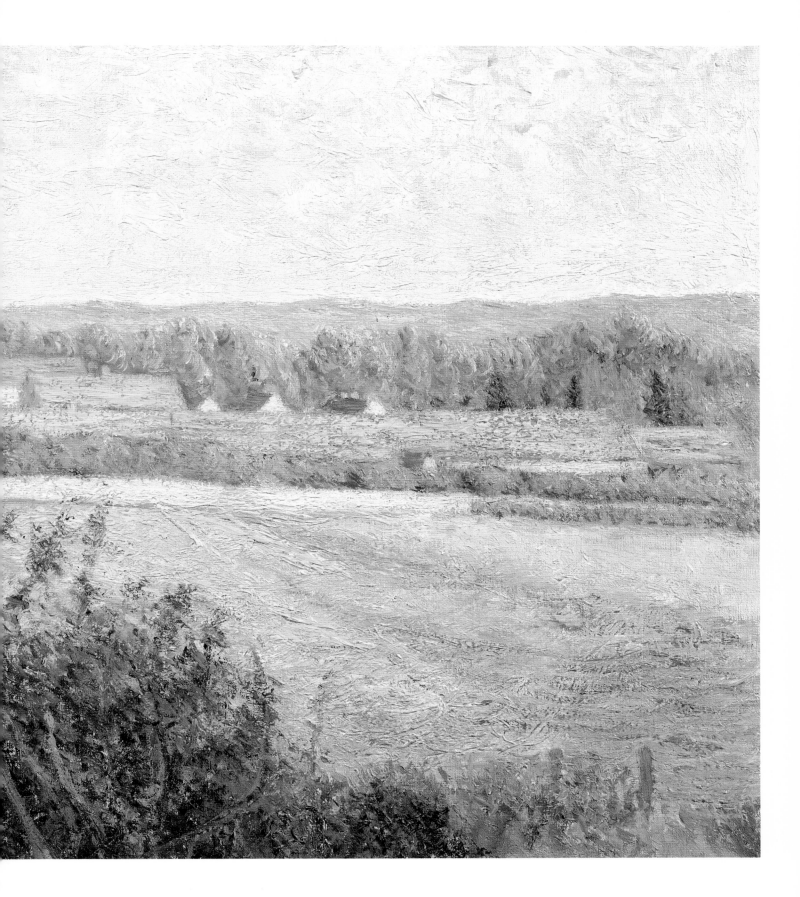

1891 that they had enjoyed in 1889, "the same rooms, beds, meals, prices, as before, and I will cast my paternal eye on them from time to time."[42] It was with great joy that Lilla Cabot Perry returned to that lovely part of the world, as her husband noted in his correspondence.

During the second summer at Giverny Perry devoted her time to plein-air figures and landscapes. Poppy reds occasionally appear in works produced at this time, such as *Alice in the Lane,* 1891 (pl. 11), but more often she uses softer colors — light pinks and blues placed directly on her canvases in smooth brush strokes, creating mauve effects. Self-portraits always reflect a personal statement. Perry's version painted at this time, *Self-Portrait,* 1891 (pl. 9) — a painting within a painting — reveals a serious, dedicated artist who aligns herself with Giverny's "new school of light."

A painting of particular interest from that summer in Giverny is Perry's subtle variation on the window theme, *Child in Window,* 1891 [Edith Perry] (pl. 13), which incorporates several levels of expression. The window serves here to frame her daughter's unspoiled vision, in an Emersonian sense referred to earlier, of the sunlit Normandy landscape, a vision which simultaneously represents the artist's own poetic view. Spiritual overtones are present, as they often are in landscapes by Caspar David Friedrich, von Uhde and the American Luminists. Perry's focus on the intersection of the window frame in the form of the Cross serves here to "eternalize" nature.[43] By contrast, the loose brushwork used to depict her daughter, seated in the foreground, illustrates the transient aspect of human existence. The overall atmosphere of this work, symbolized by the sadness in Edith's eyes as she sits by herself indoors, is one of alienation and withdrawal, themes prevalent in much of Perry's art throughout her life.

From November 1891, when the Perrys returned to America, until their next departure for France in 1894, their green and gold salon on Marlborough Street once again became the meeting ground where "the Crowned heads of Boston," as Philip Hale called them, were confronted with Giverny's "thirst" for more light. Robinson's desperate financial situation deeply moved Perry, prompting her to help organize a joint show for "the two Theodores" — Robinson and Wendel — at the Williams and Everett Gallery in Boston. Robinson welcomed the Perrys' hospitality during the show, which took place the first week in April 1892. In spite of excellent reviews of Robinson's work in the press, however, Perry later recalled that she was the only person who purchased one

of his paintings. "[Robinson's] exhibition finally took place and I believe I was the only person who bought one of his pictures, and when he died a few years later, pictures of his sold for from five to fifty thousand dollars!"[44] Monet's exhibition that same spring attracted more attention, though conservative Boston remained reticent in accepting his works.

Portraiture traditionally took precedence in Boston over landscapes, and Perry resumed her studio compositions upon her return. They principally focused on children but also included two more self-portraits painted in 1892. One of these is a conventional study wherein she strikes a noble pose. A smaller variation (pl. 8) reveals a more complex personality, however. The brushstrokes are loose, even nervous, particularly in the background, where earthy pigments are applied in an almost abstract manner. The shadow from the brim of her hat covers her gaze like a mask, and the pale yellow light on the bottom of the face lends an air of disturbance and anxiety. This portrait was never finished.

The World's Columbian Exposition of 1893, held in Chicago, overshadowed all cultural events in America in the 1890s. Hamlin Garland, a former protégé of Thomas Perry and one of the noted literary voices of the day, regarded the event as "a triumph" for Impressionism in America. Edmund Tarbell headed a committee which selected seven paintings by Perry to be among those representing Massachusetts, making her one of the best-represented women artists in the exposition. Their choice of works reflects the committee's "split decision" concerning the new movement. They selected four plein-air compositions — *Petite Angèle I, An Open Air Concert* [Perry's three daughters], *Reflections* [Edith Perry] and *Child in Window* [Margaret Perry—not to be confused

7. *Study of Light and Reflection* [Edith Perry]
1890
Oil on canvas, 28 1/2 × 22 in.
Private collection

"Until this day, excellence in art has been but rarely achieved by women. . . . Mrs. Lelia [sic] Cabot Perry's work 'ranks at once with the men,' to quote the remark of a male observer."

— Unidentifed press review, 1891
(Perry Family Archives)

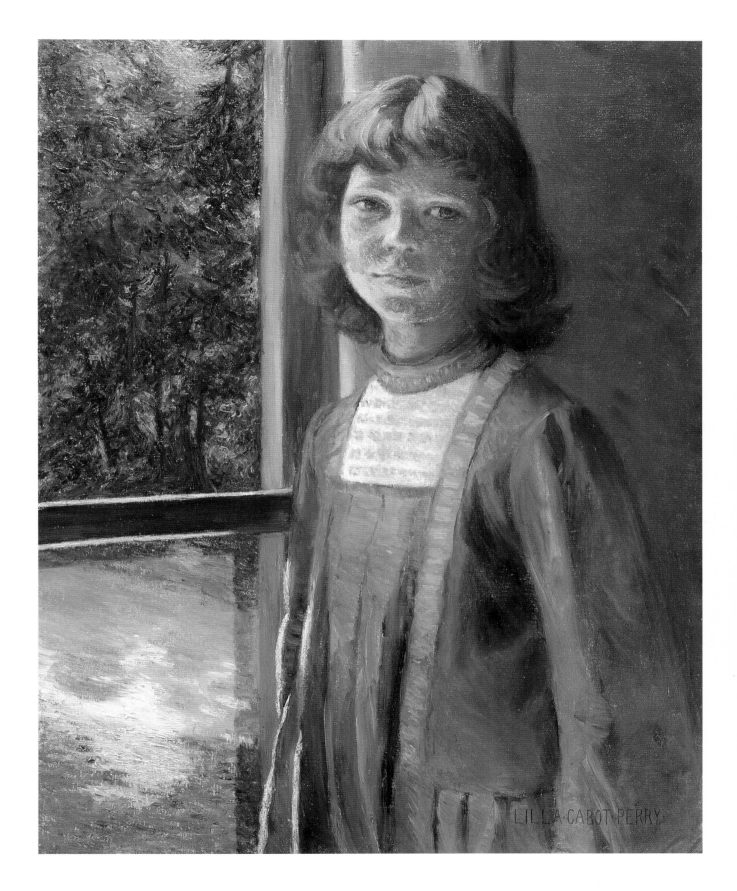

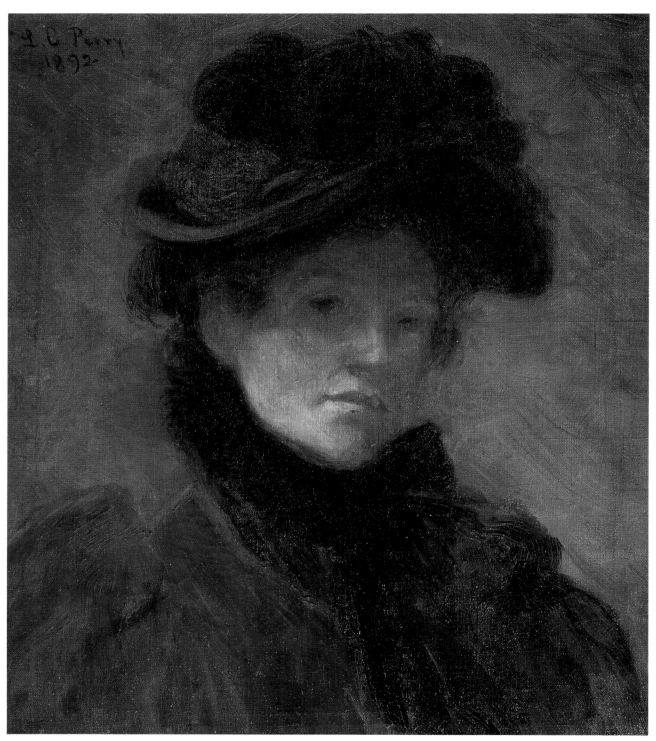

8. *Self-Portrait*
1892
Oil on canvas, 24 × 20 in.
Collection Mrs. Kline Dolan

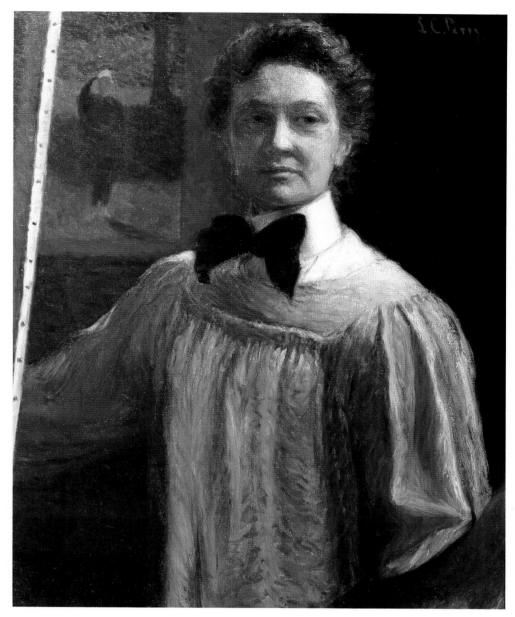

9. *Self-Portrait*
1891
Oil on canvas, 31 7/8 × 25 5/8 in.
Daniel J. Terra Collection
Terra Museum of American Art, Chicago

The figure out-of-doors as seen through the window possibly represents Perry's husband making ineffectual attempts to divert her from her art.

> Woulds't know the artist? Then go seek
> Him in his labors. — Though he strive
> That Nature's voice alone should speak
> From page or canvas to the heart,
> Yet it is passionately alive
> With his own soul! Of him 'tis part! —
> This happy failure, this is Art.
>
> — Lilla Cabot Perry, "Art" from
> *Impressions*

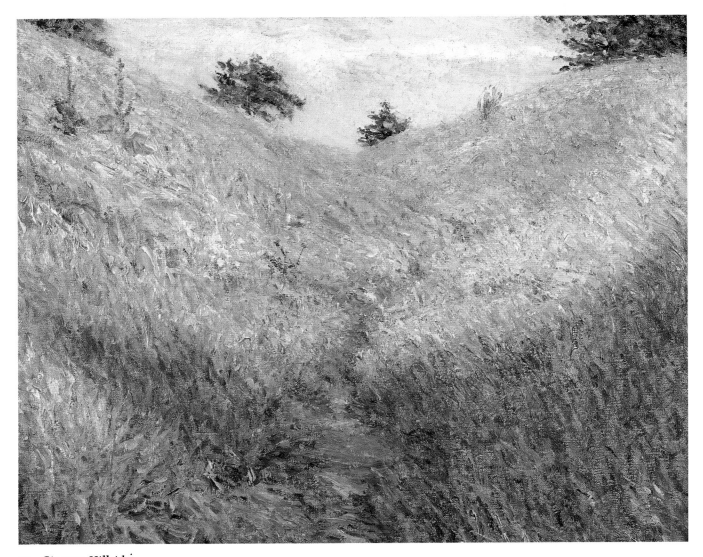

10. *Giverny Hillside*
n.d.
Oil on canvas, 18 × 22 in.
Collection Barbara and Blake Tartt

11. *Alice in the Lane* [Alice Perry]
1891
Oil on canvas, 21 3/4 × 18 1/4 in.
Collection Claude Monet Foundation, Giverny
Gift of Mrs. Lila Acheson Wallace

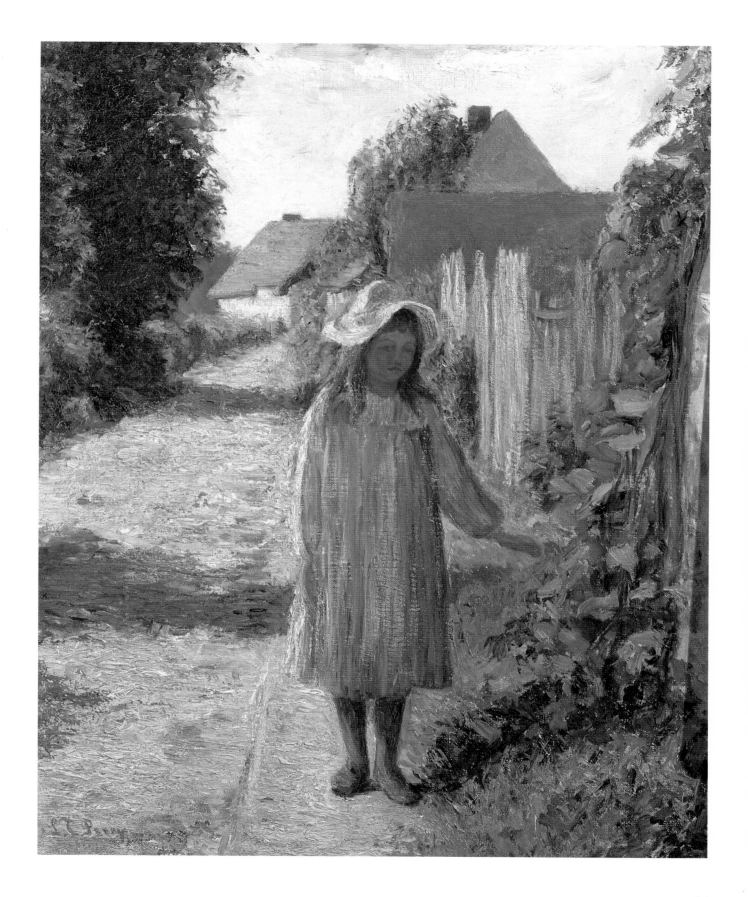

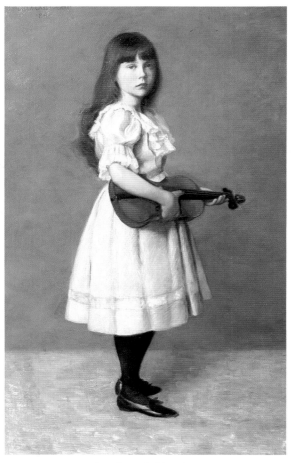

12. *Portrait Study of a Child* [Alice Perry]
1891
Oil on canvas, 60 × 36 in.
Collection Natalie, Brienne and Chase Rose

"The best of beauty is a finer charm than skill in surfaces,
in outlines, or rules of art can ever teach, namely,
a radiation, from the work of art, of human character. . . .
A confession of moral nature, of purity, love, and hope."

— Ralph Waldo Emerson, "Art"
from *Essays*

"A Boston artist, Lilla Cabot Perry has studied children with
excellent effect. The color harmonies in shades of brown in
the portrait of a child with a violin are especially well
rendered."

— Unidentified press review for Thirteenth
Exhibition of the Society of American Artists
(Perry clipping files, Hirschl & Adler)

13. *Child in Window* [Edith Perry]
1891
Oil on canvas, 38 × 24 in.
Collection Mr. and Mrs. T. Gordon Hutchinson

"A lonely child who from a window longs . . ."

— Lilla Cabot Perry from *The Heart
of the Weed*

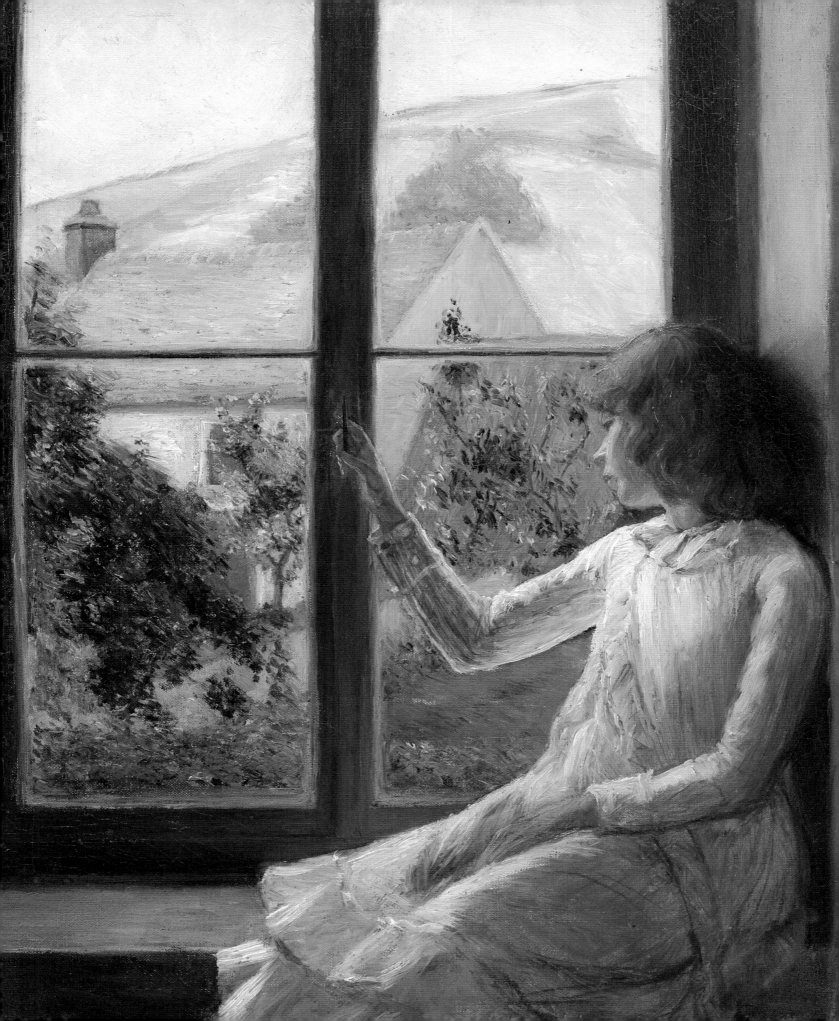

with pl. 13] — along with three studio portraits — *Portrait of a Child* [Cornelia Wolcott], *Child with Violoncello* [Edith Perry] and *Portrait Study of a Child,* [Alice Perry], 1891 (pl. 12). The Boston critics, however, simply "ignored" the presence or absence of "blue shadows," a hallmark of Impressionism, focusing all their attention on the expression of character in her portraits. As William Downes, Boston's most influential art critic, wrote, "[Perry's works] are not merely portraits, but something besides, namely true recognizable types of children we know and revere, yet which one so seldom sees adequately depicted on canvas."[45]

In September 1893 the Perrys joined thousands of other visitors touring the immense exhibition site. An article in the *Boston Evening Transcript* recorded Thomas Perry's firsthand observations on the American pavilion: "What most surely fascinated [the multitude] in sculpture was . . . a little group of the Vanderbilt family in their best clothes, or what would be other peoples' best clothes. . . . The most admired paintings were . . . an old man jauntily dancing with a young girl, scenes of domestic bliss or misery, . . . grandma in the rocking-chair . . . and always, even on the most crowded days, there were vacant seats in front of the Whistlers and Sargents"[46]

If it was perhaps a bit premature to proclaim "a triumph" for Impressionism at Chicago, two events at the end of January 1894 indicate that a small but influential circle in Boston actively promoted the new movement. The first was Perry's lecture on Monet and his methods, which took place on January 24 at the Boston Art Students' Association (subsequently rebaptized The Copley Society). Perry began her lecture by clarifying a pertinent point about what constitutes an Impressionist painting: "According to a certain definition of impressionism, every artist is an impressionist. That is, every good artist expresses on canvas the impression that the object he is painting makes on him. But in some special sense, a certain style of color has come to be called by people 'impressionism.'"[47]

The second indication that by 1894 Impressionism was gaining votes in Boston was the group exhibition at the St. Botolph Club, considered "epoch making" by the local press. The "leading local artists . . . of the new guild" featured in the show were Tarbell, Hale, Wendel, Vinton, Dawson-Watson and "Mrs. L. C. Perry." In her review of the exhibition for the *Boston Evening Transcript,* Helen Knowlton proclaimed, "Mrs. Perry takes rank among the greatest modern painters. . . . In her pictures there is a singular reminiscence of Botticelli joined to a grasp of the most realistic and yet imaginative problems of modern painting."[48]

Although the St. Botolph exhibition affirmed that Perry was part of the inner circle of Boston's art world, her husband's bitterness concerning Boston in general and the new trustees of the Boston Public Library in particular[49] accelerated his decision to return for a third "exile" in France.

They reached the port of Gibraltar on April 7, 1894, and spent the rest of that month and all of May in Spain. There, as Thomas Perry noted, "my restless wife wants to copy all of Velasquez and Ribera."[50] Copying El Greco also was one of Perry's priorities. Recalling this trip in a letter to Bernard Berenson in 1930, Perry wrote: "The next time we went to Spain [1894], we landed in Gibraltar and went to Cadiz, Grenada, Cordova, and Toledo for a full week, [El] Greco being the chief attraction for me, before going to Madrid, where I copied Velasquez, Rubens, and Ribera in the Madrid galleries. . . . I never heard people speak of [El] Greco and Zurbaran and another Spanish painter whose picture of the entombment, which hung in the long gallery of the Prado on the right hand side near the end, I greatly admired . . . and I was much struck by the Goyas, little appreciated at that time."[51]

Monet welcomed them warmly when they resettled in Giverny early in June, and they were delighted to be back. The mid-1890s appears to fall into a vague no man's land for American artists in Giverny. Art historians evoke a "first generation" of artists at Giverny, exemplified by Wendel, Breck and Robinson, all of whom first settled there in the late 1880s. A "second generation" of artists at Giverny "dates" from Frederick Frieseke's arrival in 1900, followed by Edmund Graecen's presence in 1907. Renewed attention in very recent years, however, to three other American residents — Perry, Butler and Mary Fairchild MacMonnies[52] — all of whom painted some very significant works from the late 1880s on at Giverny, suggests that there was a fairly steady output of fine paintings from Giverny throughout these years. Splitting the period in two parts, therefore, is perhaps a bit arbitrary.

For Perry, living at Giverny inspired her to paint what she loved most — landscapes. She never tired of the infinite variety of views of the village and surrounding countryside, bathed in the soft, ever-changing light. *Brook and Wash-house, Giverny* (pl. 14), *A Stream beneath Poplars* and *French Farm Houses,* with its very modern geometric perspective, illustrate her diverse treatment of

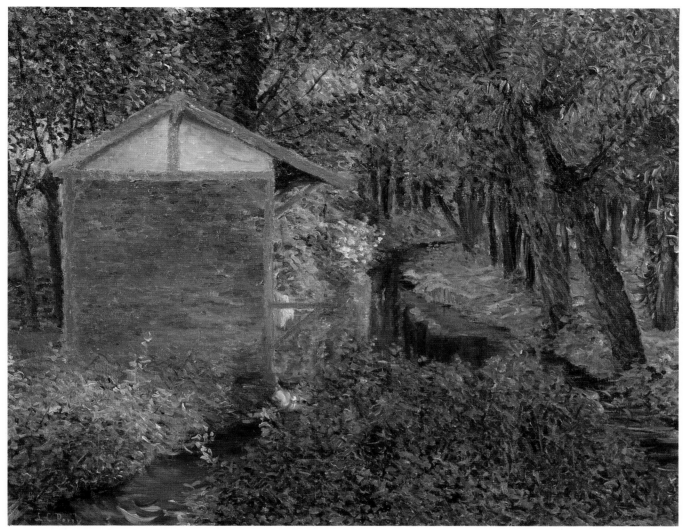

14. *Brook and Wash-house, Giverny*
(Brook from Monet's Garden)
n.d.
Oil on canvas, 25 1/2 × 32 in.
Collection Mr. and Mrs. Marshall Crawford

the landscape theme. Two of her loveliest landscapes from the summers of the mid-1890s depict a row of poplar trees. Clearly inspired by Monet's famous series, *Poplars* (pl. 15)[53] nevertheless presents Perry at her best. Chromatic spots of color here capture the effect of sunlight through the shimmering leaves of the trees, softly contrasted with variegated stripes of light pink and pale green evoking the surrounding fields.

Although landscapes occupied much of her time that summer, Perry also painted a considerable number of

plein-air figures in Giverny. *At the River's Head* [Edith Perry] (pl. 16) exemplifies Perry's personal interpretation of Impressionism, which borrows from both Monet and Old Master sources. In this two-part composition the background is composed of reflections on the river Epte, where vibrant greens and golden hues loosely "woven" together create a tapestry effect. The horizon has totally disappeared, but a sparse patch of light pinks and white on the shimmering surface of the water reflects clouds in the sky. Framed by this "modern" background, Perry

15. *Poplars*

Giverny, n.d.
Oil on canvas, 35 × 45 in.
Collection Mrs. Lilla Cabot Levitt

"I think the years we were [at Giverny] were perhaps the happiest of my life . . . and I think they were so happy because Tom was so happy there"

— Lilla Cabot Perry to Alice Perry Grew,
1928 (Perry Family Archives)

Fig. 7. Sandro Botticelli, detail from *La Madonna della Melagrana* (Madonna with the pomegranate). Firenze, Uffizi. Photograph courtesy Alinari/Art Resource, New York. Botticelli's "sentiment of ineffable melancholy," in the words of art historian Walter Pater, is evoked by many of Perry's portraits.

places a portrait of her daughter Edith. Her pose is adapted from Perry's earlier works, such as *The Letter* (pl. 5) and *The Red Hat,* updated in muted tones delicately applied in the Impressionist manner. Perry focuses first and foremost on Edith's gaze. One of the trademarks of her portrait style, this approach was inspired by her close examination of the Old Masters and, in particular, the wistful youth holding a lily in Botticelli's *Madonna with the pomegranate* (fig. 7).

Perry also completed several interior genre scenes at Giverny. Her most audacious work, *The Violinist* [Margaret Perry] (originally titled *In a Studio*), ca. 1895, announced a new orientation toward more subdued compositions. Only a sliver of light filters in from the obliquely opened window in the upper lefthand corner, greatly foreshortened here in the manner of the Dutch interiors. Moreover, Perry's focus is no longer on her daughter's

expression, but rather on the reflection of the violin in an antique mirror on the room's wall. The compositional approach of Jan Vermeer or Gerard Terborch may have inspired this work, although Perry's interpretation of the composition is awkward. It is significant, however, to note that in 1895 Perry's interest also was shifting from the plein-air works of her first years of Giverny to more subdued interiors that soon characterized the Boston School from the turn of the century on.[54]

Three portraits painted by Perry in Paris during this third sojourn in France from 1894 to 1897 also illustrate the influence of the Old Masters. *Edith with Lierre,* 1895 (fig. 8), originally titled *Girl with a Cat,* very obviously is inspired by Frans Hals, whom Monet admired greatly,[55] and also underscores Perry's love of animals. If her daughter Edith's expression is almost a pastiche of Hals, Perry's portrayal of the family's handsome pet angora, Lierre, is one of her very best animal depictions. *Portrait of the Baroness von R.* (pl. 19) from 1895 portrays the quintessential Jamesian aristocrat in a noble profile pose. Perry uses even brushstrokes in rendering her model's delicate features, which take on a certain timeless beauty. By contrast, the loose brushwork of the brocade material in the background, painted in transient, aquatic blue tones, recalls the Impressionists, and possibly was inspired by Monet's newly created lily pond at Giverny. *Young Bicyclist* [Alice Perry] (pl. 18), which is less dependent on the "wistful" chords of her earlier portraits, is one of Perry's best works from this period. Her daughter's "noble" expression is highlighted here by her somber beret and coat. The vibrant accent on the handlebar of the bicycle, however, adds a modern touch, evoking at the same time Perry's own "wild enthusiasm for the wheel." Although women on bicycles were novelties in the mid-1890s, Perry was an avid cyclist from the start, underscoring the strong sense of independence, often hidden beneath a veneer of propriety, which motivated her throughout her life. Margaret Perry confirmed in the summer of 1895, "My mother can go over twenty-five miles now without the slightest fatigue. She is the most enthusiastic wheellady I ever saw."[56]

Symbolism was a dominant theme in Paris during the 1890s and Perry's *Children Dancing, II* [Alice and Edith Perry] (pl. 17) of 1895, one in a series of three paintings of this subject, reflects her own involvement with this movement. When exhibited in Boston in 1897, a critic remarked on the painting's "lovely grace and buoyancy, worthy of Degas."[57] Puvis's allegory *Les Jeunes filles et la mort* (Young maidens and death), however, may well

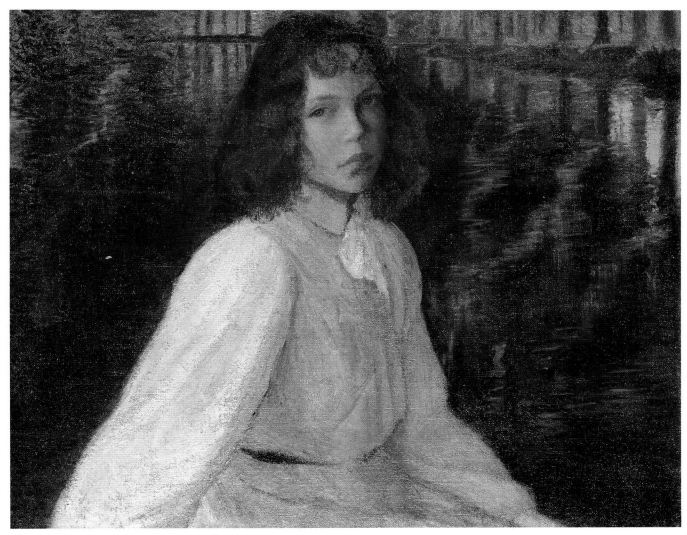

16. *At the River's Head* [Edith Perry]
(On the River, II)
1895
Oil on canvas, 25 1/2 × 32 in.
Courtesy Vose Galleries of Boston, Inc.

"Monet came in yesterday p.m. & looked at L[illa]'s pictures. He gave one of the highest praises he ever gave anything, 'pas mal,' & she feels highly flattered. He was very encouraging."

> — Thomas Sergeant Perry to Hercules Warren
> Fay, September 10, 1895 (Houghton
> Library, Harvard University)

Although Thomas Perry did not identify the paintings by Perry which Monet admired in 1895, *On the River* (as it was originally titled) could have been part of the group.

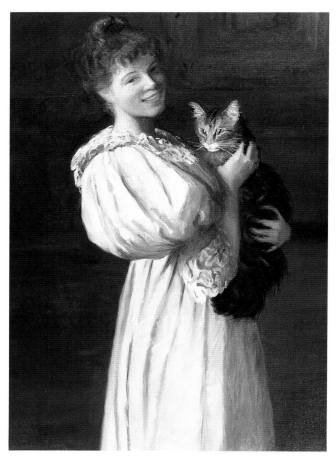

Fig. 8. *Edith with Lierre* [Edith Perry]
 ca. 1895
 (Girl with Cat)
 Oil on canvas, 44 × 33 in.
 Collection Susan and Rudy Wunderlich

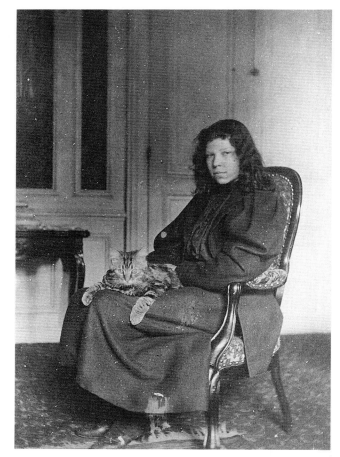

Fig. 9. Edith Perry with the family cat Lierre, Paris, *ca.* 1895.

have inspired this work because the overall atmosphere is somber, suggesting deep anxiety.[58] Whether or not Perry drew inspiration from Puvis's work, Puvis himself considered Perry's art, "very original, of charming colour and very delicate."[59] Her paintings regularly were exhibited at the new Salon de la Société Nationale des Beaux-Arts (Champ de Mars) of which he was president.

So many friends of the Perrys flocked annually to Paris that Thomas Perry remarked in jest that the capital of France was simply a "suburb" of Boston. Paris was, of course, the undisputed international center for art. The Perrys, however, remained just as attached to Giverny, particularly during those exciting four summers when they lived at Le Hameau next door to Monet.[60] The master often stopped in for informal visits and an occasional critique of Perry's work. The proximity of their

residences also provided memorable occasions for their friends, whom they took to meet Monet. Berenson, for example, was "taken off his feet" in 1895, according to Thomas Perry,[61] when he viewed the Rouen cathedral series in Monet's presence. Cecilia Beaux never forgot her own introduction to Monet the following summer: "Geniality, welcome, health and power radiated from his whole person."[62]

Perry's close ties with Monet, documented by her two published articles, have nevertheless completely overshadowed her friendship with another great artist whose works she also immensely admired — Camille Pissarro. Eragny, where Pissarro lived, was within "cycling" distance of Giverny, and the Perrys were most anxious to meet him during the summer of 1894. It was not until October 28, however, after they returned to

Paris, that the memorable event took place. Thomas Perry gave a detailed account of the meeting to his friend Hercules Fay. "We left Paris at 9:15 this a.m. and went to Gisors. Thence we drove to Eragny and saw old Pissarro, who is a noble-looking fellow with a beak on him like an eagle and an eye like Sophocles As Monet told me, [he] was a most charming and simple soul, with enormous interest in his work. A fine old fellow. He is as simple as a child. . . . We spent some time and saw much of his work and bought a mighty pretty watercolour, a real masterpiece."[63]

One tends to forget today, with the astronomical prices attached to the Impressionists, how financially desperate Pissarro continued to be even into his late years. A moving letter to his son, Lucien, written only a week before the Perrys' visit, evokes his plight: "Black poverty and not a ray of hope. I am waiting for some miraculous chance. For the moment, my hopes are limited to Miss Cassatt's recommendations to Miss Halloway [sic—Pissarro is referring here to Sara Tyson Hallowell], who I am sure loves my work, but has not yet gotten anything of mine sold."[64]

No doubt in Pissarro's eyes, the Perrys were that "miraculous chance," and he hastened to follow up their visit with a little note addressed to Perry requesting another meeting at her convenience. Thus began a very warm friendship. Deeply affected by Pissarro's impoverished state, Perry actively tried to stimulate a few sales for him, arranging for private teas in Paris with collector friends, like the Quincy Shaws, and alerting correspondents in America. The response was largely negative, as Pissarro sadly confirmed to his son in the spring of 1896. "Mrs. Perry hasn't been able to place a single painting for me so far, really the Americans can't get used to my painting which is too sad for them . . . Monet alone is recognized in America."[65] The following spring Perry finally managed to arrange for a small sale of six watercolors by Pissarro to her brother Arthur Cabot. The Perrys returned to Boston in July 1897. Thomas Perry expressed his sadness, "All is ending. We are dying to slow music. The day is over; twilight is beginning."[66] All, of course, was not ending, but they would never see one beloved friend again—Pissarro died in 1903, two years before the Perrys returned to France.

* * * * * *

During the Perrys' three-year absence, Boston had undergone great transformations in an effort to maintain its cultural prestige in the face of an increasing challenge from New York. The most notable development was the completion of the new Boston Public Library, "a splendid palace," as Perry's husband characterized it, which symbolized America's "Renaissance." Puvis's great mural paintings, which crowned the grand staircase, were a

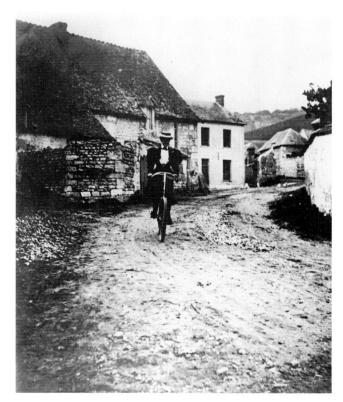

Fig. 10. Lilla Cabot Perry on her bicycle in Giverny, *ca.* 1895. Photograph by Margaret Perry.

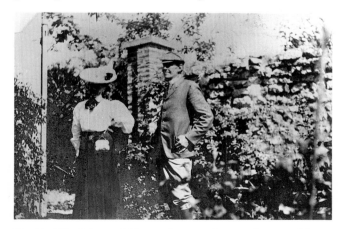

Fig. 11. Lilla Cabot and Thomas Sergeant Perry at the gate of their house in Giverny called Le Hâmeau, *ca.* mid-1890s. Photograph by Margaret Perry.

45

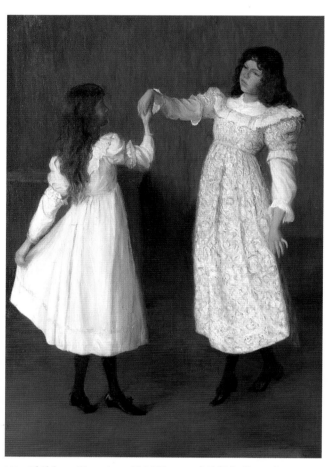

18. *Young Bicyclist* [Alice Perry]
ca. 1894–95
Oil on canvas, 39 × 30 in.
Collection Alice Lyon

The bicycle was still a novelty for women in the mid-1890s, and Perry was very much taken with it. Her husband noted that she was "simply wild on bicycling."

> — Thomas Sergeant Perry to Hercules Warren Fay, May 14, 1895 (Houghton Library, Harvard University)

"[Perry's portraits] lead the mind back to old pictures and illustrate the amity between the old and the new, and thus take on added beauty by virtue of the many indefinable associations with life and art"

> — *Boston Evening Transcript,* November 11, 1897

17. *Children Dancing, II* [Alice and Edith Perry]
1895
Oil on canvas, 48 × 33 1/2 in.
Private collection

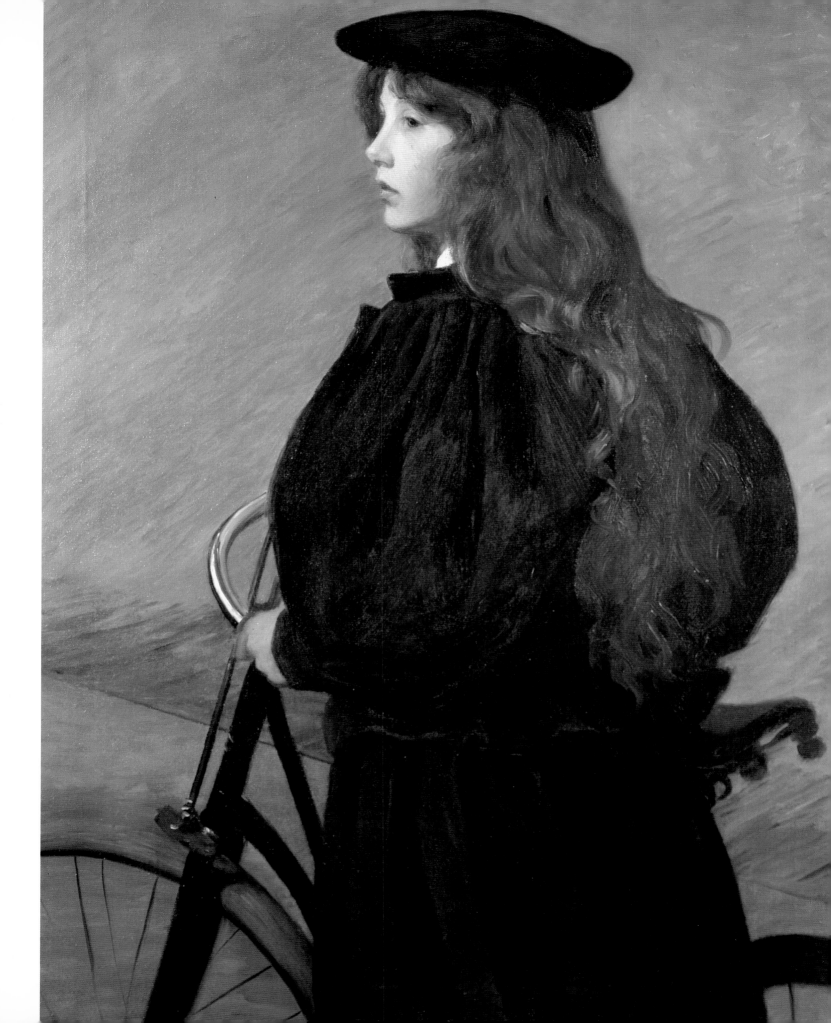

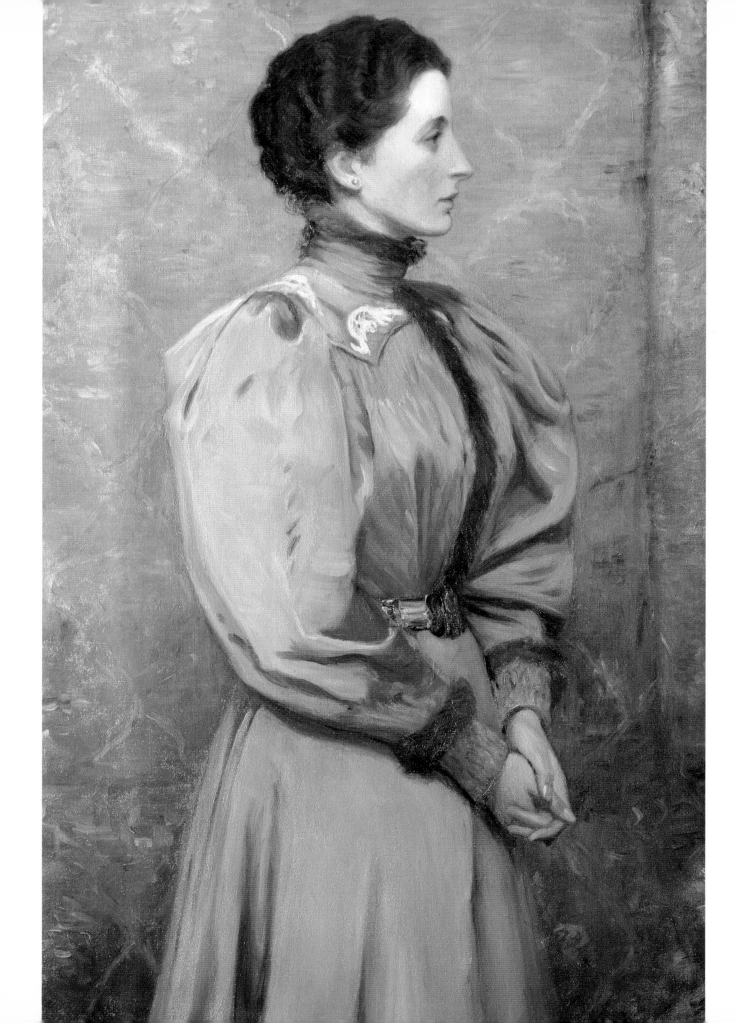

19. *Portrait of the Baroness von R.*
1895
Oil on canvas, 46 × 29 in.
Collection Boston Harbor Hotel

"I enclose a blueprint of Lily's portrait. She has on a sort of café au lait silk (gros grain) dress trimmed with sable, and the background is that lovely blue brocade which covered the box on which the Pissarro water-colors lay on Wednesdays. Strangely enough it's the first time L. [L. C. Perry] ever used it for a background, though I think it is the most beautiful stuff she has."

— Margaret Perry to Edith Perry,
January 5, 1896 (Perry Family Archives)

Fig. 12. Claude Monet by his new water garden during a rare "interview" with Thomas Perry, September 28, 1895. Photograph by Margaret Perry.

source of immense civic pride. Perry was particularly enthusiastic about the central panel entitled *The Inspired Muses,* which expressed the spiritual virtues of music. Puvis previously had evoked this theme in his painting of 1852, *Inspiration.*[67] It was certainly no coincidence that Perry's own graceful portrait *Playing by Heart* [Alice Perry] (pl. 20), a variation on a similar theme with fresco allusions, was painted at this time.

If enthusiasm for Puvis was at its zenith in Boston in the late 1890s, the scandal caused by the presence of Frederick MacMonnies's nude sculpture *Bacchante with Infant* in the courtyard of the Boston Public Library illustrated how far removed Boston art circles were from Paris.[68] Even Boston's timid acceptance of Impressionism, for example, was limited to Monet's landscapes, which were "more or less known," as Thomas Perry remarked, adding that "Pissarro, Renoir, Degas, and Cézanne are

comparatively or absolutely unknown."[69]

Perry's paintings, however, drew high praise in Boston when the St. Botolph Club opened the winter season of 1897 with her first solo show. Although a substantial number of landscapes from Giverny were presented, the conservative art critic of the *Boston Evening Transcript,* William Downes, focused all his attention on the "artistic verity" of her portraits. "Mrs. Perry is one of the most genuine, no-nonsense, natural painters that we know of; the distinguishing trait of her work is its genuineness. . . . The row of pictures . . . impresses one with a sense of invaluable candor and wholesomeness, where nothing is done for effect, but every touch is inspired by an ardent conviction of artistic verity and fitness. It is only superior art which can afford to be so open, so free from artifice, and so self-forgetful. . . . Such work must be taken seriously."[70]

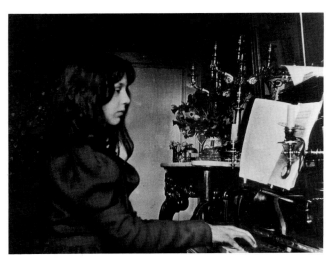

Fig. 13. Alice Perry playing the piano, Paris, *ca.* 1894–95. The Perrys resided during this time at 14 rue de Tilsitt.

"There is more than a promise of similar beauty of expression and character in [Perry's] unfinished 'Playing by Heart' (20), in which a girl in a dark-blue gown is seated at the piano, with her mind's eye seeing melodious visions, and her profile speaking of thoughts beyond. . . . This is a piece of art which does not lie upon the surface of things, but moves upon the imagination with a certain potency, yet it is formulated and constructed with a sure hand and true-seeing eyes."

— *Boston Evening Transcript,*
November 11, 1897

The St. Botolph Club exhibition was a milestone for Perry and a consecration of her art in her native Boston. It also ended an important chapter in her career as an artist. Her daughters were past childhood and thus could no longer serve as the models upon which her reputation was established. She needed a new orientation. It came sooner than expected when her husband accepted a position as Professor of English Language and Literature at Keiogijiku University in Tokyo.

Residence in Japan

After her experience in the European cultural scene, Perry's three-year residence in Japan opened up a whole new direction in her art. As her husband pointed out, "Japanese prints and paintings, besides conveying to the outside world the most vivid knowledge of what the country is, have practically revolutionized modern art by their wonderful artistic simplicity."[71]

Both Perrys soon discovered, however, that the situation of the art world *inside* Japan in 1898 was anything but simple. In brief, the prints and paintings of the Ukiyo-e School, as exemplified by Hokusai, Utamaro and Hiroshige, symbolized Japonism to Western eyes and were a source of inspiration for Whistler, La Farge and the Impressionists, in particular. Inside Japan, however, such works were "forbidden" during the Meiji reign through the 1880s. By contrast, an "orgy of foreignism" characterized the attitude of the leaders in power after Commodore Perry "forced open" the doors of Japan in 1854.

Counteracting this "wholesale destruction" of the nation's culture were the efforts of two of the world's leading orientalists—Ernest Fenollosa, Curator of Oriental Art at the Museum of Fine Arts, Boston, and his colleague Okakura Kakuzo (fig. 14). Together, with the Emperor's consent, they founded the Imperial Art School in Tokyo, which was dedicated to reviving traditional skills, as well as to promoting Western trends. In 1898 Okakura resigned to found a new school, the Nippon Bijutsu-in, to accelerate the rehabilitation of traditional arts and crafts. Thirty-nine of the country's finest artists formerly associated with the Imperial School joined Okakura in his new endeavor.

Perry had met Okakura, a close friend of La Farge, and Fenollosa eleven years earlier, when the three of them toured the National Gallery in London in the summer of 1887.[72] She greatly appreciated the friendship of Okakura, who shared her admiration of Rembrandt, for example, and other Old Masters. She was, of course, particularly honored when Okakura helped to organize an exhibition of her paintings in Tokyo in October 1898. Subsequently, she became an honorary member of the Nippon Bijutsu-in Art Association. Fenollosa's "fanaticism," as Thomas Perry privately remarked, in denouncing "everything" Western as "inferior" and his scandalous private life, however, made him a most unattractive figure in Lilla Cabot Perry's eyes.[73]

The Perrys' new residence in Tokyo, located in the elegant Azabu district, resembled "a big Roxbury house" from the outside, but the interior was distinctly oriental.

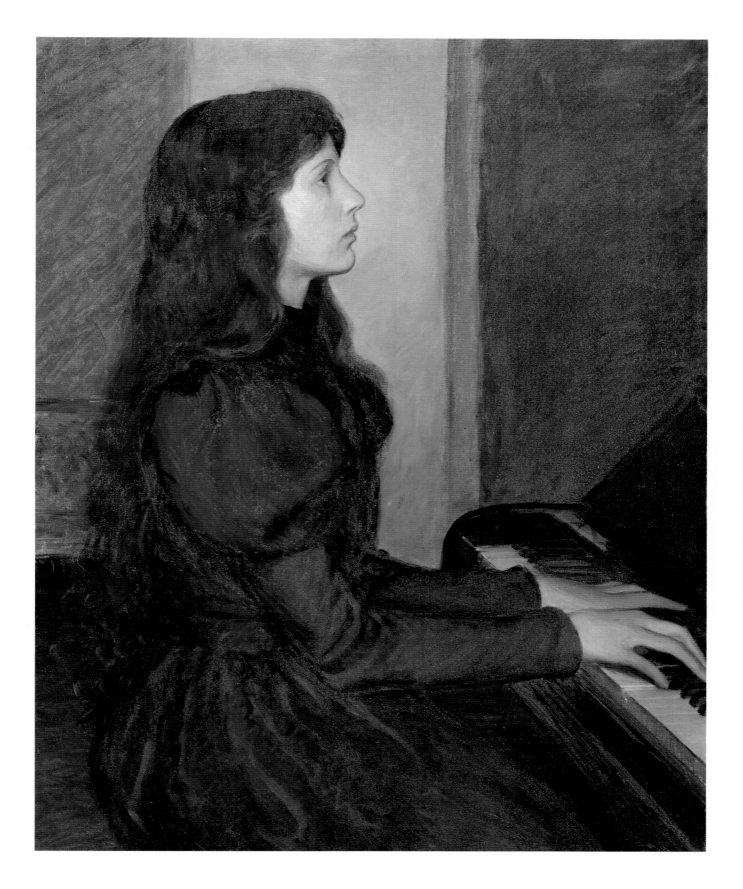

Presumably, Perry depicted their drawing room in *The Trio* [Alice, Edith and Margaret Perry] (pl. 21), a rare group painting of her three daughters playing chamber music. The exact circumstances of the inspiration for this work are not known. The fact that it was Perry who first introduced informal concerts "at home," a practice which soon was adopted by other members of Tokyo's international community, suggests that *The Trio* was inspired by these events. The composition reflects three artistic styles, which adds a second meaning to the title of the work. The burst of sunlight on the central wall and on her daughters' bright spring dresses recalls the Impressionists, while the seriousness and poetic solitariness of each figure evokes Perry's New England roots. The reminiscences of both Monet and Emerson are balanced within a highly linear, geometric decor, inspired by old Japanese prints. No one influence outweighs the other, and this harmony of three "streams"—or "chords"—is suggested by the symbolic presence of cherry blossoms in the background.

While the painting of landscapes prevailed during Perry's three years in Japan, one motif dominated all others — the "simple splendour" of the divine mountain, Fujiyama or Mount Fuji (pls. 26 and 27; fig. 15). At least thirty-five versions of Fuji by Perry were exhibited during her lifetime, and she certainly painted many others. She would travel for weeks at a time, sometimes with one or two of her daughters, sometimes simply with her chambermaid, Tsune, to observe and record the sacred mountain from all angles and at all hours. Wherever she went, crowds soon gathered around her easel, amazed both to see a lady painting out of doors and to view the results on her canvases. Years later she still recalled their comments: "very like, very like!"[74]

Many bystanders also gathered when Perry went to Oya, near Karuisawa, in September 1900 to paint another sacred theme — a bed of lotus flowers. La Farge and Whistler had introduced the cult of the lotus into American art forty years before. Perry's plein-air interpretations of the theme, such as *Lotus Flowers, ca.* 1900 (pl. 28), are vibrant, decorative, full-blown bursts of color which present similitudes with the work of certain Fauve artists and several paintings by Georgia O'Keeffe.

During her stay in Japan, Perry also completed several charming portraits of children, such as *Child in Kimono* [Alice Perry], 1898–1901 (pl. 22) and *Portrait of a Young Girl with an Orange*, 1898-1901 (pl. 23). These works demonstrate an increasing desire to draw from both Western and Eastern aesthetic traditions.

In June 1901 the Perrys spent a final month at Kamakura by the sea, where she painted every day. By August they were back again in Boston, but the memories of that exceptional experience in Japan remained vivid for Perry all her life. Indeed, years later she wrote to her granddaughter Elizabeth Grew, "Remember when you go to a country, try to plunge into the inner life of the country and to really know the people and their point of life, their ambitions, ideals, etc. I know the French as if I had made them, and the Japanese far better than [Mrs. L.] who lived there 38 years."[75]

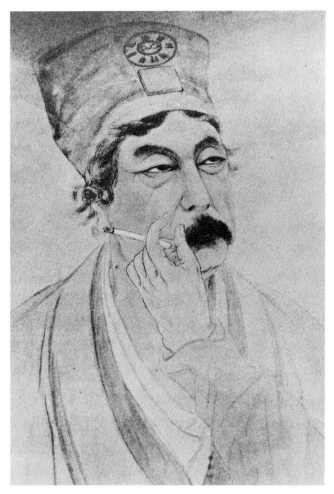

Fig. 14. Shimomura Kanzan, *Okakura Kakuzo*. Photograph courtesy C. E. Tuttle, Rutland, Vt. Renowned as an orientalist and art connoisseur, Okakura was a good friend of the Perrys.

Boston Interlude

As the 20th century unfolded, Boston artists focused more and more on the introspective theme of nostalgia

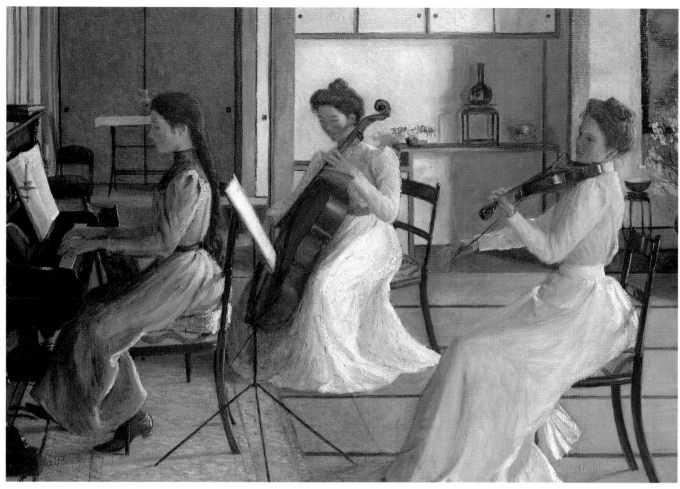

21. *The Trio* [Alice, Edith and Margaret Perry]
ca. 1898–1900
Oil on canvas, 29 3/4 × 39 3/8 in.
Collection Fogg Art Museum, Harvard University,
Cambridge, Massachusetts
Friends of the Fogg Art Museum Funds

seen through feminine eyes. This sentiment was always a favorite theme of Perry's, but, after three years of total immersion in the culture of Japan, it takes on additional meaning during this period. *Meditation* (pl. 41), which depicts Perry's daughter Margaret in a profile pose with definite oriental accents, evokes a spiritual fusion between Eastern and Western values. Other later works by Perry, such as *Lady with a Bowl of Violets* (pl. 44), *Cherry Blossoms* [Hildegarde] (pl. 42) and *A Japanese Print,* also are imbued with these sentiments. John La Farge expressed similar thoughts in dedicating his book of letters from Japan to his friend Okakura, "We are separated by many things besides distance, but the blossoms scattered by the waters of the torrent shall meet in its end."[76] For Perry, therefore, incorporating Japanese elements in her art was a personal statement, not simply the addition of a decorative motif. As such, her reverence for the culture and art of Japan allied her strongly with La Farge and Monet.

Mauve tones and Old Master references also symbolized Perry's predilection for the nostalgia theme. These characteristics of her art are exemplified in the lovely portrait of her daughter Alice in a light mauve evening dress, highlighted by the corsage of dark violets. This work was painted in Boston in late 1903, and subsequently titled *Portrait of Mrs. Joseph Clark Grew* (pl. 29) after Alice's marriage to a brilliant young diplomat. Alice's exceptional beauty was a source of inspiration for Perry throughout her career. Here her daughter's delicate

features and distinguished expression are "superimposed" on the face of the Old Master portrait on the background wall. This mixture of old with new, chiaroscuro effects with a bright palette and loose brushstrokes and the reference to a painting within a painting were techniques adopted by many Boston artists of the day.

Portrait of Mrs. Joseph Clark Grew was awarded a bronze medal at the prestigious, international Louisiana Purchase Exposition held in St. Louis in 1904. It is significant also to add here that the eminent Boston art historian, R. H. Ives Gammell, selected this particular painting to represent Perry at the important retrospective exhibition of the Guild of Boston Artists, which was held at the Museum of Fine Arts in 1942.

Alice's marriage in October 1905 was followed by her father's decision to leave Boston once again and return to France. His reasons were multifold. Finances were becoming a growing concern, as the Perrys' combined investment incomes no longer covered their current living expenses. Although family and friends encouraged Perry with portrait commissions such as *Portrait of Augustus Lowell Putnam,* 1905 (pl. 30) and *The White Bed Jacket, ca.* 1905 (fig. 16), income from the sale of art was still irregular and the completion of such commissions was dependent on Perry's own fragile health. In Japan Thomas Perry had received a modest salary for teaching, but in Boston his daily activities as "counselor" at the Boston Public Library (where he was partially reconciled with the administrators) were on a voluntary basis. Living expenses abroad were still considerably lower than in Boston, which made travel even more attractive as a means of staying within a limited budget.

Thomas Perry's decision to leave Boston in the fall of 1905 was further prompted by a grave disagreement with the directors of the art museum. He commented privately on the controversy in a letter to his friend John Morse,

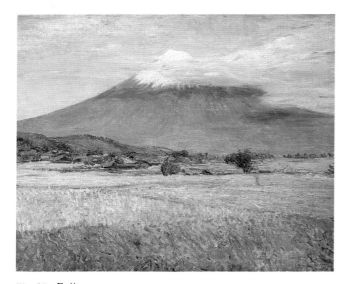

Fig. 15. *Fuji*
1898–1901
Oil on canvas, 25 1/2 × 32 in.
Private collection

22. *Child in Kimono* [Alice Perry]
1898
Pastel, 36 × 26 in.
Collection Mrs. Lilla Cabot Levitt

Alice Perry had just entered her fourteenth year when she arrived in Japan. This is one of Perry's earliest pastels. Already the strong influence that Japanese art had upon Perry is evident here in the stylized rendering of her daughter's features.

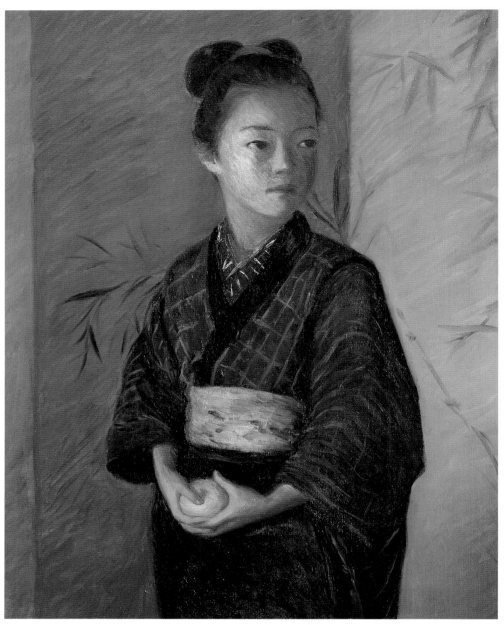

24. *In a Japanese Garden*
1898–1901 Oil on canvas,
31 × 25 in. Collection Mr. and
Mrs. Jay P. Moffat

"Time does not exist in the work of
art . . . for on one side our art is as
humble as on another side it is
great; and in this we but mirror
again the world about us, whose
great and small are but expressions
of momentary relations"

— John La Farge,
Considerations on Painting

23. *Portrait of a Young Girl with an Orange*
1898–1901
Oil on canvas, 31 × 25 in.
Private collection

"The intent gaze of a beautiful child recalls our lost hopes."

— Okakura Kakuzo, *The Book of Tea*

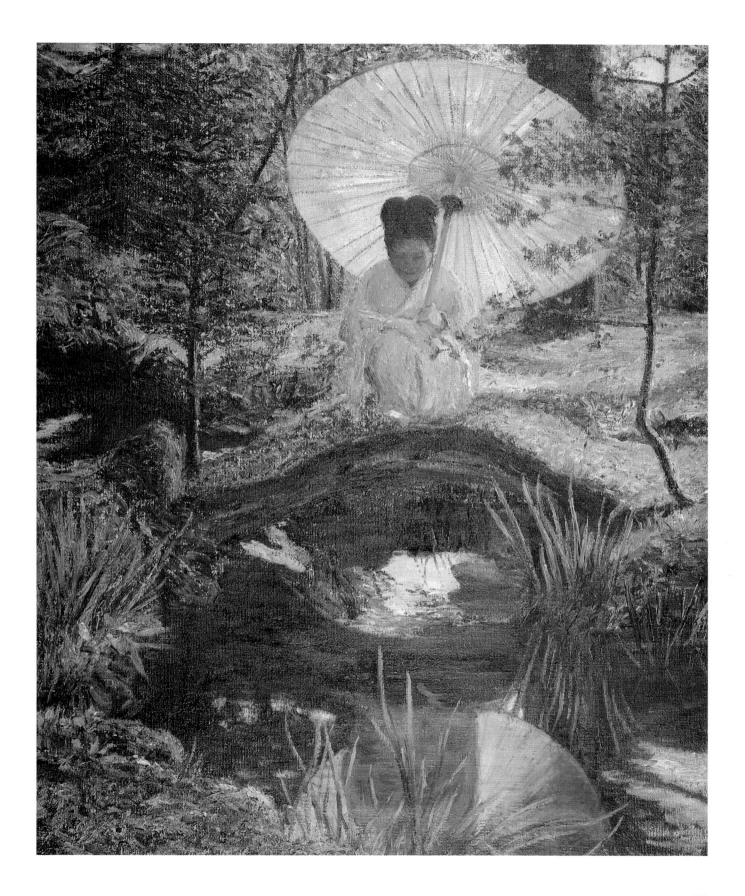

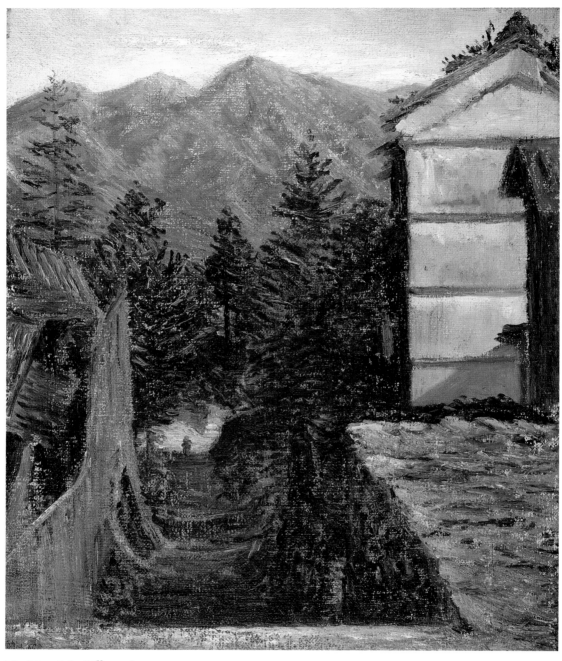

25. *Mountain Village, Japan*
1898–1901
Oil on canvas, 22 × 18 in.
Collection Mrs. Lilla Cabot Levitt

"What is absorbingly new in Japan is the light, its whiteness,
its silvery milkiness"

— John La Farge, *An Artist's Letters
from Japan*

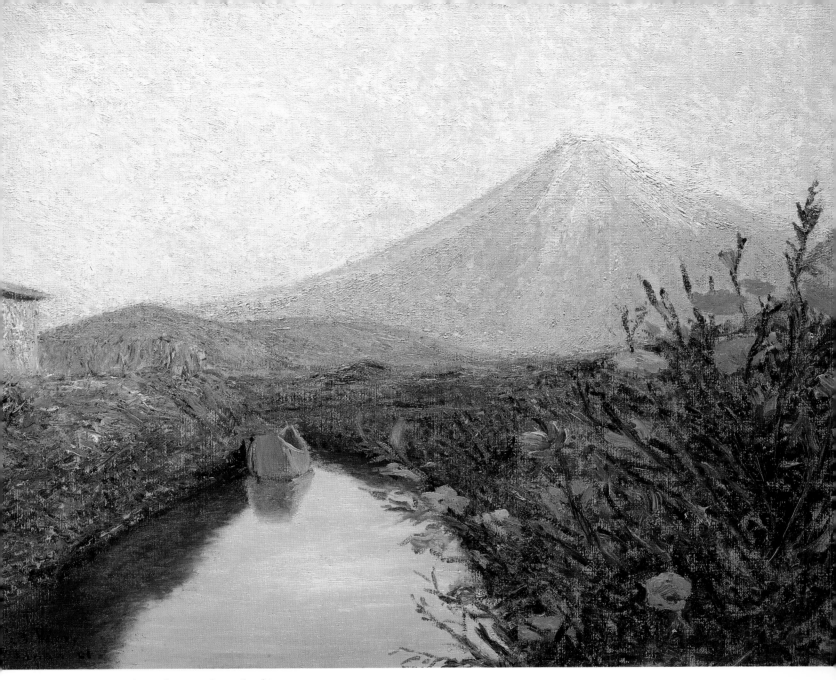

26. *Fuji from the Canal, Iwabuchi*
1898–1901
Oil on canvas, 25 1/2 × 31 1/2 in.
Collection Mrs. Lilla Cabot Levitt

"You would be amazed to see the people collected to watch me work when I was painting out of doors [in Japan]. Once my daughter happened to turn around, and in her astonishment at the numbers counted them — and there were 62 gathered to watch! They seem much impressed with our different approach to the subject of the picture.

Their painting is, of course, entirely conventional. But when they saw me painting Fujiyama, they exclaimed, 'very like, very like!'"

— Lilla Cabot Perry, press interview,
Boston Herald, February 27, 1921

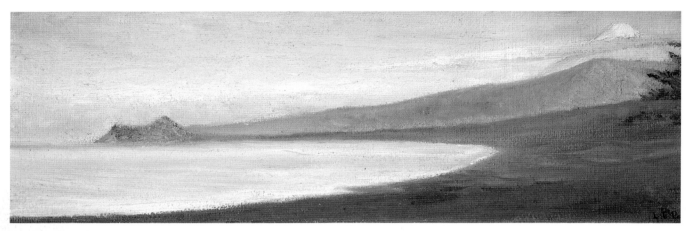

27. *Fuji from Lava Beach*
ca. 1898–1901
Oil on canvas, 7 × 21 3/4 in.
Collection Mrs. Lilla Cabot Levitt

"Lila [*sic*] Cabot Perry's exhibition of American and Japanese subjects at the Braus Galleries is one of the most interesting exhibitions given by a woman in this city in years. And while there is no apparent attempt to follow the latest mannerisms or fashions in technique, her work is so full of knowledge and sincerity that at once it is placed on a higher plain than much of the present day painting. . . .[Her] series of Japanese landscapes, portraits and subject pictures exhale the character of the country and people in a more convincing manner than any attempted by an American artist."

— *New York Morning Telegraph,*
November 5, 1922

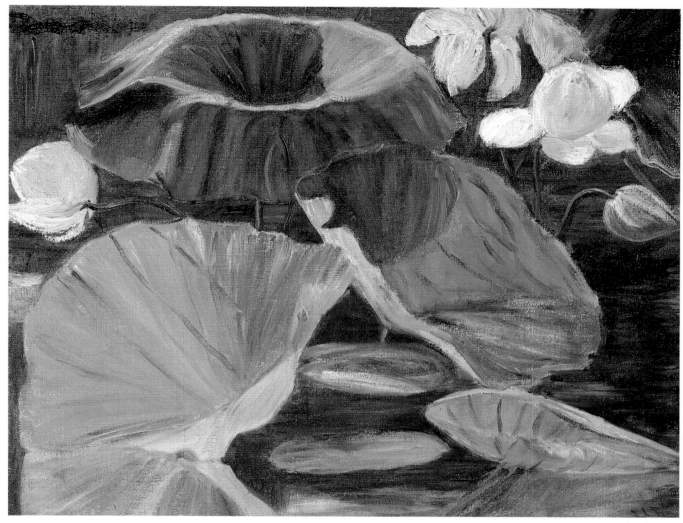

28. *Lotus Flowers* [Oya, Japan]
ca. 1900
Oil on canvas, 32 × 25 in.
Private collection

"Lilla is hard at work as ever with her painting. Twice she has been to Oya, a station on the railway 1 1/2 hours west of here, leaving at 3:30 & back at 10, to paint lotus flowers there & she has finished two fine canvases. First she sent our 'boy' there to get some which we set up in our pad, but then she went to the place, tho' the way is dull, the town hot, the crowd thick, and eagerly interested, her dinner what she could carry, her return late."

— Thomas Sergeant Perry to his sister-in-law Helen "Nelly" Almy, September 5, 1900 (Special Collections, Colby College Library)

"[Perry] appears also to have a gift for design and her impressions of . . . 'Lotus Flowers' are decorative and picturesque, enveloped in color that is personal and harmonious."

— *New York Morning Telegraph,* November 5, 1922

29. *Portrait of Mrs. Joseph Clark Grew* [Alice Perry Grew]
ca. 1903–04
Oil on canvas, 40 × 30 in.
Collection Mr. and Mrs. T. Gordon Hutchinson

"The 'gallery-trotter,' the casual observer and the critic are all immediately attracted by a picture called 'Portrait of Mrs. J. C. G.,' which was awarded a bronze medal at the St. Louis Exposition in 1904. This work places the artist among the small band of painters who think. She has made a picture, which is also eminently successful as a portrait. The arrangement is agreeably composed with the graceful and distinguished looking subject standing before a wall upon which a dark picture forms an interesting background for the head. That this dark spot appears to be a picture behind a frame, and not a square hole in the wall bespeaks the true relation of all the values. The head is strongly lighted and well modelled, good in color and particularly interesting in expression. The pale violet note of the gown with transparent sleeve draperies and the bunch of violets on the corsage, offset and emphasize the ivory tones of the complexion."

— John Nutting, review in an unidentified
Boston newspaper, *ca.* January 3,
1911 (Perry Family Archives)

30. *Portrait of Augustus Lowell Putnam*
1905
Oil on canvas, 35 × 17 in.
Private collection

adding somewhat bitterly: "In Boston, any expression of dissatisfaction is regarded as a gross breach of good manners. You are expected to tread on tiptoe, and not speak above a whisper, as if you were at a funeral, and you are at a funeral of a city which once dared to think for itself, which once respected independence. A man whose statements cannot be denied, whose arguments cannot be answered, is pointed at with horror, as a disturber of the peace."[77]

The Giverny Years — Part II

The winter of 1905 which the family spent in Paris was a dreadful one for Perry, who suffered "a near breakdown," which her husband attributed to "thirty years of insomnia."[78] It was true that Perry suffered from insomnia all her life, and she was also prone to headaches and fainting spells. Thomas Perry's own depressive states, however, and the family's uprooted lives certainly also accounted for her collapse that winter.

The exact date of Perry's series of three vibrant pastel canvases, which she called *Spring Landscape, Giverny, ca.* 1906, is not known. Capturing as they do the joys of springtime after a somber winter season, they may well date from early March 1906, when the Perrys returned to Giverny. The sunlit variation also known as *Bridge — Willows — Early Spring* (pl. 32) in particular confirms Perry's technical skill in handling the delicate medium of pastel.

There were many changes in Giverny, as the Perrys observed at the marvelous dinner at Monet's house honoring their return. Theodore Butler had remarried, following the tragic death of his first wife in 1899. The American colony was sprouting a new crop of talented artists, led by Frederick Frieseke, who was settled in with his wife in the Perrys' former residence next door to Monet. Guy Rose had returned with a charming new wife. Lawton Parker was also in residence. Edmund Graecen and Will Low joined the group in 1907.

Painting, as always, was Perry's passion at Giverny, not the rumors and scandals which monopolized so many dinner conversations at the local Hôtel Baudy. Even she, however, could not remain totally oblivious to the increasing presence of the pretty imported models who posed totally nude in her colleagues' gardens. High stone walls, thankfully, spared Perry the unpleasantness of "indecent" exposure. It is no wonder that, with rare exceptions, Perry limited her social visits to the Monet or Butler households. She also took memorable day trips with her husband to the Walter Gays' magnificent

Fig. 16. *The White Bed Jacket*
ca. 1905
Pastel on tan paper, 25 1/2 × 31 1/2 in.
Courtesy Hirschl & Adler Galleries, Inc., New York

"'The White Bed Jacket' incorporates all of Perry's best qualities into a single image of surprising modern freshness. . . . It is colored in creamy shades, with lush impressionistic lacy froth on the bedjacket. A face is finely drawn and softly shaded into the rest of the composition. The technical mastery here is so good as to be almost unnoticeable. The facial expression is what one notices first and retains longest. It is not sentimental. It is the face of a very old, clear, calm woman. One would like to think that it represents the final resolution of that private part of Lilla Cabot Perry."

— Suzanne Deats, "Whistler's Sister,"
Santa Fe Reporter, April 20, 1983

château, Le Bréau, near Melun.

If among the male artists of the Boston School nudity is only rarely depicted, it is completely absent from Perry's works. Her women, whether painted in the studio or out-of-doors, are always attired in long flowing gowns. The major change in her Giverny compositions of this period is the return of color to her palette. There is a renewed burst of bright pigments, following the somber hues of her Boston portraits. *The Violoncellist, ca.* 1906– 07 (pl. 35), which depicts her daughter Edith playing music in a meadow seen through sunlit trees, reflects Perry's revitalized adherence to Impressionism. More particularly, it evokes Monet's comment to her that "an eye or a nose is of no more importance than a leaf on a tree."[79] There is a new evolution in Perry's art during these years. Her plein-air figures, especially those of children, such as *Little Girl in a Lane, Giverny, ca.* 1906–

07 (pl. 37) and *Child in a Garden, Giverny, ca.* 1909 [Lilla Cabot Grew?] (pl. 36), no longer suggest the "inner beauty of the soul" but simply are one colorful part of the transient garden scene.

It was in Paris, more precisely the Bois de Boulogne, according to her daughter Margaret, that Perry painted a rare boating scene, *Dans un bâteau* (In a boat), 1907 (pl. 38). Boats were a favorite theme with the "Tarbellites" of the Boston School and the French Impressionists. Again, Perry has refrained from introspective statements here, focusing simply on the shimmering chromatic effects of sunlight on water and sunlight on her model. Perry's composition also illustrates her particular fondness for monumental figures centrally placed, recalling Pissarro's works from the early 1880s.

It was also in Paris, presumably during the winter of 1907, that Perry evoked a nostalgic mood in a large, diagonal, studio composition discreetly titled *Le Paravent jaune* (The yellow screen), *ca.* 1907 (pl. 39). Here an updated "Madame Bovary" in an ivory lace gown muses over past memories, symbolized by a single white gardenia which has fallen on the floor. What is new in this painting is the suggestion of sensuality — an extremely rare feature in Perry's work — expressed in the almost "sultry" gaze and rounded forms of her model as she appears to "embrace" the arm of the Second Empire loveseat. The subtle presence of the solitary gardenia in the foreground, juxtaposed with the "monumentality" of both the figure and the vibrant, gold-toned screen in the background, adds a very dramatic note here.

Roses, prior to 1911 (pl. 40), which focuses on the back of a model elegantly attired in another lovely lace dress, is a more demure and discreet variation on the nostalgia theme, possibly also painted at this time in Paris. The vase of roses, the object of the model's attention, suggests a loved one's presence.

Perry was sixty years of age when six of her paintings, including *Dans un bâteau* and *Le Paravent jaune,* were exhibited in Paris at the Salon des Indépendants in the spring of 1908. *La Revue Moderne Universelle,* a prominent art periodical, featured four of Perry's paintings with illustrations in its review of the event.[80] Inasmuch as over 6,700 works were presented at the salon, this was high praise in the Paris press.

Ironically, Perry's success at the Salon des Indépendants coincided with her strong desire to return to Boston. This broke her husband's heart, for he was never more happy than in the stimulating intellectual atmosphere of France. Furthermore, he had also just recently renewed ties with his dearest childhood friend, Henry James. At her husband's insistence, Perry agreed to postpone their departure for two more summers.

The summer of 1908 was spent touring Russia, Finland and Bohemia. The Perrys' final summer, that of 1909, was spent in Giverny. It was a wet, dreary season during which Monet "barely touched a brush" and was burning more canvases, to the despair of his family and dealer. In response to Thomas Perry's report on the constant rain at Giverny, Henry James remarked, "Lilla must find her studies from nature a desperate business, when nature is all day long in the bath."[81] *Child in a Walled Garden, Giverny* [Lilla Cabot Grew], 1909 (fig. 17) is indeed unusually low keyed, and clearly reflects the dreary gray atmosphere of that last summer in Giverny.

In November 1909 the Perrys sailed for America, fully intending to return to France in a few years' time. They never did.

Return to New England

George Moore believed that "the story of a painter's mind may be read in every picture,"[82] and Perry's view of the Boston State House in 1910 certainly reveals her pleasure in coming home. She rarely painted urban views, although she had visited far more cities in Europe and Japan than most artists of her day. It is significant, therefore, that she began this new chapter in her life with a lovely landscape of the Boston skyline perceived through a delicate, almost oriental, pattern of barren trees across the Boston Commons.

The State House, Boston (pl. 43) was included, along with landscapes from Giverny and Japan, in Perry's solo exhibition at the Copley Gallery in 1911. The show focused, however, on her recent interior portraits of elegant ladies exemplified by her eloquent *Lady with a Bowl of Violets, ca.* 1910 (pl. 44). William Downes, the art critic for *The Boston Evening Transcript,* expressed his personal satisfaction that Perry had "abandoned," as *he* concluded, the Giverny School of outdoor light. He noted further, "[her] gain has been in the direction of a more expressive and delicate use of line, and a greater completeness and greater refinement of style."[83]

The Copley Gallery exhibition announced Perry's return to the inner circle of the Boston art scene. It was followed by a new series of children's portraits featuring Hildegarde, a pretty little model with long blond curls. This was the most popular series that Perry ever painted, and largely contributed to her bronze medal at the prestigious Panama-Pacific International Exposition in San Francisco in 1915. *Cherry Blossoms* (pl. 42), a variation

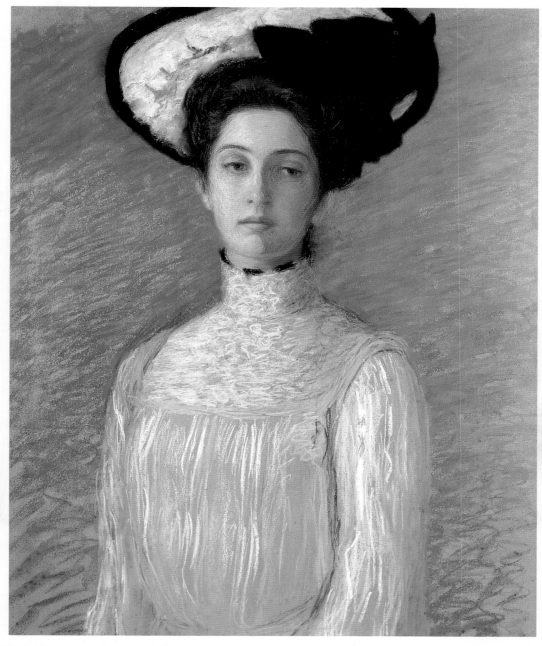

31. *Alice in a White Hat* [Alice Perry Grew]
 ca. 1904
 Pastel on paper (laid on linen canvas), 31 1/2 × 25 1/2 in.
 Private collection

"I do not think the camera ever does you so much justice as I do."

— Lilla Cabot Perry to Alice Perry Grew, December 31, 1917 (Perry Family Archives)

32. *Spring Landscape, Giverny — no. 1*
"Bridge — Willows — Early Spring" inscribed on back of
stretcher
ca. 1906
Pastel on paper, 25 × 31 in.
Private collection

33. *Late Afternoon — Giverny*
(Railway Embankment — Giverny; Normandy
Landscape)
n.d.
Oil on canvas, 26 × 32 in.
Private collection

One of two rare views of the railway train embankment
which separated Monet's house from his Japanese garden.

34. *Autumn Afternoon, Giverny*
Giverny, n.d.
Oil on canvas, 25 3/4 × 31 3/4 in.
Daniel J. Terra Collection
Terra Museum of American Art, Chicago

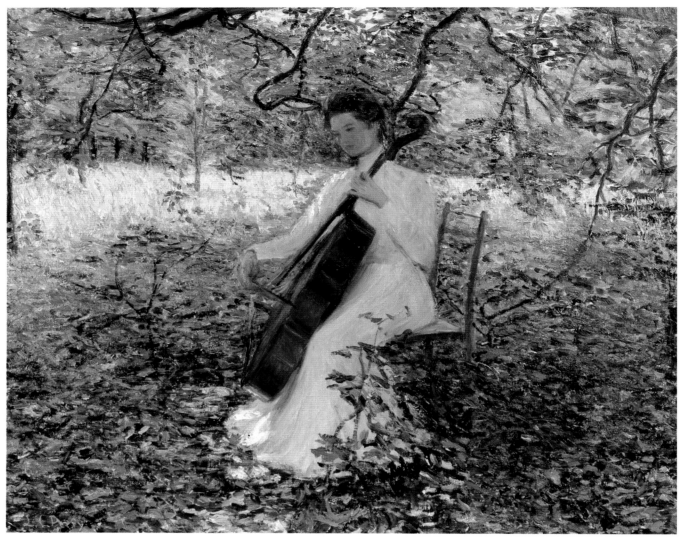

35. *The Violoncellist* [Edith Perry]
ca. 1906–07
Oil on canvas, 21 × 25 in.
Private collection

Edith, pictured here in a plein-air, impressionistic composition at Giverny, was the most gifted musician of the three Perry daughters. In the summer of 1908 she studied cello in Prague with Professor Vaska, a member of the reknowned Bohemian Quartet. This portrait of Edith recalls the Japonism of *The Trio,* which suggests that it was painted in the summer of 1906, when the artist's memories of Japan were most fresh. Half a dozen portraits of Edith with her cello are documented — from portraits from her childhood to a studio composition painted when Edith was in her early thirties.

36. *Child in a Garden,* **Giverny [Lilla Cabot Grew?]**
ca. 1909
Oil on canvas, 32 × 12 3/4 in.
Collection Mr. and Mrs. Lawrence Herbert

The very narrow, vertical format of this painting, an obvious allusion to Japanese prints, is most unusual for Perry, although she experimented with different approaches all her life and showed great versatility even in her later years.

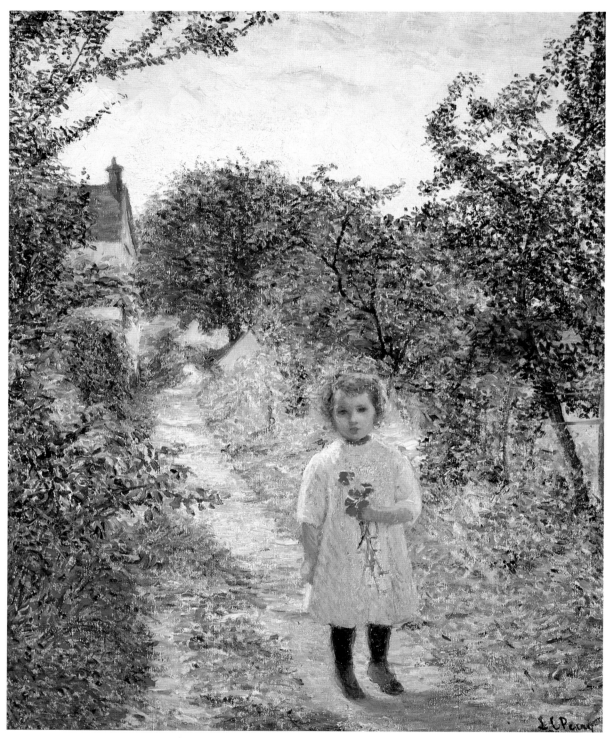

37. *Little Girl in a Lane, Giverny*
ca. 1906–07
Oil on canvas, 32 × 27 in.
Collection James M. B. Holsaert

38. *Dans un bâteau* (In a boat)
1907
Oil on canvas, 45 × 35 in.
Private collection

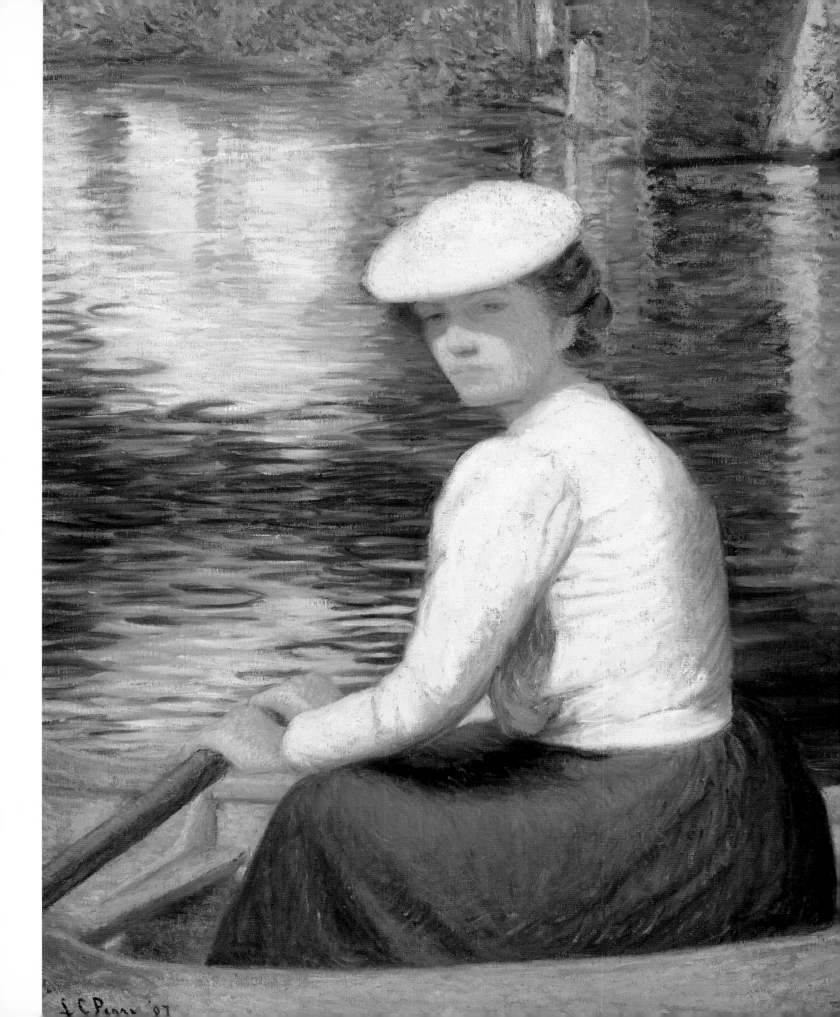

40. *Roses*
(The Scent of Roses)
Prior to 1911
Oil on canvas, 39 1/2 × 29 1/2 in.
Collection Mr. and Mrs. Jeffrey
. Marcus

"I twined a wreath of flowers one day.
And lo! Love! mid the roses lay. . . ."

— Lilla Cabot Perry
from the Garden of Hellas

39. *Le Paravent jaune* (**The yellow screen**)
ca. 1907
Oil on canvas, 50 1/4 × 36 in.
Collection T. Messina

41. *Meditation* [Margaret Perry]
Fenway Studio, Boston, n.d.
Oil on canvas, 24 × 20 in.
Private collection

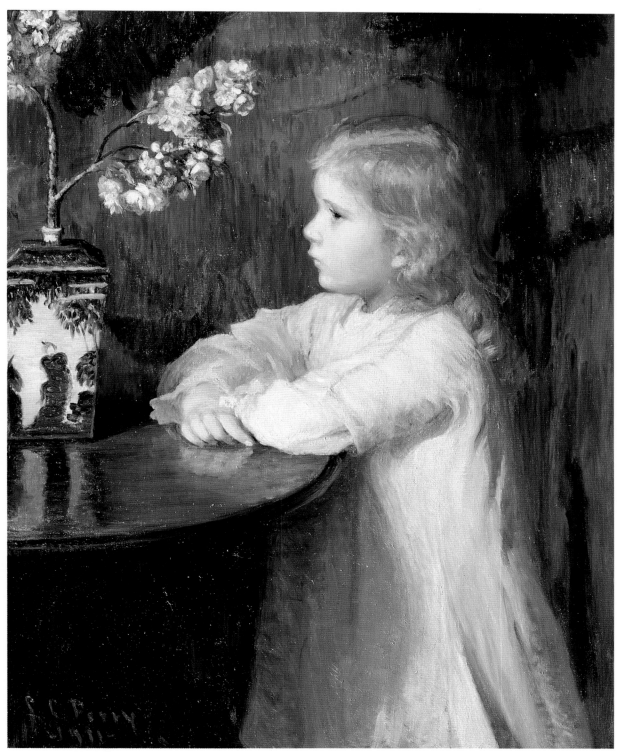

42. *Cherry Blossoms* [Hildegarde]
1911
Oil on canvas, 31 3/4 × 25 1/2
Collection Elaine and Elliott Caplow

Fig. 17. *Child in a Walled Garden, Giverny* [Lilla Cabot Grew]
1909
Oil on canvas, 26 × 32 in.
Collection Sarah Moffat Srebro

on the Hildegarde series, goes beyond the level of storybook portraits and reaffirms Perry's faith in art as a universal language.

Lady in an Evening Dress (pl. 45), painted in 1911 and originally titled *Renée,* recalls the diaphanous ladies of Thomas Dewing. It also has a strong similarity to the "porcelain" model depicted in William McGregor Paxton's painting *The Other Room* from 1916 (fig. 20). Resemblances should always be treated with caution, however, at a time when so many artists were focusing on similar themes.

Far more revealing are the differences which distinguish Perry's works from other prominent artists of the Boston School. Within this "refined world of retreat,"

where social issues were altogether absent, sexual innuendos were nevertheless discreetly present in several of her colleagues' paintings, such as Paxton's *Nude,* Tarbell's *The Venetian Blind* and a number of compositions by Philip Hale. Perry, however, maintained her sights on the "intellectual highmindedness" of her Boston roots, elegantly expressed in the portrait of her niece Elizabeth Cabot Lyman, *Portrait of Mrs. Henry Lyman, ca.* 1910 (pl. 48). Melancholia was the only adult "gray area" Perry explored in her art, shrouding at times her sitters' faraway gazes under the flamboyant brims of their hats in paintings such as *The Green Hat* [Edith Perry], 1913 (fig. 19), *The Black Hat* and *Alice in a White Hat,* 1904 (pl. 31).

With conservatism being the dominant trend of the

43. *The State House, Boston*
1910
Oil on canvas, 18 1/4 × 22 1/2 in.
Private collection

day, it was no wonder that the International Exhibition of Modern Art, or as it is more widely referred to, "the Armory Show," which presented a selection of European avant-garde artists in Boston, created such a negative stir in 1913. The event no doubt prompted the establishment the following year of the ultra-conservative Guild of Boston Artists. The driving force behind this collective action, led by Tarbell, was Lilla Cabot Perry. The seeds for this counterrevolution may well have been sown in Paris in 1907, when the Perrys encountered "modern art" to their "horror," as exemplified by Henri Matisse. Two decades previously Perry actively contributed to impose Impressionism among Boston patrons. She now, however, bitterly opposed the latest avant-garde trends from France. As Perry later recounted in an interview which appeared in the *Boston Herald:* "I went to an exhibition in Paris . . . [which] was supposed to be a beautiful example of some modern work. Well, all that I can say is that one cheek was a bright grass green, the nose was a pea green, and the other cheek was a flaming vermilion. . . . Now

that sort of thing is as easy to paint as you can imagine. What is not easy is to paint good flesh color. Flesh is the most difficult, the subtlest thing in the world to paint. It requires all the primary colors blended with utmost care. And it differs under differing lights. I suppose these modern painters, so-called, are too lazy to attempt such a difficult task, so they make their pea green noses!"[84]

In 1920 Frank Benson, the guild's president, presented Perry with a commemorative silver bowl honoring her six years of loyal service. A congratulatory letter signed by all the members accompanied the gift: "To your personal influence [the guild] owes its inception and to your untiring efforts on its behalf we feel its success is largely due, and with the continuation of this happy condition we are confident that its future success is assumed. . . ."[85] Her husband recorded the event in a letter to his daughter Alice. "Nothing could have been more surprising for although Lilla has worked much for the Guild, we never knew they knew much about it; but they did."[86]

Fig. 18. Installation photograph of *An Exhibition of Portraits and Other Pictures by Lilla Cabot Perry,* The Copley Gallery, Boston, Jan. 2–14, 1911.

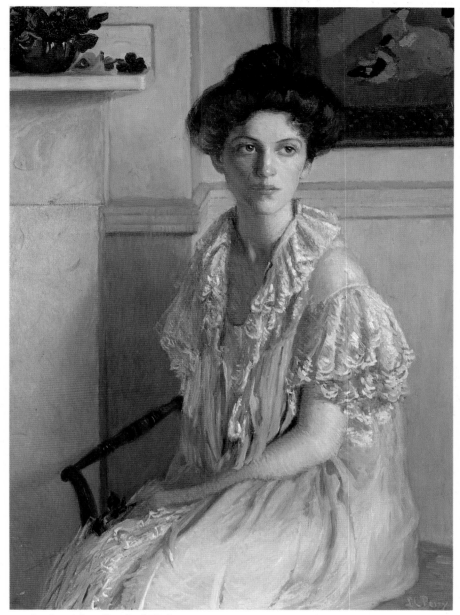

44. Lady with a Bowl of Violets
ca. 1910
Oil on canvas, 40 × 30 in.
Collection National Museum of Women in the Arts
Gift of Wallace and Wilhelmina Holladay

"Mrs. Lilla Cabot Perry has a large number of portraits in
the Copley Gallery. The exhibition is one that improves
with each visit and gives an impression of strong
intellectuality."

— *Christian Science Monitor,*
January 7, 1911

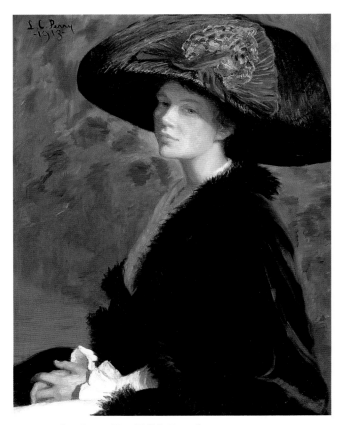

Fig. 19. *The Green Hat* [Edith Perry]
1913
Oil on canvas, 33 1/2 × 26 in.
Collection Terra Museum of American Art, Chicago

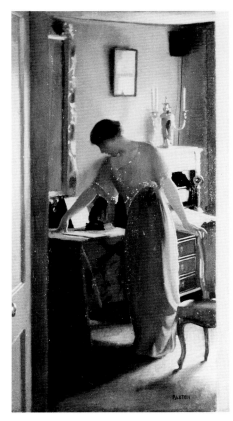

Fig. 20. William McGregor Paxton, *The Other Room,* 1916. El Paso Museum of Art. The pose of the model here shows a strong similiarity with Perry's *Lady in an Evening Dress,* 1911.

Perry was seventy-two years old and certainly deserved compliments, for the constant "bondage" (in her words) of portrait commissions to help supplement the family's modest income drained her. "Once when we were very hard up, I painted thirteen portraits in thirteen weeks, four sitters a day at two hours each," she recounted in 1929 to Berenson.[87]

Perry's first solo exhibition in New York took place in November 1922 at the Braus gallery on Madison Avenue. Forty-four of her paintings were presented, including many landscapes from Giverny and Japan. The *New York Morning Telegraph* called it, "one of the most interesting exhibitions given by a woman in this city in years."[88] Prices ranged from $200 to $1,000 for a full-length portrait, and there were several sales. These funds helped ease some of the additional family expenses incurred when Edith Perry's mental health totally collapsed, and she was transferred to a private institution in Wellesley.

Edith's illness was the tragedy of Perry's life. It was followed by two other traumatic events — Perry herself became critically ill with diphtheria in late December 1923 and her granddaughter Edith Grew died suddenly of scarlet fever in April 1924. These grave circumstances undoubtedly conditioned Perry's retreat from the genteel portraits painted at her Fenway studio back to plein-air works and landscapes, which highlighted the last chapter of her life.

* * * * * *

The subtle portrait of her husband, half-hidden behind his morning newspaper, is one of the first canvases Perry painted during her long convalescence. An eloquent variation on her earlier window themes, it illustrates the transition in her style that was taking place in the late summer of 1924 and foreshadows her retreat from the studio scene. *Thomas Sergeant Perry Reading a Newspaper* (pl. 46), with its total disregard for the "grand manner" so popular during the Gilded Age, places Perry firmly within the style of 20th-century American

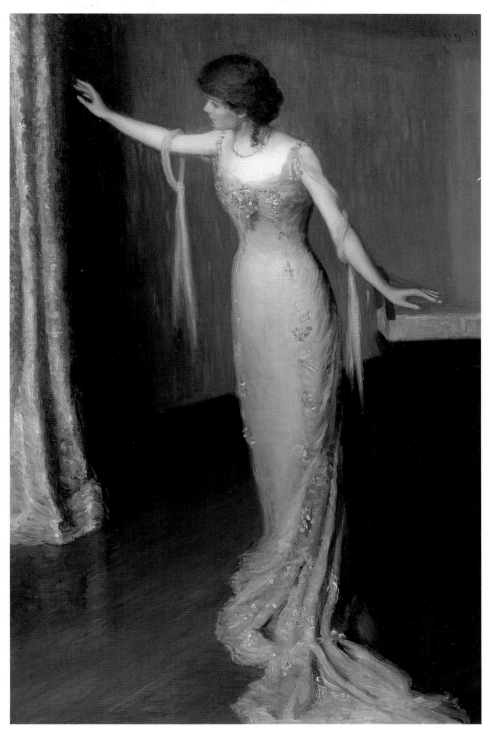

45. *Lady in an Evening Dress*
(Renée)
1911
Oil on canvas, 36 × 24 in.
Collection National Museum of Women in the Arts
Gift of Wallace and Wilhelmina Holladay

portraiture.[89] The delicate harmony here of muted blue and mauve tones, bathed in the softly filtered sunlight, adds a subtle note to the sensitive portrait of this distinguished New England gentleman in the twilight years of his life. Symbolically, the curtains are closed.

Charleston, South Carolina, where Perry continued her convalescence in 1925, is far distant from Giverny, but the memories of those nine summers spent in Monet's village, "the happiest of her life," were constantly present as she painted some of her finest landscapes at the age of seventy-seven. *Road from Charleston to Savannah* (pl. 49), for example, which depicts in the Impressionist manner a group of live oaks laden with Spanish moss along a sunlit road, definitely recalls the charm of *Poplars* (pl. 15), painted thirty years before in Giverny. This lovely landscape also confirms that trees were a favorite motif of Perry's all her life.

Other influences also surfaced that summer, as demonstrated by Perry's sensitive plein-air rendering of a black laborer plodding home across open fields, *A Field, Late Afternoon, Charleston, S.C.,* which brings to mind the simplicity of Millet's rural settings transposed to the South Carolina countryside. Perry also evokes here a brilliant sunset, which she captured in unusually vibrant aquamarine and rose pigments applied in loose brushstrokes.

Hancock, New Hampshire, is far less familiar to most people than Dublin, only nine miles away, where Abbot Thayer's presence attracted many other fine artists, or nearby Peterborough, where a cultural elite still communes every summer at the MacDowell Colony. The views of Mount Monadnock, however, the principal

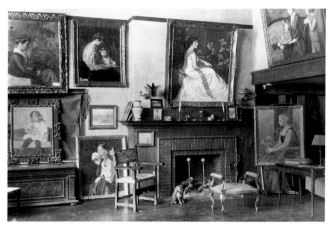

Fig. 21. One of Lilla Cabot Perry's studios (probably no. 411) in the Fenway building on Ipswich Street, Boston. Perry often allowed her friends to use her studio.

natural attraction of this region, are just as lovely as seen from this quiet village. For Perry, Hancock embodied "the soul" of the New England landscape, as seen through Emerson's eyes.

In 1903 she purchased a modest farm house in Hancock surrounded by 250 acres of beautiful scenery. It was not until 1910, however, the year Henry James paid a memorable visit after the death of his brother, William, that the Perrys regularly sojourned there from May through September. A stream of family and friends received a warm welcome every summer. Several posed for Perry's brush, including William Dean Howells (pl. 47) in 1912, the artist Frederick Bosley, also in 1912, and, in 1916, the poet Edwin Arlington Robinson (fig. 28), who subsequently was "in residence" every summer.

Gradually the Perrys extended their stays in Hancock through October to be able to fully savor the brilliant autumn season. "How wonderful these mornings are," Thomas Perry wrote to John Morse in 1922, "with the long shadows over the wet grass and the fogs in the valleys looking like lakes, and air so much like champagne. . . . At this time Giverny was another wonder, when Monet would go and paint the dawn on the Seine; I rapturously enjoy it, and Lilla is out twice a day immortalizing it on canvas. . . . The trees are trying to ingratiate themselves by putting on their best clothes and these are very scrumptious. They are late [this year] in changing their garments, but they have put on brilliant ones [and] now we have the full blaze."[90]

After Perry's return from Charleston, more and more months of the year were spent in Hancock. "Like Tom, I learned to stay up here long into the winter, and to realize that the country is never so beautiful or the mountains so grand as in the late autumn with but few leaves on the sugar maples, and those a glory of gold and red against the dark pine trees or the blue mountains," she later reminisced to Berenson.[91]

Snow scenes, or as Perry called them, "snow-scapes," became favorite themes. These she painted at times through her window (*A Snowy Monday*, 1926, pl. 51). More often, as with *After the First Snow*, 1926, they were completed while she sat huddled in the old Ford sedan under a heavy coat and blankets with two hot water bottles, "to keep the paint on my palette, as well as myself from freezing stiff." Dawn or 4 p.m. or "when the snow and trees and mountains are bathed in a pink glow with deep blue shadows after sunset,"[92] were Perry's favorite hours for recording her impressions of the severe New England winter scenery.

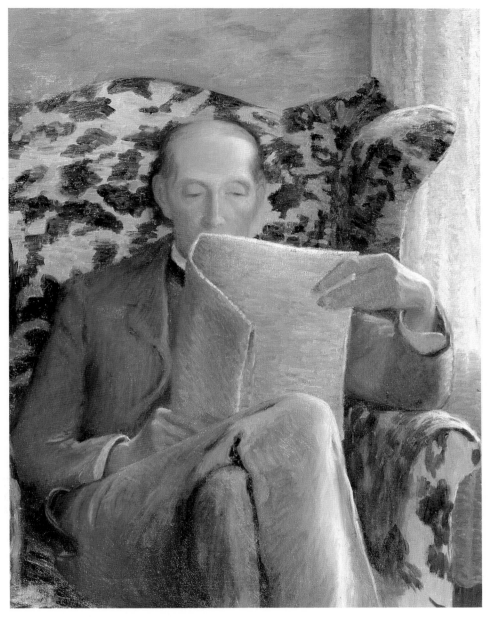

46. *Thomas Sergeant Perry Reading a Newspaper*
1924
Oil on canvas, 39 1/2 × 30 in.
Collection Terra Museum of American Art, Chicago

"On the whole I am pretty frisky [Thomas Perry had just turned eighty] & Mrs. Perry is painting my picture in Hancock on Sundays."

Thomas Sergeant Perry, August 14, 1924
From Edwin Arlington Robinson,
Selections from the Letters of Thomas Sergeant Perry, 1929

47. *Portrait of William Dean Howells*
1912
Oil on canvas, 30 × 40 in.
Special Collections, Colby College, Waterville, Maine
Gift of Margaret Perry

Perry began this rare portrait of William Dean Howells in August 1912, when Howells visited the Perrys in Hancock, N.H., and finished it that fall from a photograph. She loaned the portrait to the National Institute of Arts and Letters in New York at the request of Hamlin Garland, who wrote to her to express his gratitude: "How long can you let us have [the portrait]? . . . There are so few portraits of Howells of any sort. As I recall yours it was admirable. If sometime you want to sell it to the Academy, some good friends may rise up and buy it for us. We have no funds for pictures. We need a portrait of our first president as part of our permanent vessel" (Hamlin Garland to Lilla Cabot Perry, May 20, 1921 — Perry Family Archives).

48. *Portrait of Mrs. Henry Lyman* [**Elizabeth Cabot Lyman**]
(Lady with a Black Hat)
ca. 1910
Oil on canvas, 32 × 25 1/2 in.
Private collection

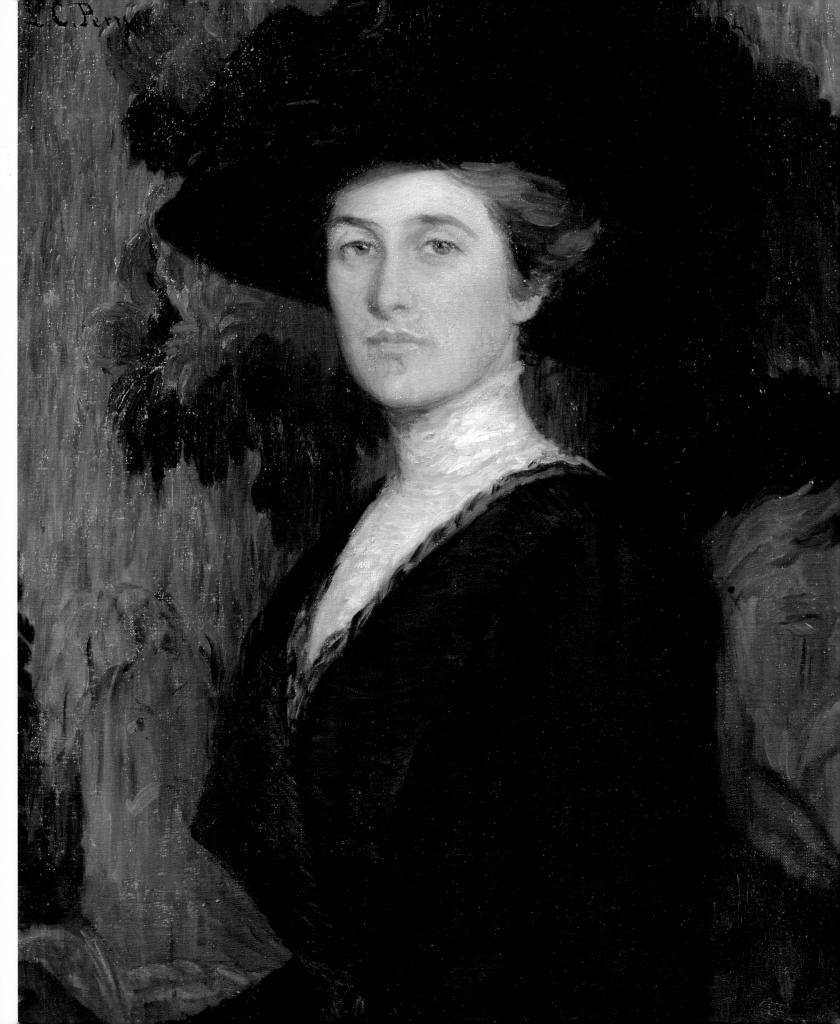

49. *Road from Charleston to Savannah*
1925
Oil on canvas, 18 × 22 in.
Collection Mrs. Lilla Cabot Levitt

Fig. 22. *The Pearl*
ca. 1913
Oil on canvas, 35 1/2 × 25 1/2 in.
Collection Eleanor and Irv Welling

Fig. 23. Postcard of Giverny (as seen from the Hôtel Baudy) sent to the Perrys by several members of the Monet family as a New Year's greeting for 1926. Although the Perrys did not return to Giverny after 1909, they maintained a warm friendship with Monet and his family.

A moving letter from Theodore Butler in Giverny brought the sad news of Monet's death in December 1926. Perry was in the midst of preparations for two solo exhibitions in early 1927 — The Guild show in January and her first exhibition in Washington, D.C., in February at the Gordon Dunthorne Gallery. In Washington *A Snowy Monday* and other landscapes painted at Hancock were warmly praised in the press. The show was financially successful as well. In the first hour, as she later reported to Berenson, she sold works to "Gladys Vanderbilt, Mrs. Marshall Field (Chicago) and Perry Belmont," prompting her dealer, Gordon Dunthorne, to remark to Margaret Perry that he would be glad to have another show of her mother's work at any time.[93] The prices received ranged from $250 for *Autumn Road* to $500 for *Woodland Road*.

On May 7, 1928, Thomas Perry died quietly in his sleep after a brief bout with pneumonia. At eighty-three years, "though his mind," as Perry informed Berenson, "was as brilliant as ever his body [was] worn out. But I

don't find that having lived with a person you had loved for 54 years + 1 month makes you miss them less!"[94]

Painting was her primary solace, easing the many sadnesses which clouded her final years — the loss of her husband, Edith's incurable illness, the desperate plight of so many of her artist friends. "Thank Heaven I can in my old age give up the bondage of painting portraits, except for a few interesting and distinguished people," she confirmed to Berenson in 1929. "I refused 3 this last year, and I am devoting my small remaining strength to what Monet begged me to and said was my forte, plein-air and paysage."[95]

Perry had begun her career fifty years earlier with portraits. She culminated her career with landscapes, which she exhibited at the Guild of Boston Artists in 1929 and 1931. As Tarbell remarked, these very late "impressions" (*Autumn Leaves* [Hancock, N.H.], 1926; *Lakeside Reflections, ca.* 1929–31, pl. 52; and *Snow, Ice, Mist* [Hancock, N.H.], 1929, pl. 53), painted in her early eighties, were among her finest works. Her most original

late landscape is *Mist on the Mountain* (pl. 54), painted in 1931. Here, an almost formless flush of muted hues suggests that both Mount Monadnock and Fuji were symbols of the same, invisible, Eternal Being. In this very last painting exhibited during Perry's lifetime, the fusion between East and West had become a reality.

Nevertheless, in spite of genuine praise from both Tarbell[96] and Benson[97] (the latter returned five times to view her exhibition at the guild in 1931), sales were infrequent and times were difficult. As Perry wrote to Berenson in a rare moment of self-confession: "In both New York and Washington, I sold for much higher prices than in Boston, which is the worst market in the world, I believe, for anyone who has the misfortune to be considered in society — though, in fact, I have not been in "society," or accepted any social invitations for forty years since I showed my first portraits of Tom and Edith in 1889! But I have worked as hard, if not harder, than most painters."[98]

In her poem symbolically titled "Requiescat in pace," published in 1898, Perry summarized the many pressures she juggled throughout her career: "Artist and woman, daughter, mother, wife." Now, at the end of her life — at the end of her "tether," as she expressed it — Perry touched again on a very sensitive chord. Far more than her gender, it was her name, like a double-edged blade, which, if it opened many doors for other artists whom she introduced to the Boston scene, closed many doors in her own career.

* * * * * *

In the early 1880s Thomas Perry described the role of the author or artist as that of an interpreter for the human race as it confronts age-old situations. "Every generation comes face to face with the old problems of life, with grief, joy, death, as well as the new ones that every century brings; and it says its say, it puts on record what impresses it, what fills its thoughts, what it hopes, and what it fears, and whether it prefers to stand up against fate, or yield without a struggle."[99]

Perry chose never to yield. Her niece Eleanor Bradley confirmed this in her memoirs: "Aunt Lilla died [on February 28, 1933] at 86 and was painting the day she died."

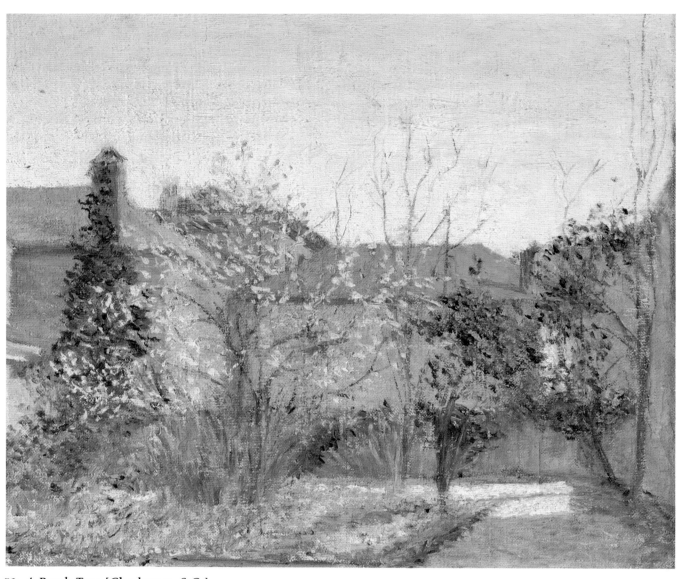

50. *A Peach Tree* [Charleston, S.C.]
1925
Oil on canvas, 12 × 14 in.
Collection Alice Lyon

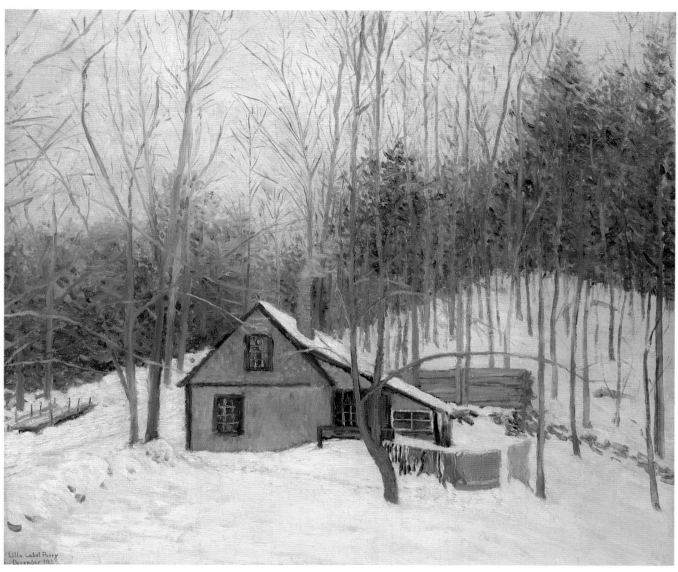

51. *A Snowy Monday*
(The Cooperage, Hancock, N.H.)
1926
Oil on canvas, 25 × 28 in.
Private collection

"The painting [in Perry's exhibition] which remains most clearly fixed in the mind shows a cottage blanketed in snow and backed with slim trees which rise dark and sentinel-like toward the sky."

— *Washington Star*,
February 6, 1927

52. *Lakeside Reflections*
 ca. 1929–31
 Oil on canvas, 14 × 18 in.
 Private collection

"Thank Heaven I can in my old age give up the bondage of painting portraits except a few interesting and distinguished people. I refused 3 this last year and I am devoting my small remaining strength to what Monet begged me to do and said was my forte: Pleine Air [*sic*] and Paysages."

> — Lilla Cabot Perry to Bernard Berenson,
> August 23, 1929 (Berenson Archive, Villa
> I Tatti, The Harvard Center for Italian
> Renaissance Studies)

53. *Snow, Ice, Mist* **[Hancock, N.H.]**
(Ice Storm)
1929
Oil on canvas, 18 × 22 in.
Private collection

Why does this desolate season fairer show
Than all the glory that made summer sweet?

— Lilla Cabot Perry, "December"
from *Impressions*

54. *Mist on the Mountain*
 (Misty Weather)
 1931
 Oil on canvas, 12 × 15 in.
 Collection Easterly and Bayly

"Your show at the Guild [of Boston Artists] is perfectly beautiful, and those latest landscapes seem to me to be the finest you have painted."

— Edmund C. Tarbell to Lilla Cabot Perry
March 19, 1931 (Perry Family Archives)

Lilla Cabot Perry
1931

Notes

Sources frequently cited have been identified by the following abbreviations:

Harlow, TSP	Virginia Harlow, *Thomas Sergeant Perry: A Biography* (Durham, N.C.: Duke University Press, 1950)
LCP, BA	Lilla Cabot Perry Papers, Library of the Boston Athenaeum
LCP, Colby	Lilla Cabot Perry Papers, Special Collections, Colby College Library, Waterville, Maine
LCP, Copley	Lilla Cabot Perry, "Informal Talk Given by Mrs. T. S. Perry to the Boston Art Students' Association in the Life Class Room at the Museum of Fine Arts, Wednesday, January 20, 1894," (Boston: Boston Art Students' Association [subsequently The Copley Society of Boston], 1894)
LCP, H & A	Lilla Cabot Perry Papers, Hirschl & Adler Galleries, New York
LCP, I Tatti	Lilla Cabot Perry correspondence with Bernard Berenson, Berenson Archive, Villa I Tatti, The Harvard Center for Italian Renaissance Studies, Florence, Italy
LCP, Remsc.	Lilla Cabot Perry, "Reminiscences of Claude Monet from 1889 to 1909," *The American Magazine of Art*, 18, no. 3 (March 1927)
Perry Archives	Perry Family Archives, private collection
Perry, BMFA	Perry Papers, Library of the Museum of Fine Arts, Boston (includes correspondence concerning Lilla Cabot Perry, Margaret Perry and Thomas Sergeant Perry)
TSP, Colby	Thomas Sergeant Perry Papers, Special Collections, Colby College Library, Waterville, Maine
TSP, Houghton	Thomas Sergeant Perry correspondence (particularly with Hercules Warren Fay), as well as annotations and letters from Lilla Cabot Perry, The Houghton Library, Harvard University, Cambridge, Mass. — MS Am., 1865, Boxes 1–4
TSP, I Tatti	Thomas Sergeant Perry correspondence with Bernard Berenson, Berenson Archive, Villa I Tatti, The Harvard Center for Italian Renaissance Studies, Florence, Italy

1. Leon Harris, *Only to God: The Extraordinary Life of Godfrey Lowell Cabot* (New York: Atheneum, 1967), lx.

2. Harris, 41.

3. One example of her feelings for others is a line in her poem "The Cairn": "The world's weight of sorrow crushes me." Near the end of Perry's life, on November 16, 1931, her granddaughter Lilla Grew Moffat wrote to her: "How can I keep you from worrying about other people? . . . You are made that way and I suppose

there's nothing to do about it" (Perry Archives).

4. Perry Archives.

5. Perry was a "brilliant" student and was two years younger than many of the girls in her class. She spent her childhood years at boarding school and attended Miss Clapp's private school for girls in Boston as an adolescent. Her keen literary interest is suggested by the fact that she wrote poetry all her life, three volumes of which were published during her lifetime — *The Heart of the Weed* (1886), *Impressions* (1898), inspired by the impressionist movement in all the arts, and *The Jar of Dreams* (1923). Perry's background in both Latin and Greek was exceptionally solid, she was fluent in French and German and spoke Italian well. She also published her own translation of some epigrams in a Greek anthology — *From the Garden of Hellas*. In addition, her memoirs mention a translation of Turgenev's *Poems in Prose* and her diaries at Colby College refer to a translation of passages of Sainte-Beuve from French to German.

6. Helen Choate Bell, the noted Boston patron of the arts and music, was one of Perry's intimate friends. See in particular Thomas Sergeant Perry's memorial tribute, "Helen Choate Bell," *Boston Evening Transcript,* July 25, 1918.

7. Oliver Wendell Holmes, "The Brahmin Caste of New England" in *Elsie Venner: A Romance of Destiny*, 1861. Reprint (Boston: Houghton Mifflin Co., 1889), 16.

8. Harlow, TSP, 38.

9. Henry James's sister Alice, who was Perry's former classmate at Miss Clapp's school, made a rather catty remark on this point in a letter to her friend Sara Sedgwick: "Sargy and Lilla are to be married in a month or two and to live on no one knows what, they themselves less than any one I fancy." Jean Strouse, *Alice James: A Biography* (Boston: Houghton Mifflin Co., 1980), 161–62.

10. Lilla Cabot Perry, *Painting and Poetry* [unpublished ms.] (Perry Archives).

11. Letter to Mrs. Thomas Meteyard, June 23, 1908 (TSP, Colby).

12. Priscilla M. Pennell, "Portland Painter's Life a Mystery," unidentified newspaper article published in Portland, Maine, summer 1941 (Alfred Q. Collins's clipping files, Archives of American Art, Smithsonian Institution, Washington, D.C.). See also Kenneth Frazier, "Alfred Quentin Collins," *The Arts* 7, no. 4 (April 1925) and Hamlin Garland, *Roadside Meetings* (New York: MacMillan Co., 1930).

13. LCP to Mrs. Leonard Opdycke, January 24, 1886. (LCP, Colby).

14. LCP ltr. to Mrs. Opdycke, January 24, 1886 (LCP, Colby).

15. May Brawley-Hill, *Grez Days: Robert Vonnoh in France*, exhibition catalogue (New York: Berry-Hill Galleries Inc., 1987).

16. LCP to Mrs. Opdycke, November 6, 1886 (LCP Colby).

17. "The Cowles Art School," *Boston Evening Transcript, ca.* 1891 [month and day not recorded] (Perry Archives).

18. LCP to Mrs. Opdycke, December 27, 1886. (LCP, Colby).

19. Harlow, TSP, 21.

20. See excerpts of LCP memoirs, January 1888, in Appendix "Lilla Cabot Perry: Memoirs and Correspondence" in this book.

21. LCP to Bernard Berenson, August 23, 1929 (LCP, I Tatti).

22. Ernest Samuels, *Bernard Berenson: The Making of a Connoisseur* (Cambridge, Mass.: Belknap Press, 1979), 34–35; 50–51.

23. TSP diary, September 27, 1887; October 2, 1887 (TSP, Colby). Although Perry copied many paintings by Velázquez, she was in France in 1906 at the time of the *Old Master Copies* exhibition in Boston, which was dominated by reproductions of Velázquez by American artists, and her works apparently were not included. See *Boston Evening Transcript,* March 7, 1906.

24. Clara Erskine Clement, *Women in the Fine Arts from the Seventh Century B.C. to the Twentieth Century A.D.* (Boston: Houghton Mifflin Co., 1904), 271.

25. Harlow, TSP, 110.

26. *Symboles et réalités: La Peinture allemande, 1848–1905,* exhibition catalogue (Paris: Petit Palais, 1984), 229–305.

27. Clement, *Women in Fine Arts,* 271.

28. Cecilia Beaux, *Background with Figures* (Boston and New York: Houghton Mifflin Co., 1930), 118.

29. Clement, *Women in Fine Arts,* 271.

30. Camille Lemonnier, *Alfred Stevens et son oeuvre* (Brussels: Van Oest, 1906), 33.

31. Interview with Margaret Perry on October 31, 1966, by Thomas N. Maytham of the Museum of Fine Arts, Boston (Perry, BMFA).

32. Will Low, *A Chronicle of Friendships, 1873–1900* (New York: Scribner, 1908), 447. There is a voluminous amount of published material on the American artists who gravitated to Monet at Giverny. See particularly William H. Gerdts, *American Impressionism* (New York: Abbeville Press, 1984); Richard H. Love, *Theodore Earl Butler: Emergence from Monet's Shadow* (Chicago: Haase-Mumm Pub. Co., 1985); Laura L. Meixner, *An International Episode: Millet, Monet and Their North American Counterparts,* exhibition catalogue (Memphis, Tenn.: The Dixon Gallery and Gardens, 1983); and David Sellin, *Americans in Brittany and Normandy, 1860–1910,* exhibition catalogue (Phoenix, Ariz.: Phoenix Art Museum, 1982). As all recent texts point out, French Impressionism had passed its prime before the first Americans arrived at Giverny in the late 1880s.

33. LCP, Copley.

34. Stuart P. Feld, *Lilla Cabot Perry: A Retrospective Exhibition,* exhibition catalogue (New York: Hirschl & Adler Galleries, Inc., 1969), no. 6.

35. A major obstacle we have faced in preparing this exhibition has been the disappearance of Perry's account book, which listed the artist's works by title, apparently in chronological order. This book was extant at the time of the retrospective exhibition of Perry at Hirschl & Adler Galleries in 1969, which presented forty-seven of her works. When works included in the retrospective overlap with the selection for this exhibition, therefore, we have referred to the exhibition catalogue cited above to help identify and date certain works. Our selection includes many Perry works not presented in 1969, however, some of which we have been unable to date with certainty.

Another source of confusion is the titles. We have indicated to the best of our knowledge the actual titles that Perry gave to her works. Perry herself was not consistent, however, and some of her paintings had as many as three different titles during her lifetime. Other works had identical titles.

For an artist of her scope, research on Perry is still very limited. Hopefully, Perry's account book will resurface, which will help answer many questions concerning titles, dates and sales.

36. Thomas Sergeant Perry, "Some Greek Portraits," *Scribner's* 2 (February 1889): 219–25.

37. As David Sellin has pointed out, plein-air painting "did not necessarily have to be done outside, but it had to have the effect of outdoor light." David Sellin, *Americans in Brittany and Normandy, 1860–1910,* 3.

38. Christopher Lloyd, *Camille Pissarro* (New York: Rizzoli, 1981), 94.

39. Undated press review for the *Thirteenth Exhibition of the Society of American Artists* in 1891 (LCP, H & A).

40. Thomas Sergeant Perry, "Among the Paris Pictures," *Boston Post,* June 30, 1891.

41. Thomas Perry, *Boston Post,* June 30, 1891.

42. Letter from Theodore Robinson to Thomas Perry, June 9, 1891 (Perry, BMFA).

43. For an in-depth discussion of the window theme in 19th-century art, see Lorenz Eitner, "The Open Window and the Storm-Tossed Boat: An Essay in the Iconography of Romanticism," *The Art Bulletin* 37 (December 1955): 281–290. Also, Steven Z. Levine, "The Window Metaphor and Monet's Windows," *Arts Magazine* (November 1979): 98–104.

44. Perry's undated notes to an 1892 letter from Theodore Robinson to her husband (LCP, Colby).

45. William Howe Downes, "New England Art at the World's Fair," *American Art and Artists* 1 (1893): 363. See also LCP, H & A. Perry was awarded a silver medal for her two paintings exhibited at the *Massachusetts Charitable Mechanics' Association Eighteenth Triennial Exhibition* in Boston in 1892, which included the works selected for Chicago: *Child's Head,* no. 89 (which she painted in an hour!) and *Child with Violin,* no. 90. The latter is no. 15 in the current exhibition, titled *Portrait Study of a Child.*

46. Thomas Sergeant Perry, "At the Greatest Show," *Boston Evening Transcript,* September 8, 1893.

47. LCP, Copley.

48. Helen M. Knowlton, *Boston Evening Transcript,* February 9, 1894.

49. TSP corres. to Hercules W. Fay, July 27, 1895 (TSP, Houghton). See also, Harlow, TSP, 175.

50. Harlow, TSP, 160.

51. LCP to Bernard Berenson, January 27, 1930 (LCP, I Tatti).

52. For the work of Butler, see in particular Richard H. Love, *Theodore Earl Butler.* For the work of MacMonnies, see Adina E. Gordon, *Frederick William MacMonnies — Mary Fairchild MacMonnies,* exhibition catalogue (Vernon: Musée Municipal A. G. Poulain, 1988). Perry and Mary MacMonnies lived intermittently in Giverny in the 1890s.

53. The second variation, not exhibited here, is in a private collection, courtesy De Ville Galleries, Los Angeles.

54. *The Violinist* is not dated. Its strong resemblance to another genre painting from Giverny, *In the Studio,* which Stuart Feld dates "about 1895" suggests that it, too, was completed in the mid-1890s, however. See Feld, *Lilla Cabot Perry,* no. 19.

55. "When [Monet] learned that I was going to Holland, he said that he would give a good deal to see the Franz [sic] Hals again" (LCP, Copley).

56. Margaret Perry letter to Mrs. Opdycke, June 21, 1895 (Perry Archives).

57. "Exhibition of Mrs. Perry's Paintings at the St. Botolph Club," *Boston Evening Transcript,* November 11, 1897.

58. Lisa Ward, "Lilla Cabot Perry and the Emergence of the Professional Woman Artist in America, 1895–1905," Master's thesis, University of Texas, Austin, 1985.

59. Harlow, TSP, 161. Writing to Bernard Berenson in 1929, Perry herself noted, "Though I have not the art of self-advertisement, I have had the pleasure of having Monet and Pisarro [sic] and Puvis take an interest in my painting." LCP ltr. to Berenson, August 23, 1929 (LCP, I Tatti).

60. See Kathryn Corbin, "John Leslie Breck, American Impressionist," *Antiques* (November 1988): Pl. II, *In a Garden,* 1890. "Depicted is the garden of Boston painter, Lilla Cabot Perry (1848–1933), next to Monet's in Giverny, Terra Museum of American Art, Chicago, Illinois, Daniel Terra Coll."

61. TSP corres. to Hercules W. Fay, September 6, 1895 (TSP, Houghton).

62. Beaux, *Background with Figures,* 201–02.

63. TSP corres. to Fay, October 28, 1894 (TSP, Houghton).

64. John Rewald, *Camille Pissarro: Letters to His Son, Lucien,* Lionel Abel, trans. (New York: Pantheon, 1943), 248–49.

65. Rewald, *Camille Pissarro,* 283 and 292.

66. TSP corres. to Fay, July 7, 1897 (TSP, Colby).

67. Louise d'Argencourt, *Puvis de Chavannes,* exhibition catalogue (Paris: Grand Palais, 1977), 33, 36, 234–35.

68. Trevor J. Fairbrother, *The Bostonians: Painters of an Elegant Age, 1870–1930,* exhibition catalogue (Boston: Museum of Fine Arts, 1986), 60–63. The MacMonnies sculpture ultimately was removed, after being denounced as "the glorification of that which is low and sensual and degrading" by Boston's ever-powerful Watch and Ward Society, "staunchly" supported by Perry's own brother Godfrey Lowell Cabot. The Metropolitan Museum of Art welcomed the sculpture in 1897.

69. Thomas Sergeant Perry, "The Goncourt Academy, Part IV," *Boston Evening Transcript,* October 29, 1897.

70. *Boston Evening Transcript,* November 11, 1897.

71. Thomas Sergeant Perry, "First Impressions of Japan," *The Far East Review* 3, no. 29 (June 20, 1898): 473–75.

72. LCP and TSP dia. July 10–11, 1887 (TSP, Colby).

73. TSP corres. to Berenson, June 26, 1898. (TSP, I Tatti)

74. LCP interview with *Boston Herald,* February 27, 1921.

75. LCP undated letter to Elizabeth Sturgis Grew (Perry Archives).

76. John La Farge, *An Artist's Letters from Japan,* 1897. Reprint (New York: Kennedy Graphics, 1970), vii.

77. TSP corres. to John Morse, March 12, 1906 (TSP, Colby).

78. TSP corres. to Morse, March 12, 1906 (TSP, Colby).

79. LCP Copley.

80. Claude Neuilly, "Le Salon des Indépendants," *La Revue Moderne Universelle,* April 15, 1908, 34–35.

81. Harlow, TSP, 329.

82. George Moore, *Modern Painting* (London: Walter Scott, Ltd., 1893), 188.

83. William H. Downes, "Mrs. Perry's Pictures," *Boston Evening Transcript,* January 4, 1911, 16. In fact, Perry had by no means "abandoned" Impressionism.

84. LCP interview, *Boston Herald,* February 27, 1921.

85. The guild's congratulatory letter is in the Perry files at Vose Galleries, Boston. The commemorative bowl is the property of Perry's granddaughter Lilla Cabot Levitt.

86. TSP corres. to Alice Perry Grew, December 17, 1920 (Perry Archives).

87. LCP to Bernard Berenson, August 23, 1929 (LCP, I Tatti).

88. *New York Morning Telegraph,* November 5, 1922.

89. For an in-depth discussion of American portraiture, see Carolyn Kinder Carr, *Then and Now: American Portraits of the Past Century from the National Portrait Gallery,* exhibition catalogue (Washington: The National Portrait Gallery, Smithsonian Institution, 1987).

90. TSP corres. to John Morse, September 11, October 1 and October 17, 1922 (TSP, Colby).

91. LCP ltr. to Bernard Berenson, August 23, 1929 (I Tatti).

92. LCP ltr. to Berenson, August 23, 1929 (I Tatti).

93. LCP ltr. to Berenson, August 23, 1929 (I Tatti).

94. LCP ltr. to Berenson, July 20, 1928 (I Tatti).

95. LCP ltr. to Berenson, August 23, 1929 (I Tatti).

96. Ltr. from Edmund. C. Tarbell to LCP, March 19, 1931 (original, LCP Colby; copy, Perry Archives). "My dear Mrs. Perry, Your show at the Guild is perfectly beautiful, and those latest landscapes seem to me the finest you have painted. I don't know when I have enjoyed an exhibition so much. . . . My warmest congratulations, and many thanks for allowing us to see some real painting."

97. Ltr. from Frank W. Benson to LCP, March 18, 1931 (original, LCP Colby; copy, Perry Archives). "Dear Mrs. Perry, Good for you! I have been to see your show five times and I assure you it looks better to me every time. There never was truer, more direct and sincere painting, and I thought I should feel better to write and tell you so than simply say it when I saw you. I think it is the best show I have ever seen of your work, and I don't see how you have been able to accomplish so much when I know you have often had to lie by on account of your health. I hope you'll have many years of this kind of painting."

98. LCP ltr. to Berenson, August 23, 1929 (I Tatti).

99. Thomas Sergeant Perry, *English Literature in the Eighteenth Century,* 1883. Reprint (New York: Books for Libraries Press, 1972), 442.

American Women Artists at the Turn of the Century Opportunities and Choices

Nancy Mowll Mathews

The economic prosperity enjoyed by Americans during the Gilded Age opened up artistic opportunities for women that have seldom been equaled before or since. For many women the new prosperity meant that their families could provide them with training and support. For these women, and even for others from less prosperous families, the economic situation also meant that they could look forward to a rosy future in the burgeoning arts-related industries. Furthermore, by the turn of the century, art training was easily obtainable throughout the United States and in Europe. Since living in Europe was affordable at that time, even for those on a limited student budget, Americans typically went there and stayed, sometimes for years. On the whole, in light of the financial support for the arts and the accessibility of training, it was a promising time for women who aspired to careers in the arts.

One would expect that such an era would produce great women artists. Without minimizing the complexity of the term "greatness,"[1] we might say that this era does claim two Americans who have had this term applied to them — Mary Cassatt and Georgia O'Keeffe — as well as a large number whose recognition in their own day has continued into ours, among them Cecilia Beaux, Elizabeth Nourse, Lilian Westcott Hale and Lilla Cabot Perry. Because of the proliferation of good, successful women artists during the late 19th century, and because of the climate of interest in the arts that these artists did much to foster, it is important to understand the factors that shaped this distinct epoch in the history of women artists.

While a career as an artist may have seemed well suited to a woman's interests and circumstances in the 19th century, it also made demands on women that many found hard to satisfy. Unlike being a writer, for instance, being an artist meant learning a manual skill at a specialized school which provided not only training but a type of "certification." Few artists could earn recognition without proving mastery of advanced techniques and without the prestige of a recognized school or master to smooth the way. Then, after completing such training, he or she was faced with a professional life competing in a public and often willful marketplace. Exhibition juries, critics, dealers and collectors had to be persuaded of the subjective merit of his or her work. Successful male artists were not only talented in art but clever about marketing. The same skills were necessary for women, but fewer women had the business background and public aplomb that served their male colleagues so well.

A career as an artist made other demands on women as well. The necessary training and travel, the public aspect of the visual arts and the subjective nature of the finished product made it hard for women to conduct a traditionally accepted personal life. In addition to the practical difficulties, an artist — whether male or female — often chose to remain unmarried rather than risk living in an environment in which his or her work was made trivial. Degas, for example, when asked why he never married, replied, "I was too afraid that after I had finished a picture I would hear my wife say, 'What you've done there is very pretty indeed.'"[2]

The risk of having one's work dismissed or misunderstood was even greater for women, and caused much agonizing over personal choices that even spilled over into contemporary fiction. The fact that Lilla Cabot Perry was a married woman with children when she began her career was an unusual circumstance, and serves as a touchstone for an examination of the choices made by other women of her generation.

Even if training was readily available in the late 19th century, it also had acquired certain quirks that affected the women who received it. Students in art classes tended to be separated by gender, which produced mixed results for women artists. In addition, the issue of women's access to the nude model was still very much alive, in spite of the lowering of the barriers that had taken place earlier in the century. Finally, women at the turn of the century suffered from perhaps too much academic training and tended to remain within an essentially conservative framework. For instance, Lilla Cabot Perry's friendship with Monet and her subsequent interest in Impressionism enhanced but never replaced her original mastery of what might be termed "proper usage" in art: anatomy, perspective and chiaroscuro. While modernism

took root among the young male artists, as a rule the women felt a much stronger attachment to the academic training they received as students.

Perry was a woman who not only successfully pursued training in the United States and abroad but also achieved and maintained the rare status of professional artist throughout her life. Barriers against women students in art academies fell, but barriers against women as professionals lingered much longer. The male teachers and students were themselves perplexed about what happened to all those promising young women in the art schools across Europe and America. As a teacher at the Slade School of Fine Art in London remarked, "After the twenties their good work seems to stop. Possibly their powers have not really diminished, but marriage, children, or some such interest has interfered."[3] The threat of vanishing from the art scene was very real for women artists, and only a few managed to make the leap from promising student to established professional through monumental persistence.

Using Lilla Cabot Perry as a pivotal figure, we will examine the circumstances for women artists in this period, who faced increased opportunities but, at the same time, thorny personal decisions.

Perry was surrounded by people in the arts throughout her life. She could hardly be said to come from an artistic family, or even an artistic community, but she was a member of a society that spawned an unusually large number of writers and artists. She numbered among her friends some of the greatest American examples of both, such as John La Farge, Mary Cassatt and Henry James. These people did not form a coherent group, but they represented an American artistic "type" that emerged toward the end of the century. All were from good families, but most lived in circumstances that made earning a living through their art desirable or even necessary. Another woman of this period who was from a good family yet supported herself through her art was Edith Wharton, whose first literary success was a helpful addition to her family's bank account. Her autobiography chronicles the drastic change that affected her generation by contrasting the new business-like mentality to the manners of her youth:

It will probably seem unbelievable to present-day readers that only one of my own near relations, and not one of my husband's, was "in business." The group to which we belonged was composed of families to whom a middling prosperity had come, usually by the rapid rise in value of inherited real estate, and none of whom, apparently, aspired to be more than moderately well-off. I never in my early life came in contact with the gold-fever in any form, and when I hear that nowadays business life in New York is so strenuous that men and women never meet socially before the dinner hour, I remember the delightful week-day luncheons of my early married years, where the men were as numerous as the women.[4]

Most of the best-known artists and writers from this period came from wealthy and often prominent families from the East or Midwest. Some of them, such as Cecilia Beaux, Elizabeth Nourse and Louisa May Alcott, came from families that had lost their money, and were forced, therefore, to look upon their art as a means of producing necessary income. Others, such as Elizabeth Gardner, Henry James and Mary Cassatt, came from prosperous families, but not prosperous enough to allow the budding artists to live away from home, especially abroad, without requiring them to earn at least some of their upkeep. For them, as for Edith Wharton and Lilla Cabot Perry, the sale of a story or a painting meant continued independence and greater freedom to travel abroad. Furthermore, as the cult of American business grew, the artists saw themselves as hardworking businessmen and businesswomen, who kept regular working hours and handled their contracts and commissions in a professional manner.

For Perry to begin serious art studies at the age of thirty-eight, after having been married for over ten years, required a good deal of the type of practical zeal that marked her generation. While her husband was a writer and a scholar, his teaching appointments at Harvard were irregular, and family money was not sufficient to support two adults and three children comfortably. Perry's success as a student and then as a painter must attest to her great powers of organization and the willing cooperation of her husband and children. Sarah Choate Sears, Perry's contemporary in Boston, also managed to forge a career with a growing family, although the great wealth of her husband may have given her more advantages. Wharton, who was also married, did not have the added pressure of children.

The women of Perry's generation who had the

greatest success tended, like Wharton, to be childless; the most famous American women artists, in fact, tended to be unmarried. The tendency for women artists of the late 19th century not to marry or, if married, not to have children, may have been due to the Americans' need for European travel. Whereas Berthe Morisot, Marie Bracquemond or Käthe Kollwitz could absorb Western traditions in art without travel that was disruptive to their marriages, American women who sought similar success needed the freedom not only to work in solitude but also to cross the Atlantic to the art centers of current and historic importance. Some, like Mary Fairchild MacMonnies, Elizabeth Boott Duveneck or Maria Oakey Dewing, resolved this problem by becoming wives of American artists who also traveled a great deal. Others, like May Alcott and Elizabeth Gardner, married European men.

For those who stayed single, however, the opportunities for study and work were much greater, and, to some extent, this must account for the success of Cassatt, Beaux and Nourse. All three of these artists maintained their home life and close ties with their families. They were highly regarded by the artistic community as well as by a larger circle of distinguished society. Although they did not make public their reasons for not marrying, we can gain some insight into their decisions by reading short stories by contemporary unmarried writers, such as Constance Fenimore Woolson and Louisa May Alcott. Both wrote about women artists and examined issues of ambition, artistic achievement and marriage.

In her stories "The Street of the Hyacinth" (1882) and "At the Château of Corinne" (1886),[5] Woolson describes a painter and a writer in similar situations: they are both pursued by men who love them but have low opinions of their talent. In both cases they finally adopt the man's view and abandon their artistic careers in favor of marriage. Ettie Macks, the painter in "Hyacinth," and Katherine Winthrop, the poet in "Corinne," are devastated by the loss of their career plans as well as their self-esteem, and exact a high measure of devotion from their lovers in return. While this has been interpreted as Woolson's expression of outrage that men's opinions can be so destructive to the women they love,[6] it may also be Woolson's criticism of women who make such inaccurate assessments of themselves that they have no choice but to give up hope of artistic success and put their fate in the hands of a husband.

Another forum for the articulation of these issues was Louisa May Alcott's unfinished and unpublished novel *Diana and Persis* (1879). Based on her sister May Alcott's life as an art student in Paris, the novel examines the types of relationships that are best for a woman artist. First and foremost is the loving and mutually supportive relationship between the two women of the title, Diana, a sculptor, and Percy (Persis), a painter. Percy, however, soon falls in love with and marries a Swiss businessman, and they set up house with their newborn in Paris. She is deeply happy with her new life and soon lets her domestic responsibilities take her away from painting. When Diana comes to visit, Percy's love of art is rekindled. Her husband sees that, if he is to make her completely happy, he must and will support her artistic career. Diana, who had always chosen art over marriage, then meets a sculptor, like herself, who recognizes not only her beauty but her talent, and, although the novel goes no further, she seems headed for a perfect artistic union.

Alcott's message, unlike Woolson's, is that marriage can enrich a woman's art and career — if it is with the right man. In her story both Diana and Percy meet men who are sympathetic and supportive. One, as might be expected, is an artist, but the other is a businessman. Short of finding such a sympathetic man, however, she cautions that an artistic woman is best off remaining single and looking to other women for support.

While the issues of art, love and marriage were debated in contemporary literature, each woman artist of the 19th century considering a productive career had to make her own decision about what made her happiest. Lilla Cabot Perry found one of those rare, supportive marriages that her fellow Bostonian Alcott envisioned for all women artists.

Since Perry married before she began her formal training as an artist, she was once again in the minority. Private art classes and art schools were more typically populated by single, eligible, young people in their late teens and early twenties. Men and women may have taken instruction in separate classes, but they had ample opportunities for interrelating outside of class, particularly when occupied with copying works of art in museums and galleries. Naturally, for some young people the art student experience was at times only marginally more concerned with art than with socializing. As Mary Cassatt's friend Eliza Haldeman wrote to her sister from Paris in 1868, "There is a quantity of our old Artist acquaintances over here just now and I am afraid the Louvre will become a second [Pennsylvania] academy for talking and amusing ourselves."[7]

For an older, married student like Perry, however, the art instruction itself would have been of foremost

importance. For years she had worked on her own as a poet, absorbing the cultural life of Boston from her position at the center of the city's intellectual circle. Her friends and family included her husband's colleagues, her brother-in-law John La Farge and Henry and William James.

In 1886, when she took her first formal classes in painting, she embarked on a course of training that reflected new American standards for art education. The Cowles Art School had been established only recently, in 1882, and already had expanded into new quarters. Like its rival, the School of the Museum of Fine Arts, it offered a system of training that stressed basics. As in the European academies, the student was taken through an orderly series of drawing exercises to master anatomy and composition before embarking on painting techniques. This system, which had been adopted by the Pennsylvania Academy of the Fine Arts in the 1860s, had only

taken hold in Boston after the death of William Morris Hunt, whose more intuitive approach to painting held sway for decades.[8] Women flocked to the Cowles School just as they had to Hunt previously. Some of them, such as Lucia Fairchild Fuller from Madison, Wisconsin, and Anna Mary Richards Brewster from Philadelphia, added to the growing circle of women artists from Boston.

Perry's success under her teachers Robert Vonnoh and Dennis Bunker was such that within a year she arranged to continue her studies in Paris. Although the American schools were by this time nearly identical in approach to those abroad, the benefits of studying in Paris went beyond mere coursework, and every serious student was encouraged to go. In addition to receiving personal encouragement to visit Europe from her art teachers and friends in Boston, Perry would have been inundated with information and advice on studying abroad from printed sources. May Alcott [Nieriker] published her

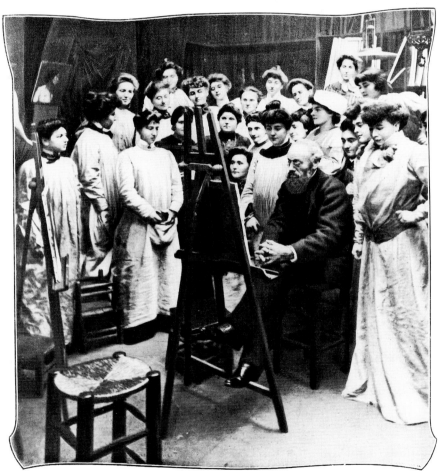

Fig. 24. A women's painting class at the Académie Julian conducted by Jean-Paul Laurens, *ca.* 1903. *Femina* 50, February 15, 1903.

pamphlet *Studying Art Abroad and How to do it Cheaply* in 1879, and another Boston artist, Ellen Day Hale, was sending back letters from Paris to the *Boston Traveler* in 1885. In addition, as Lois Fink has pointed out in her studies of American women in Paris, "[by] the 1880s journals of art, popular magazines, and even newspapers kept their potential patrons constantly informed about the Parisian art scene. Through reproductions in these publications, numerous exhibitions, and access to private and public collections, works of contemporary French painting were known across the country, the yardstick against which other works were measured."[9]

In the years from 1885 to 1889, many of the best-known American women artists were studying in Paris at the Académie Julian, among them Ellen Day Hale (1885), Mary Fairchild MacMonnies (1886–88), Cecilia Beaux (1887) and Elizabeth Nourse (1887). This school offered by no means the only educational opportunity in Paris — most studied also at the Académie Colarossi or the less-well-known Académie des Champs-Elysées. Julian's was the best-known school in Paris, however, and most Americans wanted at least to be able to list it in their credentials. Often the Americans would sample a variety of courses, spending time at each of the academies. They would also supplement their coursework with group or private lessons from artists such as Carolus Duran, Alfred Stevens or Edouard Krüg.[10]

As a rule, the American students in Paris were slightly older than those in academies back home, since the Paris experience was considered a "graduate" level of studies. The social aspect was no less important in Paris than it was in America, however, particularly since many of the students found themselves on their own for the first time. For the women this usually meant establishing households in small groups of two or three. They spent days working at the academies and nights entertaining their fellow students at low-budget dinner parties in their primitive Paris apartments.

We find accounts of these experiences in the letters and memoirs of Eliza Haldeman, Emily Sartain, May Alcott, Cecilia Beaux and Elizabeth Nourse. They give us a clear picture of how complete an "art" experience it was for these young women. In class and in their daily lives, they were immersed in an environment unheard of in the United States. Every activity, every conversation, revolved around art and artists. This concentration on the arts resulted from several factors: the presence of a large number of art students from all over the world congregating in neighborhoods throughout the city, the interna-

tional importance of the annual Salons and the unusually avid attention that the Parisian press paid to the arts. All of these factors combined to give the young art student the sense of being at the center of the universe. They also promoted a new appreciation of the French concept of "fame."[11]

Inspired by the heady prospect of fame, the students were prepared to work hard and accepted the labor-intensive French system of instruction. Most of them, trained in art schools in the United States, were already familiar with the principles. In Paris, however, they practiced drawing from the model (nude and clothed) more, were expected to do independent work and had the thrill of an occasional word of advice from an internationally renowned artist. The merest *"pas mal"* from Jules Lefebvre or Tony Robert-Fleury was enough to reward the back-breaking work that they put in.

The atmosphere in the classroom itself was competitive; the overcrowded and truly international group was put through a number of major and minor competitions to win everything from prizes to easel positions near the model. Cecilia Beaux wrote, "The room was always filled 'to capacity' as we say, and it was necessary to mark each easel and chair with white chalk and to look out for encroachments. . . . Every week subjects for composition were given out. The compositions were handed in on a Saturday, and the student who had produced the best in the opinion of 'le Maître' had the privilege of first choice of place on Monday morning, for the new pose. . . . I had the good luck to win it pretty often."[12] In the absence of easy communication, a student could win her colleagues' respect only by her artistic performance.

While the women in these classes gained a great deal from the single-sex environment — they benefited from the climate of respect for women artists that prevailed, and they did not suffer the discrimination that often takes place in a mixed classroom — nevertheless, they were also aware of the drawbacks. As Fink has pointed out, the women's classes at Julian's were visited by instructors only once a week, while the men were seen twice.[13] Furthermore, the women paid twice as much for this limited instruction. Most damaging of all, however, is the suspicion that the women were held to lower standards of performance by their teachers. "At a crucial time in their education women were thus denied the competition of males, against whom they would have to compete throughout their careers," writes Fink. "They were denied being pushed to excellence by their instructors, who give every impression of having been easily satisfied with the

efforts of female students."[14]

The women were aware of the inequities and occasionally rebelled against this system of segregation. May Alcott reported to her family about a group of American women students who insisted on attending a male class at Julian's and worked steadfastly for some months in the face of the subtle and not-so-subtle opposition of the men.

> There is Julien's [sic] upper and lower school, in Passage Panorama, where a student receives criticism from the first leading authorities, and is surrounded by splendidly strong work on the easels of the many faithful French, who for years have crowded the dirty, close rooms, though I believe the lower school as it is called, or male class, no longer opens its doors to women, for the price being but one half of the upper school, attracted too many. Also, with better models, and a higher standard of work, it was found impossible that women should paint from the living nude models of both sexes, side by side with the Frenchmen.
>
> This is a sad conclusion to arrive at, when one remembers the brave efforts made by a band of American ladies some years ago, who supported one another with such dignity and modesty, in a steadfast purpose under this ordeal, that even Parisians, to whom such a type of womanly character was unknown and almost incomprehensible, were forced into respect and admiration of the simple earnestness and purity which proved a sufficient protection from even their evil tongues
>
> Something besides courage was needed for such a triumph; and women of no other nationality could have accomplished it.[15]

It was primarily the life classes that were segregated and remained so until after the turn of the century in most academies.

It is not a coincidence that the nude human body, which is central to male/female relationships, is also central to the study of art. The fact that it evokes the deepest human feelings makes it the grandest subject, but it also makes it extremely difficult for men and women to study objectively, particularly when they are in the same room. The 20th-century approach of draining emotion from the study of the nude has allowed mixed classes to work successfully together, but it also perhaps reflects the decline of the human figure as the most potent artistic subject.

Women artists of the 19th century fought for and won the right to study from the nude. The Pennsylvania Academy of the Fine Arts instituted life classes for women in 1868. Private teachers in Paris, such as Krüg and Evariste Luminais, allowed women students to draw from the male and female nude in the 1870s. Life classes were a standard feature of the Julian course of instruction for women in the 1880s. Even then, the figure was not entirely nude — male models wore drapes wrapped around them in the form of classical "shorts."

These studies provided women with a grasp of anatomy and helped them produce the types of work that often were their specialty: portraits, child studies and figurative compositions. With the decline in popularity of classical subjects and other branches of history painting, however, the nude itself began to appear most often in a genre or "modern life" setting, which few women could bring themselves to paint with any frequency. Thus, the life classes for women, which had been so hard won, were of limited use to them in their later professional careers. This fact, more than any other, distinguishes their experience as professional artists from that of their male colleagues.

In spite of the questionable usefulness of the life classes offered by academies in the United States and Europe, the training provided to women was as close to a traditional academic course of art study as possible. As the century drew to a close, this traditional course of study was being challenged, but few of the American women students filling the classrooms at Julian's joined in the criticism. Although they may have been aware of the more radical movements afoot in Paris in the 1880s — Impressionism, Neo-Impressionism, Symbolism — or even been familiar with the more rebellious students who also took classes at the academy, they believed so strongly in the traditional academic art training they were receiving that nothing could dissuade them. Cecilia Beaux, recalling her years in Paris from a vantage point in the 1920s, felt that modern art movements denigrated the academic training she received and attempted to explain why she herself did not question that training.

> Where were we just then? Some believe, plodding along stupidly on a beaten track. I am glad that my long hours in the Life-Class were untroubled by doubt. I was working my way into

the mystery of Nature, like a chipmunk storing up what could be used later, every step revealing secrets of vision I burned to express; to cease from blundering and begin to conquer, to state what I saw as being a salvage of the best; discovery of integral truth, discovery of means to report it that would mate with my emotion.[16]

For Beaux, the training was like building a nest. She saw and admired "Monet's iridescent pigments," but she had "no desire to follow."[17] Her own path stemmed directly from the basics taught at Julian's.

The allegiance that artists like Beaux and Perry felt toward the academic approach was so strong that it went beyond simple artistic preference. It suggests that the systematic studies were part of a belief system that was at the core of educated American life. We can gain insight into this phenomenon by noticing that the Americans often referred to this training in linguistic terms, as if their academic art studies were akin to learning an alphabet or vocabulary. In Constance Woolson's "The Street of the Hyacinth," for example, the heroine is sent to a teacher who claims he will correct her earlier haphazard training and send her "back to the alphabet."[18] Frank Millet, another expatriate American artist, criticized William Morris Hunt's teaching that allowed his students "to remain like people who have learned the beauties of a language before they can write or speak it."[19]

The tendency to see the elements of the academic style — anatomy, perspective and chiaroscuro — as analogous to the correct use of language may even have had something to do with the upper-class origins of this group of women. They were brought up to believe that attention to proper English was part of one's class identity. In a similar vein, they may have felt that any less attention to detail in drawing would have betrayed their deeply ingrained class values. A telling statement by Edith Wharton demonstrates how essential proper usage was.

Usage, in my childhood, was as authoritative an element in speaking English as tradition was in social conduct. . . . You could do what you liked with the language if you did it consciously, and for a given purpose — but if you went shuffling along, trailing it after you like a rag in the dust, tramping over it, as Henry James said, like the emigrant tramping over his kitchen oil-cloth — that was unpardonable, there deterioration and corruption lurked.[20]

In Wharton's eyes, incorrect usage was not only technically but morally and socially wrong. For the artists of a similar educational and social background, like Cecilia Beaux, Elizabeth Nourse and Lilla Cabot Perry, such an admonition might apply not only to language but to art as well. It is no wonder then that when an artist like Perry went farther than Beaux in investigating modern movements, she did so without ever losing her "consciousness" of the proper usage of art that the training in Boston and Paris had instilled in her.

When Perry met Monet and began her long friendship and apprenticeship with him, she took steps that Americans were just beginning take into the outer reaches of the Parisian art world. As Beaux remarked, the newer trends and movements were visible, and little by little Americans made contact with the artists from these groups. One woman artist from the radical fringe who may have seemed as distant as the others was Mary Cassatt, but, as with Monet, more American students in the late 1880s and 1890s began to make contact with her.

Mary Cassatt at this time was one of the very few American women artists to have taken up permanent residence in Paris.[21] During the 1860s and 1870s she was in close contact with the American students, first as a student herself and then as a young professional artist occasionally sitting in on classes.[22] From 1879 on, however, when she began exhibiting with the Impressionists, she became farther removed from the contemporary crop of students, as well as from the community of American artists in general. In the early 1880s she exhibited less than she had the decade before, and only showed with the Impressionists in 1881 and 1886.

In 1888 she began exhibiting regularly again, becoming more active with the encouragement of the dealer Paul Durand-Ruel, who started to represent her. At this period she reemerged into the Paris art world. The introduction of the mother and child theme into her work gave her a recognizable trademark, bringing her more attention from critics and collectors. Because of this renewed activity in the late 1880s, newcomers to Paris, such as Perry and Elizabeth Nourse, soon got to know her. When Bertha Honoré Palmer, President of the Board of Lady Managers for the Woman's Building of the World's Columbian Exposition of 1893, came to Paris in 1892 looking for American women to paint murals in the building, she chose one recent art student now living in Giverny, Mary Fairchild MacMonnies, and one veteran, Mary Cassatt.[23]

Cassatt was, like most of the American women, well

bred and well educated. She had, nevertheless, escaped the influence of the academic system in her early career, and was believed to be a poor draftsman by her fellow Americans.[24] Concentrating instead on her painting skills, she spent several years studying the techniques of the Old Masters in museums around Europe. It was her painterly qualities and the freshness of her approach to the figure that account for the invitation she received to join the Impressionists in 1877. Her association with Degas, however, had convinced her of the value of strong drawing skills, and she, belatedly, began to sharpen her "alphabet" in the drawing media — pastels and prints. By the time she once again became friendly with Lilla Cabot Perry, Sarah Choate Sears and other Americans, she was working in a style much more acceptable to them, even though she still resolutely rejected the tyranny of strict academic principles.

Cassatt also serves as an example of a woman who had established herself as a professional artist in Europe. Although there were women in the United States who had made a place for themselves as painters — Ellen Day Hale in Boston, Lilly Martin Spencer in New York and Emily Sartain in Philadelphia, among others — none of them achieved the success enjoyed by such European women as Rosa Bonheur or Louise Abbéma, or American artists living in Europe, such as Harriet Hosmer or Anna Lea Merritt. Cassatt felt strongly that a woman achieved more in Europe than in America, and a statement she made was repeated to Mrs. Palmer: "After all give me France — women do not have to fight for recognition here, if they do serious work. I suppose it is Mrs. Palmer's French blood which gives her organizing powers and her determination that women should be *someone* and not *something*."[25]

Many American women shared Cassatt's view, but not all were prepared to act on it. Expatriation was a serious step even though it paid off for many. A compromise, albeit expensive, was to travel back and forth frequently, as became the custom of Perry, Sears and Beaux. The key for all women who were determined to be professional painters was to enlarge their horizons, stay at the heart of the largest art markets in Europe or America and avoid a situation in which they had to compete directly with male artists for a small group of patrons. However successful a woman artist might be, commissions were more likely to be given to men. Therefore, the successful women established themselves where there were enough patrons to provide commissions for a large number of artists.

Since portraiture was the type of painting most often purchased by the general public, women usually found a niche in this field. Genre works and other appealing subjects, such as still lifes, were also widely popular and attracted a large number of women. Child subjects — both genre and portraiture — were by far the easiest for women artists to sell, and very few women could avoid or resist the great demand for them. Children figure prominently in the work of all the important, successful women artists of the day — Gardner, Cassatt, Nourse, Beaux and Perry.

Beyond placing herself in a sympathetic environment and mastering forms of art that had a widespread appeal, what else did the student need to do to complete her metamorphosis into professional artist? Successful women in this period all understood the need for as much exposure as possible, particularly in exhibitions but also in the press and commercial galleries. Probably the highest hurdle for the woman who had spent years quietly learning her craft in the classroom was to suddenly begin to systematically and ceaselessly promote her own work to the outside world. Gardner and Cassatt did this very well; in fact, they linked promotion of their own work with the promotion of other artists.[26] Perry was to follow in their footsteps by bringing Monet's paintings back to Boston. Sarah Sears was herself a collector of French paintings. When women artists promoted the art of others or collected art themselves, it often led to sales of their own work. It also granted them privileged access to some of their more famous contemporaries.

Another avenue women took to achieve lasting professional status was teaching. Emily Sartain followed in the tradition of the Sartain family and became principal of the Philadelphia School of Design for Women (now Moore College of Art). Cecilia Beaux taught in New York and Philadelphia. Louise Jordan Smith established the art department and collection at Randolph-Macon Woman's College in Virginia. Teaching gave one professional status and economic security, as well as increased public exposure.

Some women, such as Lilla Cabot Perry, actively participated in artists' associations, which helped them to maintain their professional status. While Perry, unlike Cassatt or Beaux, did not reach a level of sales that would support herself and her family, she did sell works regularly. Her recognition as an artist was increased by exhibitions in Boston and other parts of the country and by her dedication to the smooth running of such societies as the Guild of Boston Artists. She was a founding member and first secretary of the guild, which included other

successful Boston artists, such as Edmund Tarbell and Frank Benson.

The various strategies for success followed by American women artists at the turn of the century show an awareness of the workings of the professional art field. They differ very little from the approaches used by their male colleagues, except in the numbers of exhibitions that resulted and in the comparative degrees of success achieved. For men and women, reaching the peak of their accomplishments and recognition depended on a great deal of good fortune and an inborn will to overcome all obstacles. Women artists such as Mary Cassatt, who felt she was born with a "passion for line and color,"[27] and Lilla Cabot Perry, who remembered from her youth having "a longing to paint,"[28] knew they were on an inevitable course through life. This drive may have set them apart from the masses of other women who soon dropped by the wayside, overwhelmed by the demands made on them to lead another kind of life. Women artists found, just as their male counterparts did, that temperament could be a determining factor, and that "if a young painter be not fierce and arrogant God should help him to be so."[29]

Notes

1. See Linda Nochlin, "Why Have There Been No Great Women Artists?" and "Ten Replies" in *Art and Sexual Politics,* Thomas B. Hess and Elizabeth C. Baker, eds. (New York: Collier Books, 1973).

2. Ambroise Vollard, *Degas* (Paris: F. Cres, 1924), 71, as quoted in Roy McMullen, *Degas* (London: Secker & Warburg, 1985), 264.

3. Sybil Vincent, "In The Studio of Professor Henry Tonks," *Studio* 112 (1937): 86, as cited in Hilary Taylor, "'If a Young Painter be not Fierce and Arrogant, God . . . Help Him': Some Women Art Students at the Slade, c. 1895–9," *Art History,* 9, no. 2 (June 1986): 234.

4. Edith Wharton, *A Backward Glance,* 1933 (New York: Scribner, 1964), 56.

5. "The Street of the Hyacinth" was first published in *Century* 2 (May, June 1882); "At the Château of Corinne" was first published in *Harper's* 75 (Oct. 1887). Both have been reprinted in Constance Fenimore Woolson, *Women Artists, Women Exiles: "Miss Grief" and Other Stories,* Joan Myers Weimer, ed. (New Brunswick, N.J.: Rutgers Univ. Press, 1988). I am grateful to Tamar Heller, Assistant Professor of English, Williams College, for bringing these and Louisa May Alcott's *Diana and Persis* to my attention.

6. Joan Myers Weimer, for example, believes regarding "At the Château of Corinne" that, "[the] overblown rhetoric Woolson assigns Ford is a clear sign of her disapproval of his stereotypical masculinity, while the space she gives his violent opinions indicates her belief that such opinions were a very serious obstacle to women writers." Introduction, Woolson, *Women Artists, Women Exiles,* xxxvii.

7. Eliza Haldeman to Alice [?] Haldeman, May 13, 1868, cited in Nancy Mowll Mathews, *Cassatt and Her Circle: Selected Letters* (New York: Abbeville, 1984), 56.

8. See Trevor J. Fairbrother, "Painting in Boston, 1870–1930," in *The Bostonians: Painters of an Elegant Age, 1870–1930,* exhibition catalogue (Boston: Museum of Fine Arts, 1986), 43.

9. Lois Marie Fink, "Elizabeth Nourse: Painting the Motif of Humanity," in *Elizabeth Nourse (1859–1938): A Salon Career,* exhibition catalogue by Mary Alice Heekin Burke (Washington, D.C.: Smithsonian Institution Press, 1983), 89.

10. For more about educational opportunities in Paris, see Fink, "Elizabeth Nourse," 91.

11. Eliza Haldeman to her mother, September 5, 1867: "The difference between Americans and French is that the former work for money and the latter for fame and then the public appreciates things so much here." Mathews, *Cassatt: Selected Letters,* 46.

12. Cecilia Beaux, *Background with Figures* (Boston and New York:

Houghton Mifflin, 1930), 122.

13. Fink, "Elizabeth Nourse," 93.

14. Fink, 93. The author points out that a weak drawing by Elizabeth Nourse was evidence that Nourse could have used more rigorous instruction rather than being told "she was so competent she had no further need of continuing at the Académie."

15. May Alcott to Anna Alcott (October 1876) as quoted in Caroline Ticknor, *May Alcott: A Memoir* (Boston: Little, Brown, 1928), 139–40.

16. Beaux, *Background with Figures,* 124.

17. Beaux, 127–28.

18. Woolson, *Women Artists, Women Exiles,* 183.

19. Fairbrother, "Painting in Boston," 43.

20. Wharton, *Backward Glance,* 48, 51.

21. Another was Elizabeth Gardner, follower and then wife of William Bouguereau.

22. In 1874, after being on her own for four years, Cassatt took classes with Thomas Couture at Villiers-le-Bel. In Louisa May Alcott's *Diana and Persis,* the Cassatt figure, Miss Cassal, is said by Percy (May Alcott) to come "to our studio to draw when we have a fine model." The novel is based on letters to Louisa about May Alcott's lessons with Krüg. See *Alternative Alcott,* Elaine Showalter, ed. (New Brunswick, N.J.: Rutgers Univ. Press, 1988), 400.

23. Cassatt's longtime fellow-expatriate, Elizabeth Gardner, was Palmer's first choice, however. Gardner declined the invitation. See Madeleine Fidell-Beaufort, "Elizabeth Jane Gardner Bouguereau: A Parisian Artist from New Hampshire," *Archives of American Art Journal* 24–25 (1984–85): 8.

24. For a discussion of Cassatt'a mastery of drawing, see Mathews, "The Color Prints in the Context of Mary Cassatt's Art," in *Mary Cassatt: The Color Prints* by Nancy Mathews and B. Shapiro (New York: Abrams, 1987), 22.

25. Sara Hallowell to Bertha Palmer, February 6 [1894], in Mathews, *Cassatt: Selected Letters,* 254.

26. Elizabeth Gardner helped Americans obtain paintings by Corot, Gérome, and Bouguereau. See Fidell-Beaufort, "Elizabeth Jane Gardner Bouguereau," 4. Cassatt is well known for helping Americans obtain works by the French Impressionists.

27. Mary Cassatt to Bertha Palmer, October 11, [1892], in Mathews, *Cassatt: Selected Letters,* 238.

28. Lilla Cabot Perry memoirs, Perry Family Archives.

29. Alfred Thornton, *The Diary of an Art Student of the Nineties* (London: Sir I. Pitnam & Sons, 1938), 3, as quoted in Taylor, "'If a Young Painter be not Fierce,'" 243.

Reminiscences of Claude Monet
From 1889 to 1909
Lilla Cabot Perry

As Monet refused to take pupils and almost never granted interviews, Perry's article from 1927 reproduced here provides a rare insight into the work of "the world's greatest landscape artist," in her words. Perry's initial observations, published in 1894, when her memories were far more fresh in her mind, have received much less attention. For this reason, large extracts from this early text are included among the present annotations. They offer additional valuable information and confirm that after her second summer in Giverny (1891), Perry had already established a close friendship with Monet.

The museum is particularly grateful to both The American Federation of Arts and The Copley Society of Boston (formerly the Boston Art Students' Association) for their kind authorization to reproduce these texts.

* * *

Monet is dead![1] How well I remember meeting him when we first went to Giverny in the summer of 1889! A talented young American sculptor told my husband and me that he had a letter of introduction to the painter, Claude Monet. He felt shy at going alone and implored us to go with him, which we were enchanted to do, having seen that very spring the great Monet-Rodin exhibition which had been a revelation to others besides myself.[2] I had been greatly impressed by this (to me) new painter whose work had a clearness of vision and a fidelity to nature such as I had never seen before. The man himself, with his rugged honesty, his disarming frankness, his warm and sensitive nature, was fully as impressive as his pictures, and from this first visit dates a friendship which led us to spend ten summers at Giverny.[3] For some seasons, indeed, we had the house and garden next to his, and he would sometimes stroll in and smoke his after-luncheon cigarette in our garden before beginning on his afternoon work.[4] He was not then appreciated as he deserved to be, in fact that first summer I wrote to several friends and relatives in America to tell them that here was a very great artist only just beginning to be known, whose

First printed in *The American Magazine of Art* 18, no. 3 (March 1927). Reprinted by permission of The American Federation of Arts.

Fig. 25. Monet's second studio, 1906. Photograph by Margaret Perry. Daniel Wildenstein has emphasized the historic importance of this photograph, which documents Monet's painting of the main *allée* to his house, a work the artist later destroyed.

pictures could be bought from his studio in Giverny for the sum of $500. I was a student in the Paris studios at that time and had shown at the Salon for the first time that spring, so it was natural that my judgement should have been distrusted.[5] Only one person responded and for him I bought a picture of Etretat. Monet said he had to do something to the sky before delivering it as the clouds did not quite suit him, and, characteristically, to do this he must needs go down to Etretat and wait for a day with as near as possible the same sky and atmosphere, so it was some little time before I could take possession of the picture.[6] When I brought it home that

autumn of 1889 (I think it was the first Monet ever seen in Boston), to my great astonishment hardly any one liked it, the one exception being John La Farge.[7]

This intense artistic conscientiousness was one of Monet's most marked traits.[8] About 1906 I took a friend to his studio,[9] she was much taken with a certain picture and tried hard to buy it, but he said he could not sell it until the series was finished as he did not feel sure it was up to his standard. A year or two later he dropped in one afternoon and casually mentioned that he had burnt up over thirty canvases that morning. I asked him whether Mrs. Blank's picture was among those destroyed and he admitted that it was. "I must look after my artistic reputation while I can," he said, "Once I am dead no one will destroy any of my paintings, no matter how poor they may be."[10]

His opinion of his own work was not, however, always calmly judicial. On one occasion, particularly disgusted at his own inadequacy, he decided to give up painting altogether. He was painting from his boat at the time, so overboard flew the forevermore useless paint box, palette, brushes and so forth into the peaceful waters of the little Epte. Needless to say, the night brought counsel and the following morning he arose, full of enthusiasm, but without any painting materials! It was, of course, a Sunday (such things always take place on Sundays), but a telegram to Paris sent a sympathetic color man flying to his shop and a complete kit left by the next train for Normandy where a reconverted painter awaited its arrival with savage impatience.

There were two pictures on the wall of his studio which I particularly liked. They were of his step-daughter in a white dress, a green veil floating in the breeze under a sunshade, on the brow of a hill against the sky.[11] He told me that an eminent critic called them the Ascension and the Assumption! Seeing me looking at them one day with keen admiration, he took one down off the wall and showed me a tremendous criss-cross went right through the center of the canvas, but so skilfully [sic] mended that nothing showed on the right side. I exclaimed with horror, and asked what on earth had happened to it. With a twinkle, he told me that one afternoon he had felt thoroughly dissatisfied with his efforts and had expressed his feelings by putting his foot through the canvas. As he happened to have on sabots, the result was painfully evident at the time.

Monet was a man of his own opinions, though he always let you have yours and liked you all the better for being outspoken about them. He used to tell me that my forte was "plein air," figures out-of-doors[12] and once in urging me to paint more boldly he said to me: "Remember that every leaf on the tree is as important as the features of your model. I should like just for once to see you put her mouth under one eye instead of under her nose!"

"If I did that, no one would ever look at anything else in the picture!"

He laughed heartily and said:

"Vous avez peut-être raison, Madame!"[13]

In spite of his intense nature and at times rather severe aspect, he was inexpressibly kind to many a struggling young painter. He never took any pupils,[14] but he would have made a most inspiring master if he had been willing to teach. I remember his once saying to me:

"When you go out to paint, try to forget what objects you have before you, a tree, a house, a field or whatever.[15] Merely think, here is a little square of blue, here an oblong of pink, here a streak of yellow, and paint it just as it looks to you, the exact color and shape, until it gives your own naive impression of the scene before you."[16]

He said he wished he had been born blind and then had suddenly gained his sight so that he could have begun to paint in this way without knowing what the objects were that he saw before him. He held that the first real look at the *motif* was likely to be the truest and most unprejudiced one,[17] and said that the first painting should cover as much of the canvas as possible, no matter how roughly, so as to determine at the outset the tonality of the whole.[18] As an illustration of this, he brought out a canvas on which he had painted only once; it was covered with strokes about an inch apart and a quarter of an inch thick, out to the very edge of the canvas. Then he took out another on which he had painted twice, the strokes were nearer together and the subject began to emerge more clearly.[19]

Monet's philosophy of painting was to paint what you really see, not what you think you ought to see; not the object isolated as in a test tube, but the object enveloped in sunlight and atmosphere, with the blue dome of Heaven reflected in the shadows.[20]

He said that people reproached him for not finishing his pictures more, but that he carried them as far as he could and stopped only when he found he was not longer strengthening the picture. A few years later he painted his "Island in the Seine" series. They were painted from a boat, many of them before dawn, which gave them a certain Corot-like effect, Corot having been fond of painting at that hour. As he was showing them to me, I remarked

on his having carried them further than may of his pictures, whereupon he referred to this conversation and said again that he always carried them as far as he could. This was an easier subject and simpler lighting than usual, he said, therefore he had been able to carry them further. This series and the "Peupliers" [Poplar] series[21] also were painted from a broad-bottomed boat fitted up with grooves to hold a number of canvases. He told me that in one of his "Peupliers" the effect lasted only seven minutes, or until the sunlight left a certain leaf, when he took out the next canvas and worked on that. He always insisted on the great importance of a painter noticing when the effect changed, so as to get a true impression of a certain aspect of nature and not a composite picture, as too many paintings were and are. He admitted that it was difficult to stop in time because one got carried away, and then added:

"J'ai cette force-là, c'est la seule force que j'ai!" And that from the greatest landscape painter in the world! I give his exact words, they show his beautiful modesty, as great as his genius.

One day he referred to the many criticisms of his work, comparing it to worsted work and so forth, on account of his dragging the color on to the canvas with the long flexible brushes he had made to order for his own use.[22] He said he was sure some of Rembrandt's pictures had been painted even more thickly and heavily than any of his, but that time with its levelling touch had smoothed them down. In illustrating this, he took out of one of the grooved boxes in which he kept his pictures a view of the Rouen Cathedral that had been kept in the box practically ever since it had been painted and put beside it one that had been hanging on the wall of his studio for some two or three years. The difference between the two was very marked, the one which had been exposed to the air and to the constant changes of temperature had so smoothed down in that short space of time that it made the other one with all its rugosities look like one of those embossed maps of Switzerland that are such a delight to children.

He said he had never really seen these Rouen Cathedral pictures until he brought them back to his studio in Giverny as he had painted them from the window of a milliner's shop opposite the cathedral.[23] Just as he got well started on the series, the milliner complained bitterly that her clients did not care to try on their hats with a man about, and that he must go elsewhere to paint, since his presence interfered with her trade. Monet was not to be daunted, he persuaded her to let him build a little enclosure shutting him off from the shop, a small cell in which he could never get more than a yard away from his canvas. I exclaimed at the difficulty of painting under such conditions, but he said that every young painter should train himself to sit near his canvas and learn how it would look at a distance, and that with time and practice this could be done.[24] Monet had already had experience of this sort in painting on sixteen or more canvases one after the other for a few minutes at a time from his small boat on the Epte. Later on, in his water garden pictures he made good use of this same power. He had grooved boxes filled with canvases placed at various points in the garden where there was barely room for him to sit as he recorded the fleeting changes of the light on his water-lilies and arched bridges. He often said that no painter could paint more than one half hour on any outdoor effect and keep the picture true to nature, and remarked that in this respect he practiced what he preached.

Once and once only I saw him paint indoors. I had come to his studio and, finding him at work, was for going away at once, but he insisted on my coming in and sitting on the studio sofa while he went on painting. He had posed his step-daughter, a beautiful young girl in her 'teens, in a lilac muslin dress, sitting at a small table on which she rested one of her elbows. In a vase in front of her was one life size sunflower, and she was painted full length but not quite life size as she was a little behind the sunflower.[25] I was struck by the fact that this indoor picture was so much lower in key, so much darker than his out-door figures or than most studio portraits and thought of this some years later when he paid the usual penalty of success by having many imitators. One day as he came back from a visit to the Champ de Mars Salon I asked him how he liked the outbreak of pallid interiors painted in melted butter and spinach tones for which he was indirectly responsible. As he sat there with his hands upon his knees I shall never forget the impetuous gesture with which he clasped his hands to his head and growled despairingly: "Madame, des fois j'ai envie de peintre [sic] noir!"[26]

My husband and I were much interested in the reminiscences of his early struggles. He told us that his people were "dans le commerce" at [Le] Havre and when, a boy in his 'teens, he wished to become a painter, they opposed him vigorously in the approved traditional manner. He went through some very hard times. He painted portrait heads of sea captains in one sitting for five francs a head and also made and sold caricatures.

Boudin saw one of these caricatures in a small shop, sought his acquaintance and invited him to go out painting with him. At first Monet did not appreciate this unsought privilege and went reluctantly, but, after watching Boudin at work and seeing how closely his landscapes resembled nature, he was only too glad to learn all he could from the older man. There are still some early Monets extant which plainly show Boudin's influence. Even after he had painted many landscapes that were purely in his own style, the young Monet had the utmost difficulty in selling them at the modest price of fifty francs apiece.[27]

Faure, the singer, who was by way of being a collector, bought a landscape about this time for, I believe, the sum of one hundred francs, but brought it back a few days later and asked for his money back. He said he liked the picture himself, but his friends laughed at him so much that he could not keep it on his walls. Monet said he then and there made up his mind never to sell that picture, and he never did, though often offered large sums for it by rich Americans and others. He told me he had "la mort dans l'âme" when that picture was brought back and that he would sell the last shirt off his back before he would sell it! When we left Giverny in 1909, it was still hanging on the walls of this studio, a charming view of the Church at Vétheuil, seen across the Seine on a misty winter's day with cakes of snowy ice floating in the water. It is called "Les Glaçons," and is a most exquisite and exact portrayal of nature. One can only wonder why Monsieur Faure's friends laughed at it, and laugh at them in return.

Monet was most appreciative of the work of his contemporaries, several of whom had been less successful than he in obtaining recognition during their lifetime. In his bedroom, a large room over the studio, he had quite a gallery of works of such Impressionists as Renoir, Camille Pissarro, a most expressive picture of three peasant women done during his *pointilliste* period, a charming hillside with little houses on it by Cézanne, about whom Monet had many interesting things to say. There was also a delightful picture by Berthe Morisot, the one woman of his set I have heard him praise. And richly she deserved it! I met her only once, at Miss Cassatt's,[28] she was a most beautiful white-haired old lady. She died shortly afterward and Monet and Pissarro worked like beavers hanging her posthumous exhibition at Durand-Ruel's.[29] It was a wonderful exhibition, and I think that the picture Monet owned was bought at this show. Monet was a most devoted friend to dear old Pissarro, whom no one could help loving,[30] and after his death he acquired another of his pictures which was kept in the studio and shown and praised to all visitors.

Monet was one of the early admirers of Japanese prints, many of which decorated his dining room walls. The walls were painted a light yellow which showed up the prints' delicate tonality admirably and also the blue china which was the only other decoration in the room. It was a charming room with long windows opening on the garden, windows left open at mealtimes to permit countless sparrows to come in and pick up a friendly crumb. He pointed out to me one little fellow that had lost a leg and had come for three years in succession.

This serious, intense man had a most beautiful tenderness and love for children, birds and flowers, and this warmth of nature showed in his wonderful, warm smile, a smile no friend of his can ever forget. His fondness for flowers amounted to a passion, and when he was not painting, much of his time was spent working in his garden. One autumn we were at Giverny I remember there was much interest in a new greenhouse. The heating must have been on a new plan, for when the plants were all in place and the heater first lit, Monet decided he must watch it throughout the night, to be sure everything went smoothly. Once his mind was made up there was little hope of moving him, so Madame Monet speedily acquiesced, and made her own plans for sharing his vigil. When the daughters heard of this there were loud outcries. What! Let their parents sit up all night with no one to look after them? Unheard of neglect! It ended by the entire family spending the night with the gloxinias. Fortunately, the heater was impeccably efficient so the adventure did not have to be repeated.[31]

When I first knew Monet, and for some years later he used a wheelbarrow to carry about his numerous canvases. Later on he had two beautiful motor cars to take him about, but that is not the measure of his achievement, nor is it to be measured by the fact that he lived to see the French government build proper housing under his directions for his latest pictures. His real success lies in his having opened the eyes not merely of France but of the whole world to the real aspect of nature and having led them along the path of beauty and truth and light.

Notes

1. Details of Monet's death were communicated to the Perrys in a letter from Theodore Butler, Giverny, December 10, 1926 (TSP, Colby).

2. Until further evidence surfaces, the identity of the "shy, young and talented American sculptor" who first accompanied the Perrys to Giverny in June 1889 remains an enigma. Neither Frederick MacMonnies nor George Grey Barnard, another very talented American sculptor living in France — see Colin Simpson, *Artful Partners: Bernard Berenson and Joseph Duveen* (New York: MacMillan, 1986), 142 — qualify as possible "go-betweens," since they both were extroverts. David Sellin has suggested Edward A. Stewartson of Philadelphia, the only American sculptor registered at the Hôtel Baudy that summer. See David Sellin, *Americans in Brittany and Normandy, 1860-1910*, exhibition catalogue (Phoenix, Ariz.: Phoenix Art Museum, 1982).

3. Perry forgot that the summer of 1908 was spent in eastern Europe, so, in fact, the Perrys only resided nine summers in Giverny — 1889, 1891, 1894-1897, 1906, 1907 and 1909.

4. From 1894 to 1897 the Perrys rented Le Hameau, two small houses next door to Monet.

5. After her first success at the Paris Salon in May 1889, Perry studied with Alfred Stevens for a brief period of time.

6. The one person who responded favorably was Thomas Perry's brother-in-law, William Pepper of Philadelphia, who commissioned "another masterpiece" by Monet (in Pepper's words) in 1891. Daniel Wildenstein, however, seriously questions whether Monet ever returned to Etretat during the summer of 1889, even for a very short visit. See Daniel Wildenstein, *Claude Monet, Biographie et catalogue raisonné* (Paris and Lausanne: La Bibliothèque des Arts, 1974) vol. 3: 24, 25. Perry herself painted an expressionistic view of Etretat — one of her rare seascapes — which, unfortunately, we were unable to locate for this exhibition. See catalogue for Sotheby Park Bernet's Los Angeles auction, March 12, 1979 (no. 164, *Cliffs at Etretat*).

7. Perry was not aware that three paintings by Monet were exhibited in 1883 at the Massachusetts Manufacturers' and Mechanics' Institute in Boston for the "Foreign exhibition" organized by Paul Durand-Ruel, because she was bedridden at that time. Thomas Perry noted in January 1890 that Sargent "admired the Monet" at their Boston residence. Hamlin Garland confirms in his memoirs that paintings by Breck and Monet stirred up great interest among Perry's artist and literary friends in Boston in the fall of 1889. See Hamlin Garland, *Roadside Meetings* (New York: MacMillan, 1930).

8. See LCP, Copley, 6. "I have known him to wait weeks with a picture that he was offered a large sum to finish, in order that he might get the right condition. Indeed, I have known him to leave some pictures entirely unfinished because trees had been cut down, or changes had been made, so that he was too conscientious to finish them. But I think some of these unfinished ones are as interesting as anything he has done."

9. Perry refers here to the famous Boston patron of the arts Isabella Stewart Gardner. The memorable meeting between Mrs. Gardner and Monet took place in Giverny during the second week of November 1906. Perry's niece Eleanor Cabot Bradley described the actual circumstances surrounding the event in her private memoirs, *Stories from My Life* (1988): "Mrs. Jack Gardner wrote Aunt Lilla a letter saying, 'My dear Lilla, I am in Paris for two weeks, and I do want to come and spend the day with you if I can. Tell me which day is appropriate.' Aunt Lilla went to Uncle Tom and said, 'She doesn't want to see me at all. She wants me to take her to Monet's studio which I know Monet doesn't want. What shall I do?' Uncle Tom said, 'You've always said you'd like to take a bicycle trip to Brittany. Let's do that.' So she wrote back to Mrs. Gardner that she was sorry, but they were leaving on a two-week bicycle trip. They were hardly inside the door on their return when they found another letter from Mrs. Gardner saying that she was staying on in Paris, and she did still hope to come and see them. Aunt Lilla took the letter to Monet who groaned and said, 'Well, my friend Pissarro is in trouble. If he can't sell more paintings he will have to be milked by Durand-Ruel.' (I believe that meant [Durand-] Ruel would take all Pissarro's output in exchange for a lifetime annuity.) 'I'll see if I can't sell some of his paintings for him.' So after lunch Aunt Lilla brought Mrs. Gardner to Monet's studio. There was a graciousness between the two, but Mrs. Gardner never bought a single Pissarro. . . ." Thomas Perry referred to the event in a letter to his friend John Morse on November 15, 1906: "Saturday before we left [Giverny] Mrs. Gardner came down, not so much for *nos beaux yeux*, but for those of Monet whom we took her to see" (See John T. Morse, *Thomas Sergeant Perry: A Memoir*, [Boston: Houghton Mifflin Co., 1929], 68). Isabella Gardner possibly alludes to the occasion in a letter to Bernard Berenson, also dated November 15, 1906: "Here I see collections and try and buy underclothes" (Isabella Stewart Gardner to Bernard Berenson, Berenson Archive, I Tatti).

10. See Thomas Sergeant Perry to Mrs. Meteyard, May 18, 1908. (TSP, Colby). "I am in a great state of mind over the news that Monet has destroyed all his nenuphar [water lily] pictures They were immensely interesting failures in the oddness of the perspective in lying just under the nose, etc., problems that will have to be attacked. He was very uncertain about them & would let none go from his studio."

11. Perry refers to Monet's two views of Suzanne Hoschedé — *Essai de figure en plein air (Femme à l'ombrelle)* — at the Musée d'Orsay, Paris. Theodore Robinson shared her admiration. "How they belong to the landscape in which they breathe and move! . . . To my mind no one has yet painted out-of-doors quite so truly." See Theodore Robinson, "Claude Monet," *Century* 44 (September 1892): 698.

12. Lilla Cabot Perry to Bernard Berenson, August 23, 1929 (LCP,

I Tatti): "Monet . . . said was my forte *Pleine* [*sic*] *Air and Paysage*" (editor's italics).

13. See LCP, Copley, 8. "[Monet] thinks that an eye or a nose is of no more importance than a leaf on a tree. I think, however, that, constituted as we are, we should be more troubled by an eye or nose out of place than by a misplaced leaf. We do not know always where the leaf should be, but we do know where the eye or nose belongs."[!]

14. See LCP, Copley, 6. "Monet never gives any lessons; he never takes any pupils. That he thinks is very bad. He thinks nobody should ever take a lesson." Monet allegedly also told John Breck, "Come down with me to Giverny and spend a few months. I won't give you lessons, but we'll wander about the fields and woods and paint together." See Kathryn Corbin, "John Leslie Breck, American Impressionist," *Antiques* 134 (November 1988): 1142–49.

15. See LCP, Copley, 5, 6. "Try not to think that you know the grass is green, that the road is red, or white, or gray; ask yourself not what is the local color, but rather what does it now appear to me to be. Something, perhaps, quite different if I were in some different light."

16. See LCP, Copley, 5, 6 and 7. "Monet paints in pure color. I do not mean that the color does not often cross; he does not often make composite mixtures on his palette, but his colors are superposed and cross each other on his canvas. . . . He would like to sit down with a palette set with three or four colors. He uses some bright yellow, blue, green and one or two different lakes [laques] and sometimes a little vermilion. . . . *Question.* What kind of yellow does he like? *Answer.* He tells me that he thinks there is not any good kind of yellow. He says that cadmium has been praised as the best; he thinks it is the worst. . . . *Question.* What lakes does he like? *Answer. La que rose* and *la que foncie* [*sic*]. . . . He makes all his paintings by [a] combination of blue, red, yellow, and green."

17. See LCP, Copley, 5. "[Monet] says when you first come to a thing, your eye is more capable of receiving a fresh impression. He said to me once that he hardly ever sat down to paint a picture that he did not wish that he could be as *naif* as if he had never seen it before, as if he had been blind, and his eyes had first opened on the object; that he should like to give the impression made upon his retina. That is what he means when he says he is an impressionist. He would like to give the impression without regard to his previous knowledge of the object, and represent its appearance in clear color. Color is merely the name we give to impressions made upon the retina. Color could not exist except for sight." In Japan John La Farge expressed similar sentiments in 1886: "I wished to take off my modern armor, and lie at rest, and look at these pictures of the simplicity of attitude in which [we] were once children." See John La Farge, *An Artist's Letters from Japan,* 1897. Reprint (New York: Kennedy Graphics, 1970), 110.

18. See LCP, Copley, 5, 6. [Monet] showed me a canvas on which he has painted once. It had touches all over it made with a long hair brush. . . . He will probably start in and give touches here and there, equally distributed all over the canvas. . . . He maintains that you must not paint one portion at a time, but must run over the whole picture; everything is relative, nothing can exist in color excepting as it is relative to every other color."

19. See LCP, Copley, 6, 7. "People say that [Monet] paints rapidly. So he does. But he paints an enormous number of times, always under the same conditions of time of day, weather, etc. . . . He takes a long-hair brush and then sweeps his color on with it."

20. See LCP, Copley, 3, 4. "When you look at an object you see the local color, but you also see what is between you and the object, that is the atmosphere. Atmosphere is what we see when we see the sky on a clear day. . . . Now there are many classes of "impressionists." Some men are so impressed by the envelope that they can see nothing but an envelope, almost no color. . . . In Pissarro's work there is very little color. . . . The thing that is most noticed in impressionist work is its shadows. People say they make purple shadows. But what color they really do consider shadow color is rather the reflected color of the sky [that] is composed not merely of one color but of three colors. Even blue is not entirely blue. It is partly yellow, partly pink."

21. Trees being a favorite theme with Perry, she was particularly fond of this series and, in 1894, purchased from Monet a variation — *Paysage de printemps,* exhibited at the Durand-Ruel gallery, Paris, 1895, *Exposition de tableaux de Claude Monet,* no. 39. The Eastman Chase Art Gallery in Boston acquired this work in 1897.

22. See LCP, Copley, 7. [Monet's] hair brushes are made expressly for him. Sometimes he uses a long, round bristle brush."

23. Monet actually painted the Rouen cathedral series from three different sites. See Wildenstein, *Claude Monet,* vol. 3, 44.

24. See LCP, Copley, 5. "In the first place [Monet] has a faculty which we all wish we had. He can sit down with his nose to the canvas, and can see almost how his paintings are going to look."

25. Perry refers to Monet's melancholic *Portrait de Suzanne [Hoschedé] aux soleils.* See Wildenstein, *Claude Monet,* vol. 3, 136. Note that this portrait was painted either in 1889 or, more probably, in 1891, but not 1890, because Perry was absent from Giverny that summer.

26. See LCP, Copley, 8. "I think that Monet has suffered from his copyists, who often paint very crudely."

27. See Margaret Perry's diary, June 1895 (Margaret Perry Papers, Colby): "Rouen We lunched at the Hôtel du Dauphin d'Espagne. In the dining room there were a great many pictures by Monet, Pissarro, Cézanne, etc. There were some in the bureau & the woman was so much pleased by our evident admiration that she took us upstairs & showed us some more. They had some very fine Renoirs there, too." (Note added in Lilla Cabot Perry's handwriting, "Monet sold these pictures at 50 francs apiece he told me.")

28. Thomas Sergeant Perry to H. W. Fay, September 14, 1895 (TSP, Houghton): "Yes [Miss Cassatt] is the greatest of living American painters. Monet has some of her pictures in his room with some Manets, etc." Perry totally shared her husband's admiration for Cassatt. A pastel copy by Perry of Cassatt's portrait of a little girl with a bonnet was exhibited in 1982 at the Santa Fe East Gallery. See Alma S. King, *Five American Women Impressionists,* exhibition catalogue (Santa Fe: Santa Fe East Gallery, 1982).

29. It was Degas and not Pissarro who arranged with Monet for the Morisot memorial exhibition in March 1896. See Julie Manet, *Journal, 1893-1899* (Paris: C. Klincksieck, 1979), 77–93.

30. Perry viewed Monet and Pissarro's relationship through rose-tinted lenses. Her husband, who was on more intimate terms with Monet, however, was well aware of the "coolness" at times between the two artists. For Pissarro's sentiments, see John Rewald, *Camille Pissarro: Letters to His Son, Lucien,* Lionel Abel, trans. (New York:

Pantheon, 1943).

31. In Perry's original draft for "Reminiscences" she added here: "Monet was an unusually well-read man, in fact he was a shining example of the way the appreciation of beauty in one art permeates a man's whole being & makes him sensitive to all forms of beauty. The last summer we were at Giverny, the Monets came to hear a very talented young violinist who was staying with us." Perry refers to her close friend, the musician Nina Fletcher, whose portrait she later painted. See also Margaret Perry interview, Museum of Fine Arts, Boston, October 31, 1966, with notes by Thomas N. Maytham (Perry, BMFA): "Once the Monets came to the Perrys' house in [Giverny] to hear young Miss Nina Fletcher of Worcester, one of a chain of people of talent in need who customarily stayed with the Perrys — sometimes for months, sometimes for years! — give a recitation of the violin. Monet was delighted primarily by the two Bach sonatas, not the more agreeable lighter fare that filled the middle portion of the program."

Family Recollections of Lilla Cabot Perry
Lilla Levitt, Anita English and Elizabeth (Elsie) Lyon

Lilla Cabot Perry's three granddaughters — Lilla, Anita and Elsie — knew this talented, and often formidable, woman from the unique perspective of family members, models for her art and, in one case, as apprentice artist. The memories of their beloved "Bonnemaman" which they have shared below speak of her temperament, philosophy and something of the techniques she employed in her art.

Understandably, the greatest public interest in our grandmother derives from her friendship with Claude Monet. During the late 19th and early 20th centuries Lilla and Tom Perry spent many summers in Giverny with their three daughters, Margaret, Edith and Alice. Their youngest daughter, Alice, was our mother.

Giverny — what charm and beauty that name implies. The enchanting village, the tiny river Epte, the tapestry quality of lilac and iris in full bloom were some of the features which attracted many artists to Giverny. Monet always said that he would take no pupils, but there was a close relationship between him and our grandmother. One summer, when the Perrys were able to rent the house next door to his, he often would step into their garden for his post-prandial cigarette. He gave Lilla advice that helped her considerably, until one day he suggested that she paint the mouth under one eye. "Why should it always be under the nose?" he inquired. "Well, if I did what you said, no one would look at the portrait as a whole. Their eyes would be riveted to the face!" was her rejoinder. Perhaps Monet was foreseeing Picasso's whims, but Lilla was a straightforward Impressionist and somewhat more conservative in her approach.

Monet also told her there was no such color as pure white or pure black, and that neither color should appear on a canvas. "It is a combination of colors that makes black or white. Paint what you see — a bit of color here, a dot there." They often put these tenets to the test when painting together outdoors.

In the middle of those years in Giverny, our grandparents spent three years living as a family in Japan. When our grandfather was offered the teaching job at Keio [Keiogijuku] University in Tokyo in 1898 with a three-year contract, our grandmother was a very good

Fig. 26. Lilla Cabot Perry and granddaughter Lilla Grew [Levitt], Hancock, N.H., *ca.* 1917. The inscription on back reads: "the two Lillas."

sport. It meant uprooting her three daughters from their Boston schools, and introducing them to a very different culture and way of living.

The only drawback to the trip to Japan was that our grandmother had discovered that she was a terrible sailor. Calling the Asian ocean Pacific is frequently a misnomer, as it can be exceedingly rough at times. From the moment she got on the boat until the minute she landed she was utterly miserable. Our grandmother described her disagreeable experience to us as having felt like a monkey being swung by its tail the entire time.

55. *Boy Fishing*
1929
Oil on canvas, 40 × 30 in.
White House Collection
Gift of Mrs. Cecil B. Lyon, Mrs. Albert Levitt and
Mrs. Anita English
(Not included in exhibition)

The years in Japan were a rewarding period for them all, and Bonnemaman did some of her best painting there. The countryside appealed to her very much. We granddaughters now all have examples of her Japanese paintings, and are constantly reminded of the beauty that surrounded her there.

When our father, Joseph C. Grew, became ambassador to Japan in 1931, Bonnemaman was consoled by the fact that at least our absence would allow us to experience a land she loved. When our parents arrived in Japan, mother looked up the Perrys' former maid, Tsune, whom Bonnemaman had painted. So great was her joy at seeing "Alice-chan" again that it brought tears to the eyes of this highly composed Japanese woman.

Soon after their return from Japan, the Perrys bought a farm in Hancock, New Hampshire, and our happiest memories are of time we spent there with our grandparents. The old Tuttle farm, which our grandparents named Flagstones, was located on what had been the old "King's Highway" to Montreal. It was a comfortable, big, white house with a screened porch running around the front and along the side. It had a large, welcoming living room with a fireplace and furniture covered in a pretty golden yellow.

Whether in her bedroom in Boston or in her small sitting room or in the living room in Hancock, she always had a cozy, comfortable chair by the fireplace. There was always a fire, of course, in the winter and even on a rainy or cool day in summer. She extended warmth and welcome to everyone. One always had the feeling that she had plenty of time to share, giving her full attention and a listening ear. When guests arrived they must have felt wonderfully welcome, for there was no doubting the sincerity of their reception. She was a true friend, and one can see from the letters she received how many people she helped in many ways, financially or otherwise. She had the faculty of being on the same level as others, regardless of age, and had a great gift with people. Nevertheless, although blessed with a good sense of humor, she did not have what could be called a cheerful outlook on life. Despite this trace of melancholy, however, she demonstrated great courage in everything she undertook, and one can but admire her tenacity.

Often grandparents give more of themselves to their grandchildren than they do to their children. They are more relaxed with them and have more time to enjoy them. Elsie remembers posing in the Hancock studio when she was only four years old. The grey cat Rover was in her arms and she was being entertained by her adored grandfather, Thomas Sergeant Perry, known as "Bonpapa." He adored his wife, and was happy to help her with her painting. He also tolerated his grandchildren quite happily.

When we posed for our grandmother she would sing to us or recite poetry, but mostly she would tell us special stories. She had the wonderful gift of being able to talk as she painted, and we loved all the anecdotes about her life. She also had a way of helping to awaken an arm or leg that had gone to sleep from being in one position too long — she would get onto her knees and squeeze the arm or leg with both hands until it was comfortable again. She had such a sweet understanding of a child's need.

Monet said that Bonnemaman's forte was portraits out of doors, although she claimed it was much harder to paint en plein air — the light was hard to catch and reproduce on canvas. Also the weather did not always cooperate. Many of her winter landscapes were painted from the car, where she could work well wrapped up in rugs with hot water bottles tucked around. Once she had visualized a picture in her mind's eye, no hurdle appeared insurmountable in the realization of it. Even in the warmer seasons a landscape meant carrying everything — canvas, easel, palette, paints — out from the studio each day, and this endless procession had to be repeated every day until the painting was completed. Through the years it was most often her daughter, our Aunt Marg, who made these taxing expeditions a reality.

Bonnemaman was very emotional, and her words were always tinged with color. One was swept up in a tidal wave of emotion. Our mother was a pretty emotional person, too, and when Bonnemaman got going on an emotional spree, our mother would be left quite limp. Our grandmother would be in fine form, however — all the excess of feeling taken care of — like the atmosphere after a thunderstorm.

If difficult in some ways, when it came to ego she was the most modest of artists. She realized, we are sure, that although she had to put in the hard work, often under very difficult circumstances complicated by health and weather, there was the satisfaction of heeding an inner power that kept her going as a prolific painter. She believed that her artistic gifts came from a higher source to which she was attuned. Like many Boston Brahmins of her time, Bonnemaman believed in spiritualism and sometimes visited a well-known Boston medium, Mrs. Piper.

We only knew her in her later years, of course, but she had told us much about her life. Torn between her love of writing poetry and of painting, she realized that

she had to decide to which talent she should dedicate her time and energy. After the birth of Margaret, the first of her three children, she had two miscarriages and had to spend much of her time lying on her back. During this period, perhaps inexplicably, she decided she would dedicate herself to painting.

Her poetry was never completely abandoned, however. She was a poor sleeper, and often worked on her poetry while others slept and the house was quiet. There were four published volumes of her poetry, including *Garden of Hellas* which she translated from the Greek original.

The poet Edwin Arlington Robinson valued her criticism of his poetry highly, and would regularly bring his work to her. How well we remember his coming to stay at the Perrys' beloved home in Hancock. They would have long sessions together that were not to be interrupted. They were devoted friends and, when our Bonpapa died, Robinson helped edit a book of his letters, going to infinite trouble to get it right.

How sad a reflection it is that artists are rarely fully recognized during their lifetime! Among the many letters of our grandmother's found in the attic was one which she had written from New York to her husband when she and Margaret had gone there to try to find a gallery that would accept her paintings. In her letter she was pretty discouraged but was preparing to return to Boston — mission unaccomplished. We wish she could have had the feeling of security in her lifetime that would have come from having her paintings given the high value they deserve and seeing them in many private and museum collections.

Elsie's husband, Cecil Lyon, was assigned to our Embassy in Paris in 1958. One weekend they drove out to Giverny, where Germaine Salerou Hoschédé, Monet's stepdaughter, reportedly still lived. After much fruitless questioning they eventually stood before the gate of "Les Pinsons." There, a little old lady was sitting in her garden. "Ma grand-mère était Lilla Cabot Perry," Elsie began. The gate was flung open and she was embraced with warmth by Germaine. It didn't take long to become good friends. In frequent trips to Giverny Elsie met good friends of Germaine's. She also was able to go into Monet's house and the wilderness that had been his lovingly tended garden. Now, of course, the house and garden have been beautifully restored, and crowds flock to see them. *Alice in the Lane,* Bonnemaman's painting of our mother, hangs in Monet's bedroom. A letter from Alice as a girl tells of a weekend in which she had been invited to stay with the Monets. As the great man was away, she had been put in his room and slept in his bed. Bonnemaman brought hollyhock seeds back to Hancock from Giverny, and they have continued to bloom there for many summers since that time.

In the living quarters of the Reagan White House there hung a Perry picture, *Boy Fishing,* donated by us. It shows a lad of fourteen by the railing of a bridge, dangling his rod in the stream below. Cecil Lyon had the idea of contacting the "lad," Robert Richardson, now seventy-three, and photographing him at the spot in which the picture had been painted. White-bearded Robert brought a concocted fishing pole like the one he had used before, showing us exactly where Bonnemaman had sat to paint and recounting amusing sidelights on the posing. He was paid fifteen cents a day. Our Aunt Marg stood holding an umbrella over the artist while she painted. Richardson was not allowed to bait his hook, lest a fish bite and make the line wiggle! At one point he had his hair cut, infuriating our grandmother, who said she would have to wait until it grew out to finish the painting.

Our adored grandfather died in Boston in May 1928. He had had pneumonia, and slipped away, just when the doctor had said he was better and would pull through. Bonnemaman was desperate. It took a while, but she eventually returned to her painting.

The many challenges which her later life brought to her may have strengthened her and brought out the poetry and wonderful gift of insight demonstrated in her painting. An easy life, apparently, is not so conducive to great art. In considering the legacy she has left us we can only say, "Bravo, Lilla! You had courage!"

At the time of her death in Hancock, Bonnemaman had started a large landscape of Mount Crotched in the snow. She was waiting for a fresh fall of snow to finish it. Then, in the night, came the snowfall! She was eager to get out of bed and paint, but the condition of her heart prompted her doctor to forbid it. She became extremely upset at his orders. The next day her heart stopped . . . very peacefully.

An aspiring artist, Lilla, the eldest of the three grand-daughters, received much counsel from her grandmother. She recounts below some of the insights gleaned.

In her indoor portraits Bonnemaman used earth colors, but for landscape she chose more ethereal paints. She

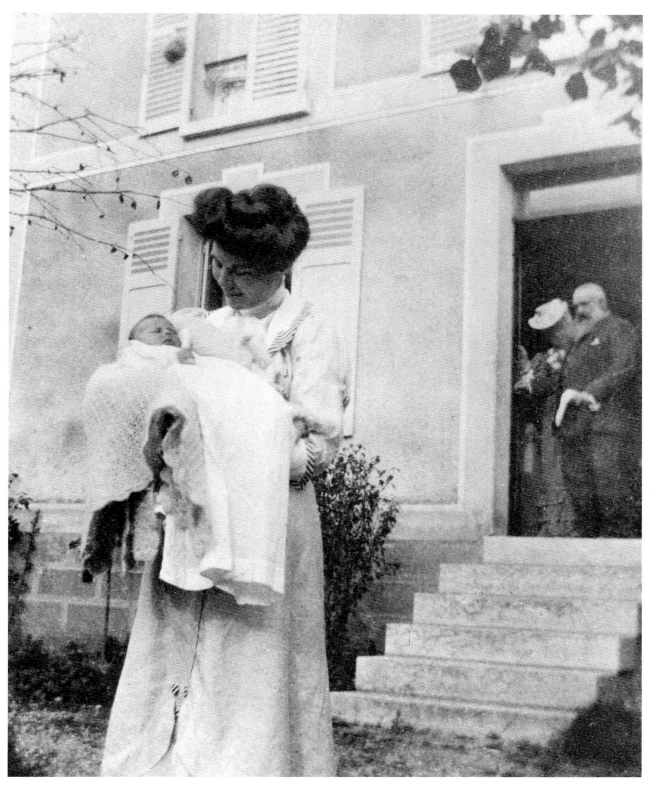

Fig. 27. Alice Perry Grew holding Anita Grew in front of Villa des Pinsons, 1909. The Monets are in the doorway of the house.

never used black. She taught me about the juxtaposition of opposite colors in nature — glimpses of earth in a green mass look pink or rose; a wholly pink subject has green wherever the pink separates, etc. Indeed, she made me find opposite colors for myself by staring at a color hard and then at a white ceiling. Opposite colors are nature's way, she explained, of resting the eyes from too much of one color. She said I should paint what I saw without mentally defining it so as not to paint it in its local color but to allow for changes brought about by the atmosphere or by the reflection of color from surrounding objects or from the sun.

Bonnemaman taught me how to paint a blue sky so that it actually looked like sky, not a blue wall. Where sky met earth she used viridian and white on one brush and alizarin crimson and white on another, with occasionally a little yellow and white on a third brush used close to the horizon. These separate puddles of paint on her palette had to be of the exact same value. She would play them onto the canvas, keeping each brush clean by wiping it on a rag she held with her palette. Her skies were always vibrant and stayed back where they belonged in the picture. When painting a mountain against the sky she used a fine brush to outline the mountain in alizarin crimson. Within the line she painted first the sky and then the mountain. The joining looked just right.

Bonnemaman had observed that sun flecks on the ground are round. Once when I took her to observe a solar eclipse, she was thrilled to note that the sun flecks on the ground became crescent shaped, thus confirming her observation.

Lilla Cabot Perry
Memoirs and Correspondence

"Art . . . is an appeal to what is better . . . it is an appeal to the permanent reality in the presence of the transient."

> — John La Farge, *An Artist's Letters from Japan*

"I hope to die in harness "

> — L. C. Perry letter to Bernard Berenson

Lilla Cabot Perry — The Artist

Perry's memoirs and letters to and from friends offer vivid insights into her artistic career. Her recollections of the Académie Colarossi represent a rare, detailed description of the school by an American artist.

L. C. Perry memoirs, Paris, January 1888 (Perry Papers, Colby)

Jan. 9th [I] began to paint for the first time in a Paris atelier. Went to Colarossi's at 8:30 a.m. A very pretty girl model posed till 12. I took her life size down to waist on a no. 2 canvas. Did nothing but draw her this day. Began to paint latter part of Monday morning, Jan. 10. Jan. 11 Joseph Blanc came to criticise. My first criticism in Paris. J. B. is a very short, fat common looking little man of about 40. I should say [he] is said to be [a] very good, strong teacher. He said, "plus de fermeté ici et ici," [more firmness here and here] (touching the corner of the mouth and nose). "La tête n'est pas trop mal. Elle a son caractère." [The head isn't too bad. It shows character.]

On Friday Courtois [Gustave Courtois] came to criticise. They told me beforehand that he never was known to praise, and was very severe, (although he does not do as strong work as Dagnan or Blanc) [Perry refers here to Pascal Dagnan-Bouveret]. He was a big English looking man with bad manners. He said the cheek was too red, and the neck too yellow, and the shoulders too low. I was discouraged by him. Not by what he said but because he does not seem to take the slightest interest in the work of any of the students, and his criticism seemed to me very careless — mere snap shots.

For instance when he said my shoulders were too low, the model was entirely out of pose and her shoulders were at least 3 inches higher than when I painted her. They cut her chin instead of her neck. I changed the color a little bit, but did not alter the shoulders, as I thought he was wrong. I asked him if he did not think it would be better for me to draw a little, instead of painting. He said it might be better for the present when the days are short . . . and take up painting again when the light was better.

So Monday Jan. 16 I began drawing. We had a thin man model. I sat right underneath him and he was proud with his head thrown back. I had a very difficult view of his head. At first, I thought I could not do it, as I had never done before a head in that position. I took him life size down to his waist. I worked like a <u>dog</u> and had the satisfaction of offering a well drawn head to Blanc on Wednesday, but I had not touched the shoulders, and hastily sketched [him] down to the waist, while [Blanc] was criticising the other drawings. He said, "La tête est très resemblante, elle a son caractère, mais les epaules ne sont pas si bons [*sic*]" [The head is true to life and shows character, but the shoulders are not as good]. He then asked me if I had measured the position of the right nipple, as he wasn't sure it was in the right place. I said I had not, and he told me very severely that I should <u>always</u> measure. He then spent some minutes in measuring it very carefully up and down, right and left, and in a slant from the Adam's apple, only to find that it was in the right place. Whereupon he looked up at me and remarked, "Vous avez eu de la chance!" [You were lucky!] The girl behind giggled! Did he really suppose it was only by luck that I put it where I did? I wonder if he would have answered, "bad luck," [as] sufficient excuse, if I had put it in the wrong place. I like him, though, much better than Courtois, for he really looks carefully at your drawing before criticising it and seems to take a little interest. I asked him if the head was "bien construite" [well done], or whether it needed alteration. He said it was all right in every respect, and if I did the shoulders as well, I should do very well.

When Courtois came Friday, I had done the shoulders with great care, but he told me they were too wide for the head. I measured them carefully after he was gone.

. . . I was very glad to get your letter of August 25th [from Tokyo] which arrived a week ago while I was at Amsterdam. I went to town and ordered the colors and canvases as nearly as I could from your description. . . . They will be sent to you from Meadows & Co., Rue Scribe [Paris], the canvases rolled, of course, and the colors in a tin box. It is better to pay expressage at your end of the journey. . . .

I ordered six tubes <u>verte emeraude</u> (Lefranc), six <u>laque rose</u> (Lefranc), and six tubes <u>laque foncé</u> (Edouard). I ordered the latter Edouard, as the Lefranc's <u>laque foncé</u> is apt to turn fatty. The Edouard's colors are a good deal more expensive, of course, but it would be no use to have Lefranc, if they arrived unfit for use.

For canvases, I ordered six meters of a canvas a trifle coarser than the example you sent. It is of a kind used by decorators to cover large wall spaces and seemed very good. As to the canvas such as Alexander uses, it is nothing but gunny sacking, and is not sold by the color merchants. I got someone to get some for you at another kind of shop, — six meters, and wide enough to stretch over [a] number 25 chassis. . . . It costs very little. I can't tell you how little until I hear from the person who got it. Alexander told me he prepared it by first stretching it on a chassis, and then giving it a thin coat of common glue, while the latter is in a melted state. . . .

[Gay's description of the Rembrandt exhibition in Holland follows]. There never has been or ever will be perhaps such an exhibition of Rembrandt again . . . there was something almost religious in the impression that those pictures gave, something quite beyond <u>this</u> world.

Yours very sincerely, Walter Gay

L. C. Perry to Bernard Berenson, Flagstones, Hancock, N.H., August 23, 1929 (LCP, I Tatti)

Dear Berenson!

. . . I learned as Tom did, during the last years of his life, to love to stay up here in Hancock long into the winter and to realise [*sic*] that the country is never so beautiful or the mountains so grand as in the late autumn with but few leaves on the sugar maples and those a glory of gold and red silhouetted against the pine trees or the blue mountains. . . . I have grown to like staying here two thirds of the year, and only seeing young people who like

coming up for winter coasting skiing for weekends or holidays, and though I cannot walk much except on the piazza, I have taught myself to paint sitting, and painted many "snow-scapes" sitting in a Sedan surrounded by hot water bottles to keep the paint on my palette as well as myself from freezing stiff when the cold was below freezing, and generally below zero Fahrenheit as the weather, with snow 4 feet deep on the level with drifts 5 feet deep, is not balmy here where our house is 1200 feet about sea level, 1/4 way up Mt. Skatutakee and with fine views of Monadnock and other mountains.

I like best to paint the snow at sunset, or when the snow and trees and mountains are bathed in a pink glow, with deep blue shadows after sunset though I must confess that when I get home in the Sedan when it is dark except for moon or stars I am as stiff and cramped that I have to be helped into the house. . . .

Yours in aft'nate [affectionate] remembrance
L. C. Perry

Lilla Cabot Perry — An Artist Who Helped Others

"[Perry] has always had fine sympathy for the artists in their struggles," wrote A. J. Philpot in his *Boston Globe* review of her exhibition at the Guild of Boston Artists in 1917. "She could understand their sensitiveness, and her words and acts of encouragement have been factors in the growth and success of not a few painters." Philpot also stressed the indebtedness felt by many other artists for Perry's assistance and compassion. Edmund Tarbell reiterated Philpot's comments in his own memorial tribute to Perry in 1933, pointing out that "her desire to aid other people" was equally as strong as her enthusiasm for her own work.

Art historians today tend to focus their attention primarily on Perry's proselytizing on behalf of Monet. The following excerpts, however, confirm how deeply concerned both Lilla Cabot Perry and her husband were with the struggles of many other artists.

Philip Hale to L. C. Perry, locality not given, December 7, 1891 (LCP, Colby)

My dear Mrs. Perry,

I permit myself the suspicion that I owe something to your kindness (as well as to your husband's remarkable perception) in the matter of my luck with the willow picture. Anyway, I congratulate myself at having it in such good hands: and hope you'll make the "Crowned Heads"

of Boston look at it when they're calling on you. If you don't mind, I think I shall wait till I get back to Paris (about three weeks, I fancy) before having it sent, as I shall be more sure that it's done up all right. . . . Pray remember me most kindly to Mr. Perry — and to the three smiling ones, and believe me

Most truly, Philip Hale

Through her friendship with Tarbell and Frank Benson, Perry arranged a teaching position for Hale at the Museum School in Boston in 1893. Hale was, again, deeply grateful.

Philip Hale to L.C. Perry, Giverny, June 1, 1893 (LCP, Colby)

Dear Mrs. Perry,

I can't tell you half how good and kind you seem to me to have been, in looking after my prospect so vigorously. It's impossible to thank you enough: so I must ask you to take a lot on credit. Of course I shall accept: that is when I get the formal offer which has not yet arrived. As you say, it will be pleasant working under two such clever men as Tarbell and Benson. Tarbell was one of my teachers at the Museum. Since then I have not seen him. Benson, I only know by reputation. I had meant to come home anyway this winter and make a try for it: so your kind offices have got me this chance just in the nick of time. You can't imagine what it is to have *something* sure — the last three years have given me enough of the hand o' mouth game.

Since I'm talking so much about myself, you may be glad to know that I had 5 pictures received at the New Salon [Société Nationale des Beaux-Arts, Champ de Mars] and pretty well hung — two on the line [eye level], etc. Good luck one sees — like misfortunes — never comes singly.

I suppose you have seen or heard from the Watsons [Dawson Watson, the American artist, and his wife] who left the other day. They were full of your praises and I didn't wonder, when I heard how many pictures you had helped them to sell. . . . I thank you again for your kindness—how can I enough? And am

Yours most sincerely, Philip Hale

Although Perry's assistance to Theodore Robinson has already been discussed in the catalogue essay, the following except from a very moving letter written two years before his death adds a poignant note to the friendship that developed between these two artists.

Theodore Robinson to L. C. Perry, New York, February 12, 1894 (Perry Archives)

Dear Mrs. Perry:

. . . I met and dined with Mad. Blanc some time ago, who spoke of her pleasant visit in Boston, and of course of meeting you. A friend brought her to my studio, and she liked some of my last summer's work — was interested in the difference between my French and American landscape and thought I had got very well our clear American atmosphere. It will take more than one summer to get "in it," but I am sure there is a great chance to do something *new* and characteristic, with a charm of its own tho' quite unlike that of the French landscape. . . . We are all very poor, and pray for better times — one or two sales seem to point that way a little. With best regards to Mr. Perry and your girls

Very sincerely yours, Th. Robinson

Perry's friendship with Camille Pissarro was brief, blossoming during her third stay in France between 1894 and 1897. As she remarked to her cousin—the poet Amy Lowell—in 1904, however, after the artist's death, "I shall miss him dreadfully when I go back to Paris." Such thoughts were related in particular to the small tea Perry gave in Paris in 1895 to introduce Pissarro to her wealthy collector friend from Boston, Quincy Shaw. John La Farge also was present at the gathering, along with a select group of other artists, art patrons and friends. Monet fully expected to attend but declined at the last moment. Mary Cassatt sent her sincere regrets.

Mary Cassatt to L. C. Perry, Paris, late April 1895 (LCP, Colby)

My Dear Mrs. Perry

Your most kind offer to give up your sitting to me is very tempting but I prefer waiting a little & looking into the matter further before seeing Mrs. Pufis[?]. . . . Will you be so good as to forgive me if I beg you to excuse me

from availing myself of your kind invitation for Wednesday?

I would be so much better able to enjoy the artists when I am rested. Thinking out new portraits is work that occupies all one's energies.

I shall have the pleasure of calling on you in a few days.

Very sincerely yours, Mary Cassatt

In spite of the two notable absences from the tea, the occasion, as Perry's husband remarked with his usual humor, was "the great social event by the side of which the vernissages, the Grand Prix are as nothing." He provided a detailed description of the event to a Boston friend.

Thomas Sergeant Perry to Hercules Warren Fay, Paris, May 1, 1895 (TSP, Houghton)

Dear Fay,

. . . The afternoon approaches teatime. John La Farge is now probably arranging to go off to the country to return about 5:30 with a gentle annoyance that everybody didn't wait & see him. I have written to him, — as if that were any good — & to Bancel [La Farge's son] to ask him to make the effort of his life & bring the Old Man in good season. . . . 6:45 . . . and there were present Quincy Shaw & daughter, Mrs. Agassiz, Alexander, Zorns [Anders Zorn, a well-known Swedish artist, and his wife] Pissarro (who is to breakfast here Friday with John La Farge), H. [Humphrey] Johnston & his sister, Mrs. J. [Jackson], J. [John] Howells [son of William Dean Howells], Miss [Sarah Tyson] Hallowell [a noted American patron], — I think that is all. I won't say all, except Pissarro, were pulling wires, because probably he was, too . . . tho' . . . this may not be true. J. L. F. [La Farge], contrary to my expectations, appeared at 3:30, thereby annulling all my claims to the powers of prophesy, but his pictures, which he wanted to show to Quincy Shaw, didn't come till 5 when Q. S. had been gone half an hour, —the delay had been an unavoidable one. . . . Miss Hallowell is a sort of agent of millionaires of the west for buying pictures. She is the sort of woman who, on leaving you, says, "I think I am beginning to know you, Mr. Perry, or whatever your name may be." . . . Pissarro is sweeter than honey from the honey comb. . . .

Yours ever, T. S. Perry

Theodore Butler was another member of the American colony at Giverny, along with Hale, Robinson and John Breck. The Perrys encouraged Butler and developed a particularly warm friendship with him.

Theodore Butler to T. S. Perry, New York, July 17, 1915 (TSP, Colby)

My dear Perry,

. . . Thanks for your good letter and its enclosed offering which Marthe [Butler's wife] has forwarded to its destination. No bad news from France, but I do wish . . . that some of the promised orders might come to me. I am sorry that you have already so many pictures, as otherwise I should endeavor to sell you some for I am in such dire need of funds, and stranded as it were, in a foreign land. [From 1913 to 1921 Butler resided in America, mainly New York. The rest of his years he lived in Giverny.] But I must hope and hope and endeavor to be cheerful. . . .With love to all

Yours, Theodore E. Butler

Theodore Butler to T. S. Perry, New York, July 23, 1915 (Perry archives, Colby College)

My dear Perry,

Your very welcome letter was received today with check safely enclosed and quite as welcome as your good messages. . . . I do think that hope must be an element, the same as fire or water, air—at least it is quite indispensable. We are all delighted that you should take a picture — struggling artists are to you and Mrs. Perry as water to the fish, a joy as well as a necessity. Most people must think you crazy. That picture of mine which may meet your approval is already yours and I hope that not much more time may elapse before we may see you. . . .

Gratefully and sincerely, Theodore E. Butler

If Perry was directly responsible for Hale's teaching position at the Museum School, her role in Frederick Bosley's nomination as Director of the Museum of Fine Arts, Boston, after Tarbell resigned in 1912 has yet to be

Fig. 28. *Portrait of Edwin Arlington Robinson*
1916
Oil on canvas, 40 × 30 in.
Special Collections, Colby College, Waterville, Maine
Gift of Margaret Perry

Robinson valued Perry's opinion of his work and often brought his poetry to Flagstones, the Perrys' home in Hancock, N.H., for her to critique.

clarified. She was, however, one of Bosley's most faithful allies after the bitter museum dispute that prompted Tarbell's departure. Bosley's admiration for both Perrys is evoked in the intimate letter which follows, announcing his initial attempts at poetry.

Frederick A. Bosley to L. C. Perry, Lincoln, Massachusetts, October 22, 1916 (LCP, Colby)

Dear Mrs. Perry,

I am taking the liberty of asking you and Mr. Perry to read the enclosed verses, which are a part of the great many I have written, both this summer in Los Angeles, and since I returned to Lincoln [Mass.]. Never having done this sort of thing before and knowing little about its technique, these poor things [are] rather writing themselves, in some unaccountable way than being the result of real labour. I would like to have you who do know much more about poetry, read these, and tell me if there be any merit in them, and if there be, whether they are, or anyone is, good enough to send to a reputable magazine for publication, which however is not at all the reason for their being written, which reason was my own pleasure, for I find it indeed a pleasure to attempt some expression of my thoughts, and so exercise my mind in an attempt at something beautiful. I have enjoyed your poetry so much, and feel you both have such a true sympathy for all things, that I hesitate the less in inflicting these upon you, than my self-consciousness would permit with others.

I hope that you are in better health this autumn, Mrs. Perry, than was the case this summer, and that I may have the pleasure of seeing you in Boston this winter, where you are, as everyone so truly says, the enthusiastic spirit of us all. . . . With best regards from Mrs. Bosley, I am

Most sincerely yours, Frederick A. Bosley

In an entirely different tone, Robert Vonnoh paid tribute to his former pupil.

Robert Vonnoh to L. C. Perry, New York, November 11, 1921 (LCP, Colby)

Dear Mrs. Perry —

. . . You certainly ought to come to the Reception on Friday & also the private view in the afternoon. I would

then be able perhaps to have a little chat with you, — you ought to do this for my sake as I feel quite proud of the hanging which was enthusiastically endorsed by the jury. . . . Also I want you to lend your great influence and support [for] the League of NY Artists. . . . We want champions like yourself who did so much for the Guild of Boston Artists & make it a success. . . .

Sincerely yours, Robert Vonnoh

Although she herself was eighty-three and handicapped by painful arthritis, Perry sent "a beautiful letter" to Philip Hale's widow, the artist Lilian Westcott Hale, on the occasion of her husband's memorial exhibition in 1931. Perry's letter prompted the following warm response.

Lilian Hale to L. C. Perry, Dedham, Massachusetts, November 30, 1931 (LCP, Colby)

Dear Mrs. Perry,

You were most kind to write me and express your wish to see Philip's exhibition. How I do wish you could have! It is beautiful beyond description and even to people who knew his work pretty well it has been a startling revelation of his power.

I do hope you are gaining strength so that when you do come to Boston you will have good health once more.

I have a beautiful letter of yours among a great unanswered group. If I should tell you how many times I have attempted to answer it unsuccessfully it would seem unbelievable and I would be foolish. But I know all the time your understanding sees that the immediate past is still too living & poignant for words written or said.

There has been much work to do and it has been a joy & comfort that it has been something like a continuation of his work. The remembrance of the exhibition will be a lasting happiness not only to me but to so many who loved him. It is a very strange thing how close his spirit has seemed (though not in the occult sense) in those galleries.

Thank you dear Mrs. Perry for all you have written me in spite of the arthritis in both your wrists!

Affectionately yours, Lilian Hale

A final tribute to Perry as a woman and friend is

Fig. 29. *Portrait of Lilla Cabot Perry*
Frederick Bosley (1881–1942)
1931
Oil on canvas, 31 1/4 × 25 in.
Collection A. Everette James and family

found in excerpts from letters from two authors who were also very dear friends.

Henry James to L. C. Perry, Lamb House, Rye, Sussex, January 3, 1912 (Virginia Harlow, *Thomas Sergeant Perry: A Biography*, 334-36)

My dear Lilla,

I have a gentle letter from you too long unacknowledged — but one of these days, long hence, when you begin to approach my dilapidated time of life (so vividly illustrated in my handwriting) you will understand the senile condition that cries, not to say whines, for indulgence at every step. . . . All of which doesn't mean, my dear Lilla, that I don't revert in fond memory to your green & gold salon, with which such associations of tea & toast & talk when the bleakness raged & the bland prospect glared without so fondly connect me. I hope the rites go on bravely & regularly in that temple of harmony & sympathy, & that the faithful & the ministrants are once more all alike happy at their posts. I think of Thomas as the high-priest, Margaret & Edith as the grand orchestra or heavenly choir, & dear Mrs. [Helen Choate] Bell as the passionate congregation. You'll ask me where *you* then come in — & I think I reply that you don't come in at all, since you have never gone out, but are simply *there* as the supporting lap & embracing arms, the whole thing richly springing from you & gratefully returning again unto you. . . .

Believe me yours all & always, Henry James

Edwin Arlington Robinson to Margaret Perry, New York, March 1, 1933 (Perry Archives)

Dear Miss Perry,

It was a great shock and surprise to me to read this morning of your mother's sudden death. It was only a short time ago that I received what appeared to be a rather eventful letter from her, and I was confidently expecting to see her again this summer as in summers past. I knew of course that she was feeble, but I had no thought of her going so soon. There is perhaps no need of my trying to tell you that you have my deepest sympathy, for you know that — as you know how much her friendship has meant to me for so many years. I don't believe that any woman ever lived who had a kinder heart — and a more thoroughly generous nature. In fact she was really too kind and too generous for her own happiness, sometimes; and that is a fault with which few of us are afflicted. She had more to bear in her later years than anyone should have to bear, and in saying this I am not forgetting you, your sense of loss will be very great, but you will hardly, for her sake, wish her back; for . . . far away, I feel somehow . . . it came as she had wished it might.

I shall think of her as long as I live as a very dear friend, and I like to believe that she knew my thoughts of her while she was living.

Yours most sincerely, E. A. Robinson

Appendixes

Abbreviations for frequently cited sources:

Harlow, TSP — Virginia Harlow, *Thomas Sergeant Perry: A Biography* (Durham, N.C.: Duke University Press, 1950)

LCP, BA — Lilla Cabot Perry Papers, Library of the Boston Athenaeum

LCP, Colby — Lilla Cabot Perry Papers, Special Collections, Colby College Library, Waterville, Maine

LCP, Copley — Lilla Cabot Perry, "Informal Talk Given by Mrs. T. S. Perry to the Boston Art Students' Association in the Life Class Room at the Museum of Fine Arts, Wednesday, January 20, 1894," (Boston: Boston Art Students' Association [subsequently The Copley Society of Boston], 1894)

LCP, H & A — Lilla Cabot Perry Papers, Hirschl & Adler Galleries, New York

LCP, I Tatti — Lilla Cabot Perry correspondence with Bernard Berenson, Berenson Archive, Villa I Tatti, The Harvard Center for Italian Renaissance Studies, Florence, Italy

LCP, Remsc. — Lilla Cabot Perry, "Reminiscences of Claude Monet from 1889 to 1909," *The American Magazine of Art*, 18, no. 3 (March 1927)

Perry Archives — Perry Family Archives, private collection

Perry, BMFA — Perry Papers, Library of the Museum of Fine Arts, Boston (includes correspondence concerning Lilla Cabot Perry, Margaret Perry and Thomas Sergeant Perry)

TSP, Colby — Thomas Sergeant Perry Papers, Special Collections, Colby College Library, Waterville, Maine

TSP, Houghton — Thomas Sergeant Perry correspondence (particularly with Hercules Warren Fay), as well as annotations and letters from Lilla Cabot Perry, The Houghton Library, Harvard University, Cambridge, Mass. — MS Am., 1865, Boxes 1-4

TSP, I Tatti — Thomas Sergeant Perry correspondence with Bernard Berenson, Berenson Archive, Villa I Tatti, The Harvard Center for Italian Renaissance Studies, Florence, Italy

Exhibition Checklist

NOTE: Unless otherwise indicated, works have been exhibited under title provided.

1. *Portrait of an Infant* [Margaret Perry] Fig. 3
 ca. 1877–78
 Oil on canvas, 8 × 7 1/2 in.
 Collection James M. B. Holsaert

Documentation: Judging by Margaret Perry's birth date, November 13, 1876, this portrait, one of Perry's earliest oil works, was probably painted in late 1877 or early 1878, when Perry was thirty. Serious health problems after Margaret's birth kept Perry bedridden for months at a time, which explains in part why she applied herself more to poetry and translation than to painting in the late 1870s and early 1880s. She certainly did other portraits, however (her husband posed on several occasions, for example), which showed enough promise to merit the encouragement of her first instructor, Alfred Quentin Collins, in 1884.

Provenance: the artist; to Miss Margaret Perry by inheritance; to Miss Patricia Holsaert by gift; to Mr. James M. B. Holsaert by inheritance.

Exhibited: No prior exhibitions.

2. *The Beginner* [Margaret Perry] Pl. 1
 ca. 1885–86
 Oil on canvas, mounted on masonite, 22 1/8 × 18 1/8 in.
 Collection the University of Arizona Museum of Art, Tucson
 Gift of James Holsaert

Documentation: This portrait was probably painted during the winter of 1885–86, when Margaret Perry first started violin lessons: "Margaret flourishes and works enthusiastically at her violin. She will make a good player, I hope, eventually. Her teacher says her progress is remarkable and her ear unusually accurate" (L. C. Perry to Mrs. Leonard Opdycke, January 24, 1886 — Special Collections, Colby College Library, Waterville, Maine).

Provenance: Mrs. Charles Almy; to Miss Margaret Perry; to Miss Patricia Holsaert by gift; to Mr. James M. B. Holsaert by inheritance; to the University of Arizona Museum of Art by gift.

Exhibited: Boston Art Club, 1933, *A Memorial Exhibition of Paintings by Lilla Cabot Perry,* no. 18 (lent by Mrs. Charles Almy), Olin Library, Wesleyan University, Middletown, Conn., 1937, no. 28.

References: Peter Birmingham, *Paintings and Sculpture in the Permanent Collection* (Tucson: The University of Arizona Museum of Art, 1983).

3. *The Red Tunic* [Edith Perry]
 1888
 Oil on canvas, 15 × 18 in.
 Signed and dated (lower right), "L. C. Perry, Paris '88"
 Collection Donald R. Korst, M.D., and Candace W. Lovely

Inscription (on back of canvas): "Paris, 1888."

Provenance: artist's family; to Alfred Walker; to Dr. Donald R. Korst.

Exhibited: Boston Athenaeum, Boston, 1982, *Lilla Cabot Perry: Paintings,* no. 16; Guild of Boston Artists, 1989, *The Founders Show.*

Note: A similar portrait of Edith with a book, which Perry completed at about the same time as this work, was exhibited in Paris at the Salon de la Société des Artistes Français in 1889. See Lisa M. Ward, "Lilla Cabot Perry and the Emergence of the Professional Woman Artist," Master's thesis, University of Texas, Austin, 1985.

4. *Portrait of Thomas Sergeant Perry* Pl. 2
1889
Oil on canvas: 32 × 25 1/2 in.
Signed and dated (upper right), "L C Perry, Paris, '89"
Collection Mrs. Lilla Cabot Levitt

Provenance: artist's family.

Exhibited: Palais des Champs Elysées, Paris, 1889, Salon de la Société des Artistes Français, no. 6595; St. Botolph Club, Boston, 1890, group show, no. 45 (as *Portrait of a Gentleman*); Milton Public Library, Milton, Mass., 1920, *An Exhibition of Paintings by Lilla Cabot Perry*, no. 18 (as *Portrait of T. S. Perry*); Boston Art Club, Boston, 1933, *A Memorial Exhibition of Paintings by Lilla Cabot Perry*, no. 41; Olin Library, Wesleyan University, Middletown, Conn., 1937, solo exhibition, no. 7 (as *Portrait of Thomas Sergeant Perry*).

Note: Perry's notes indicate that this portrait also was exhibited at the Society of American Artists in New York and at the Pennsylvania Academy of the Fine Arts in Philadelphia.

References: *Boston Evening Transcript,* December 30, 1890: "Lilla C. Perry's portrait of a gentleman reading a book is a very accomplished and interesting work."

5. *La Petite Angèle, II* Pl. 3
1889
Oil on canvas, 25 × 30 in.
Signed (lower left), "Lilla Cabot Perry"
Private collection

Note: not to be confused with *Petite Angèle, I,* which is signed and dated on the upper right: "Lilla C. Perry, Giverny '89."

Documentation: One of two almost identical works both painted the same summer at Giverny.

Provenance: the artist's estate; to Hirschl & Adler Galleries, New York; to private collection.

Exhibited: Fourteenth Exhibition of the Society of American Artists, New York, 1892, no. 166 (*Petite Angèle, I*); Massachusetts Charitable Mechanics' Association, Boston, 1893, *Massachusetts Fine Art Exhibit,* no. 109 (*Petite Angèle, I*); World's Columbian Exposition, Chicago, 1893, Fine Arts, USA, no. 819 (*Little Angèle*); St. Botolph Club, 1897, *An Exhibition of Paintings by Mrs. T. S. Perry,* no. 13 (*Petite Angèle, I*); Guild of Boston Artists, 1924, *An Exhibition of Paintings by Lilla Cabot Perry* (*Petite Angèle, I*); John Castano Galleries, Boston, 1952, *Oil Paintings by Lilla Cabot Perry* (*Petite Angèle, I*); Currier Gallery of Art, Manchester, N.H., Hirschl & Adler Galleries, New York, and the New Jersey State Museum, Trenton, N.J., 1969, *Lilla Cabot Perry: A Retrospective Exhibition* (hereon for this reference: Hirschl & Adler, New York, 1969), no. 4 (*Petite Angèle, I*); Boston Athenaeum, Boston, 1982, *Lilla Cabot Perry: Paintings,* no. 5 (*La Petite Angèle, II*); The Dixon Gallery and Gardens, Memphis, Tenn., Terra Museum of American Art, Evanston, Ill., and Worcester Art Museum, Worcester, Mass., 1982–83, *An International Episode: Millet, Monet and Their North American Counterparts* (hereon for this reference: Dixon Gallery, Memphis, Tenn., 1982), no. 56 (*La Petite Angèle, I*).

Note: Perry's own exhibition references indicate that, prior to 1892, *La Petite Angèle, I* was exhibited in group shows at the Boston Art Club and Museum of Fine Arts, Boston (the latter venue being confirmed in Hirschl & Adler's press clipping files).

References: *Boston Evening Transcript,* November 11, 1897.
 Ann Sutherland Harris and Linda Nochlin, *Women Artists, 1550–1950,* exhibition catalogue (New York: Knopf, 1976).
 Patricia Hills, "Lilla Cabot Perry and American Impressionism." Unpublished typescript for Boston Athenaeum lecture, March 10, 1982.
 Laura L. Meixner, *An International Episode: Millet, Monet and Their North American Counterparts,* exhibition catalogue (Memphis, Tenn.: Dixon Gallery, 1982).

6. *The Letter* [Alice Perry] Pl. 5
1893 [?]
Oil on canvas, 23 1/2 × 20 in.
Signed and dated (upper left), "LILLA CABOT PERRY, 1893"
Private collection

Provenance: artist's family.

Exhibited: The Pennsylvania Academy of Fine Arts, Philadelphia, 1893, group show.

Note: We believe this portrait was painted about 1890, and then postdated 1893, at the time of the group show at the

Pennsylvania Academy of the Fine Arts. Perry's notes indicate that *The Letter* also was exhibited in a group show at the Society of American Artists in New York *ca.* the 1890s (Perry Family Archives).

7. *Margaret with a Bonnet* [Margaret Perry] Pl. 4
 ca. 1890
 Oil on canvas, 16 × 13 in.
 Collection Mr. and Mrs. T. Gordon Hutchinson

Provenance: artist's family.

Exhibited: Previous exhibitions, if any, unknown.

8. *Study of Light and Reflection* [Edith Perry] Pl. 7
 1890
 Oil on canvas, 28 1/2 × 22 in.
 Signed (lower right), "LILLA CABOT PERRY"
 Private collection

Inscription (by Margaret Perry, on back of canvas): "Edith Perry at the W. E. C. Eustis house [Milton, Mass.], where we spent two or three summers in the early nineties. It was nearer Chestnut Run than their massive stone house. They wanted us there so that their daughter, Mary E., had playmates of her own sex & approximate age. The E[ustises] hoped that Mary might absorb French."

Provenance: artist's family.

Exhibited: Thirteenth Exhibition of the Society of American Artists, New York, 1891, no. 170 (as *Child in Window — Study of Light and Reflection*); Museum of Fine Arts, Boston, 1891, selections from Society of American Artists group show in New York); Massachusetts Charitable Mechanics' Association, Boston, 1893, *Massachusetts Fine Art Exhibit,* no. 112 (as *Reflection*); World's Columbian Exposition, Chicago, 1893, Fine Arts, USA, no. 820 (as *Reflection*); Pennsylvania Academy of Fine Arts, Philadelphia, 1893–94, 63rd annual group show.

9. *Landscape in Normandy* Pl. 6
 1891
 Oil on canvas, 18 × 22 in.
 Signed and dated (lower left), "L. C. Perry, 1890"
 Collection Newark Museum
 Bequest of Diana Bonnor Lewis

Documentation: "One of [Perry's] loveliest landscapes [presented in the Boston Athenaeum exhibition] and shows the extent to which she had absorbed the lessons of Impressionism, but also her gentle interpretation of the style" (Patricia Hills, "Lilla Cabot Perry and American Impressionism").

Provenance: Mrs. Salim Lewis; to The Newark Museum, bequest of Diana Bonnor Lewis, 1988.

Exhibited: Hirschl & Adler, New York, 1969, *Lilla Cabot Perry: A Retrospective Exhibition,* no. 5 (lent by Mrs. Salim Lewis); Whitney Museum, New York, 1977, *Turn-of-the-Century America,* group exhibition, no. 72; the Boston Athenaeum, Boston, 1982, *Lilla Cabot Perry: Paintings,* no. 14 (as *Landscape [in Normandy]*).

References: Doris Birmingham, "The Black Hat by Lilla Cabot Perry, *The Currier Gallery of Art Bulletin* [Manchester, N.H.] (Fall 1986).
 Patricia Hills, "Lilla Cabot Perry and American Impressionism." Unpublished typescript for lecture, Boston Athenaeum, March 10, 1982.
 Turn-of-the-Century America, exhibition catalogue (New York: Whitney Museum, 1977).

10. *Giverny Hillside* Pl. 10
 n.d.
 Oil on canvas, 18 × 22 in.
 Collection Barbara and Blake Tartt

Provenance: artist's estate; to Hirschl & Adler Galleries, New York; to Barbara and Blake Tartt.

Exhibited: Hirschl & Adler, New York, 1969, *Lilla Cabot Perry: Retrospective Exhibition,* no. 8; Dixon Gallery, Memphis, Tenn., 1982, *An International Episode,* group exhibition, no. 59.

References: William H. Gerdts, *American Impressionism* (New York: Abbeville, 1984).
 Laura Meixner, *An International Episode: Millet, Monet and Their North American Counterparts,* exhibition catalogue (Memphis, Tenn.: Dixon Gallery, 1982).

11. *Giverny*
 n.d.
 Oil on canvas, 18 × 22 in.
 Private collection

Documentation: Although the latter two are not dated, the identical size of the canvases for *Landscape in Normandy, Giverny Hillside* and *Giverny* possibly indicates that all three were painted in 1891.

Provenance: artist's family.

12. *Alice in the Lane* [Alice Perry] Pl. 11
 1891
 Oil on canvas, 21 3/4 × 18 1/4 in.
 Signed (lower left), "L. C. Perry"
 Collection Claude Monet Foundation, Giverny
 Gift of Mrs. Lila Acheson Wallace

Documentation: Recorded in Perry's account book, no. 230. While this may have been the painting exhibited at the Boston Art Club in 1933 with a date of 1889, the date 1891 is more plausible in view of the variation on this theme, *Alice Knocking at Door,* which is signed and dated 1891.

Provenance: artist's estate; to Hirschl & Adler Galleries, New York; to Claude Monet Foundation by gift of Mrs. Lila Acheson Wallace.

Exhibited: Boston Art Club, 1933, Boston, *A Memorial Exhibition of Paintings by Lilla Cabot Perry,* no. 6 (as *Child in Lane, Giverny,* 1889); Hirschl & Adler, New York, 1969, *Lilla Cabot Perry: A Retrospective Exhibition,* no. 10.

References: Lisa M. Ward, "Lilla Cabot Perry and the Emergence of the Professional Woman Artist," Master's thesis, University of Texas, Austin, 1985.

Note: No paintings by Perry were ever hanging in Monet's bedroom during his lifetime.

13. *Self-Portrait* Pl. 9
 1891
 Oil on canvas, 31 7/8 × 25 5/8 in.
 Signed (upper right), "L. C. Perry"
 Inscription (on back), "LCP/by L.C.P."
 Daniel J. Terra Collection
 Terra Museum of American Art, Chicago

Documentation: Recorded in Perry's account book, no. 111 (as *L. C. Perry in Painting Apron*).

Provenance: artist's estate; to Hirschl & Adler Galleries, New York; to the Daniel J. Terra Collection, Terra Museum of American Art.

Exhibited: Hirschl & Adler, New York, 1969, *Lilla Cabot Perry: A Retrospective Exhibition,* no. 13; Dixon Gallery, Memphis, Tenn., 1982, *An International Episode,* group exhibition, no. 61.

14. *Child in Window* [Edith Perry] Pl. 13
 1891
 Oil on canvas, 38 × 24 in.
 Collection Mr. and Mrs. T. Gordon Hutchinson

Provenance: artist's family.

Exhibited: Previous exhibitions, if any, unknown.

Note: This portrait of Edith Perry at Giverny is not to be confused with two portraits that Perry painted in Milton, Massachusetts, in 1890: *Child in Window — Study of Light and Reflection* [Edith Perry] and *Child in a Window* [Margaret Perry]. Several compositions by Balthus in more recent times recall the same theme of alienation expressed here.

15. *Portrait Study of a Child* [Alice Perry] Pl. 12
 1891
 Oil on canvas, 60 × 36 in.
 Signed and dated (upper left), "LILLA CABOT PERRY, 1891"
 Collection Natalie, Brienne and Chase Rose

Note: This is an interesting example of how Perry transposed her own vision of soulful melancholy in her portraits, particularly those of children. Family correspondence records that Alice Perry was a gregarious, fun-loving child, who actually played the piano, not the violin.

Provenance: artist's estate; to Hirschl & Adler Galleries, New York; to Santa Fe East Gallery; to Natalie, Brienne and Chase Rose.

Exhibited: Thirteenth Exhibition of the Society of American Artists, New York, 1891, no. 171; Museum of Fine Arts, Boston, 1891, selections from the Society of American Artists' group show; Eighteenth Triennial Exhibition of the Massachusetts Charitable Mechanics' Association, Boston, 1892, no. 90 (as *Child with Violin* — awarded silver medal); Massachusetts Charitable Mechanics' Association, 1893, *Massachusetts Fine Art Exhibit,* no. 111 (as *Portrait of a Child with a Violin*); World's Columbian Exposition, Chicago, 1893, Fine Arts, USA, no. 816 (as *Portrait of Alice*); Santa Fe East Gallery, Santa Fe, 1983, *Lilla Cabot Perry: Days to Remember* (as *Child [Alice] with Violin, 1891*).

References: Suzanne Deats, "Whistler's Sister," *Santa Fe Reporter,* April 20, 1983.

Alma S. King, *Lilla Cabot Perry: Days to Remember,* exhibition catalogue (Santa Fe: Santa Fe East Gallery, 1983).

Lisa M. Ward, "Lilla Cabot Perry and the Emergence of the Professional Woman Artist," Master's thesis, University of Texas, Austin, 1985.

16. *Self-Portrait* Pl. 8
1892
Oil on canvas, 24 × 20 in.
Signed and dated (upper left), "L. C. Perry, 1892"
Collection Mrs. Kline Dolan

Provenance: artist's estate.

Exhibited: No prior exhibitions.

Note: Santa Fe East Gallery presented a larger variation of this self-portrait (as *Portrait of the Artist*)in their 1983 Perry exhibition *Lilla Cabot Perry: Days to Remember.*

17. *Brook and Wash-house, Giverny* Pl. 14
(Brook from Monet's Garden)
n.d.
Oil on canvas, 25 1/2 × 32 in.
Signed (lower left), "L. C. Perry"
Collection Mr. and Mrs. Marshall Crawford

Documentation: There are two similar versions of this painting, both listed in the artist's inventory at the time of her death in 1933 — *Brook and Wash-house, Giverny* (Perry inventory no. 149) and *Wash-house, Giverny* (Perry inventory no. 16). The latter work recently has been retitled

Giverny Landscape (in Monet's Garden). It is in a private collection, courtesy of the R. H. Love Galleries, Inc., Chicago, and was included in the 1982–83 traveling exhibition *Americans in Brittany and Normandy, 1860–1910,* the first venue of which was the Pennsylvania Academy of Fine Arts, Philadelphia.

Provenance: artist's estate; to Hirschl & Adler, New York; to Adams & Porter, Houston, Tex.

Exhibited: Copley Gallery, Boston, 1911, *An Exhibition of Portraits and Other Pictures by Lilla Cabot Perry,* no. 1 (as *The Brook*); Twentieth Century Club, Boston, 1913, group show, no. 13 (as *The Brook, Giverny — Noon*); Guild of Boston Artists, 1922, *An Exhibition of Paintings by Lilla Cabot Perry,* no. 6 (as *The Brook, Giverny*); Braus Galleries, New York, 1922, *An Exhibition of Paintings by Lilla Cabot Perry* (as *The Brook, Giverny*); Guild of Boston Artists, 1934, *A Memorial Exhibition of Paintings by Lilla Cabot Perry,* no. 16; Hancock High School, Hancock, N.H., n.d., no. 27 (as *The Brook — Giverny, France*).

References: Richard H. Love, *Theodore Earl Butler: Emergence from Monet's Shadow* (Chicago: Haase-Mumm, 1985).

David Sellin, *Americans in Brittany and Normandy, 1860–1910,* exhibition catalogue (Phoenix: Phoenix Art Museum, 1982).

Lisa M. Ward, "Lilla Cabot Perry and the Emergence of the Professional Woman Artist." Master's thesis, University of Texas, Austin, 1985.

Mary Louise Wood, "American Women Artists, 1830–1930." *The National Museum of Women in the Arts News* 5, no. 2 (Summer 1987).

18. *A Stream beneath Poplars*
Giverny, 1890–1900
Oil on canvas, 25 3/4 × 32 in.
Signed (lower left), "L. C. Perry"
Collection Hunter Museum of Art, Chattanooga, Tennessee
Gift of Mr. and Mrs. Stuart P. Feld

Provenance: artist's estate; to Mr. and Mrs. Stuart P. Feld, New York.

Exhibited: Hirschl & Adler, New York, 1969, *Lilla Cabot Perry: A Retrospective Exhibition,* no. 7; Dixon Gallery, Memphis, Tenn., 1982, *An International Episode,* group exhibition, no. 57.

References: William T. Henning, *A Catalogue of the American Collection, Hunter Museum of Art, Chattanooga, Tennessee* (Chattanooga, Tenn.: Hunter Museum of Art, n.d.).

Laura Meixner, *An International Episode: Millet, Monet and Their North American Counterparts,* exhibition catalogue (Memphis, Tenn.: Dixon Gallery, 1982).

Diana W. Suarez, *Bluff and the Magic Mansion: A Children's Guide to the Hunter Museum of Art* (Chattanooga, Tenn.: Hunter Museum of Art, 1980).

Lisa M. Ward, "Lilla Cabot Perry and the Emergence of the Professional Woman Artist." Master's thesis, University of Texas, Austin, 1985.

19. *French Farm Houses*
Giverny, n.d.
Oil on canvas, 18 × 22 in.
Signed (lower left), "L. C. Perry"
Private collection

Provenance: artist's family; to Hirschl & Adler Galleries, New York; to private collection.

Exhibited: Santa Fe East Gallery, Santa Fe, 1982, *Five American Women Impressionists.*

References: Alma King, *Five American Women Impressionists* (Santa Fe: Santa Fe East Gallery, 1982).

20. *Poplars* Pl. 15
Giverny, n.d.
Oil on canvas, 35 × 45 in.
Collection Mrs. Lilla Cabot Levitt

Provenance: artist's family.

Exhibited: Guild of Boston Artists, Boston, 1915, *An Exhibition of Paintings by Lilla Cabot Perry,* no. 29.

Note: There are two variations of this work. They are not to be confused with the pastel *Poplars, II,* exhibited in Hirschl & Adler, New York, 1969, *Lilla Cabot Perry: A Retrospective Exhibition,* as no. 28.

21. *At the River's Head* [Edith Perry] Pl. 16
(On the River, II)
1895

Oil on canvas, 25 1/2 × 32 in.
Courtesy Vose Galleries of Boston, Inc.

Documentation: This plein-air portrait of Perry's daughter Edith in a pink dress, posed by the Epte River, along with a second variation painted the same summer, which depicts Edith in a white dress, may well have inspired Monet's warm words of praise recorded by Thomas Sergeant Perry in September 1895.

Provenance: Mrs. George H. L. Smith; to Abbot Williams Vose.

Exhibited: St. Botolph Club, Boston, 1897, *An Exhibition of Paintings by Mrs. T. S. Perry,* no. 18 (as *On the River, II*); Guild of Boston Artists, Boston, 1927, *An Exhibition of Paintings by Lilla Cabot Perry,* no. 13 (as *On the River*); Boston Art Club, Boston, 1933, *A Memorial Exhibition of Paintings by Lilla Cabot Perry,* no. 22 (as *On the River, II*); Brattleboro Free Library, Brattleboro, Vt., n.d., *Paintings by Lilla Cabot Perry,* no. 23 (as *On the River*); Guild of Boston Artists, Boston, 1989, *The Founders Show,* no. 2 (as *At the River's Head, Giverny*).

Note: According to Perry's notes, also exhibited at the Salon de la Société Nationale des Beaux-Arts ("New Salon"), Paris, 1896, and at the Pennsylvania Academy of Fine Arts, Philadelphia, 1898(?), group show (Perry Family Archives).

22. *The Violinist* [Margaret Perry]
(In a Studio)
Giverny, *ca.* 1895
Oil on canvas, 31 5/8 × 25 7/8 in.
Signed (lower left), "Lilla C. Perry"
Collection Ackland Art Museum, The University of North Carolina at Chapel Hill
Gift of Everette and Jeanette James

Documentation: This painting formed part of the artist's inventory at her death in 1933 (as *M. P. [Margaret Perry] with Violin,* no. 105). The date of 1895 is attributed because of its strong similarity to *In the Studio* (Hirschl & Adler, New York, 1969, *Lilla Cabot Perry: A Retrospective Exhibition,* no. 19) which was "painted about 1895."

Provenance: the artist's estate, descended in the Cabot family; to Childs Gallery, Ltd., Boston; to Dr. A. Everette James, Jr., in 1979; to Ackland Art Museum, University of North

Carolina, by gift.

Exhibited: Guild of Boston Artists, Boston, 1920, *An Exhibition of Paintings by Lilla Cabot Perry*, no. 21 (as *In a Studio*).

References: William H. Downes, "Pictures by Mrs. Perry," *Boston Evening Transcript*, November 30 (?), 1920.

23. ***Edith with Lierre*** **[Edith Perry]** Fig. 8
(Girl with Cat)
ca. 1895
Oil on canvas, 44 × 33 in.
Signed (lower left), "Lilla Cabot Perry"
Collection Susan and Rudy Wunderlich

Note: This portrait is not to be confused with *Girl with Cat* (Hirschl & Adler, New York, 1969, *Lilla Cabot Perry: A Retrospective Exhibition*, no. 24), signed and dated 1903 and erroneously identified as also depicting Lierre.

Documentation: Lierre was the Perrys' pet cat during the years they lived next door to Monet, as recorded in Thomas Perry's correspondence with Hercules Warren Fay contained in the Perry archives of The Houghton Library, Harvard University: "Mrs. Perry brought back a stray angora kitten half-starved from Vernon" (September 1, 1894); "It is now as big as a lion and playful as a mountain goat. It is called Lierre, *symbole de la fidélité*" (December 8, 1894); "Lierre is positively no more He perished in the exercise of eating pigeons and was found in a trap" (June 8, 1897).

Provenance: artist's estate; to Hirschl & Adler Galleries, New York; to Santa Fe East Gallery, Santa Fe; to Susan and Rudy Wunderlich.

Exhibited: St. Botolph Club, Boston, 1897, *An Exhibition of Paintings by Mrs. T. S. Perry*, no. 37 (as *Girl with Cat*); Olin Library, Wesleyan University, Middletown, Conn., 1937, solo exhibition, no. 30 (as *Girl with Cat*); Santa Fe East Gallery, Santa Fe, 1983, *Lilla Cabot Perry: Days to Remember*; Grand Central Art Galleries, New York, 1987, *The Genius of the Fair Muse*, group show, no. 42.

24. ***Portrait of the Baroness von R.*** Pl. 19
1895
Oil on canvas, 46 × 29 in.
Collection Boston Harbor Hotel

Documentation: Margaret Perry's detailed description of this portrait indicates that the lady who posed for Perry in Paris was an intimate friend of the family, possibly the Baroness von Reibnitz, who attended a concert with the Perrys in January 1897 at the Tysons' apartment, situated just below the Perrys' apartment on rue Galilee.

Provenance: Sotheby's, New York, 1986.

Exhibited: St. Botolph Club, Boston, 1897, *An Exhibition of Paintings by Mrs. T. S. Perry*, no. 34.

25. ***Young Bicyclist*** **[Alice Perry]** Pl. 18
ca. 1894–95
Oil on canvas, 39 × 30 in.
Collection Alice Lyon

Provenance: artist's family.

Exhibited: St. Botolph Club, Boston, 1897, *An Exhibition of Paintings by Mrs. T. S. Perry*, no. 33.

26. ***Children Dancing, II*** **[Alice and Edith Perry]** Pl. 17
1895
Oil on canvas, 48 × 33 1/2 in.
Private collection

Documentation: This portrait is one of three variations all done at the same time. One variation is signed and dated (upper left), "L. C. Perry, '95," courtesy Berry-Hill Galleries, Inc., New York. The somber quality of this work contrasts strongly with Cecilia Beaux's sprightly *Dancing Sisters*, 1899. Perry may have been inspired in this work by Puvis de Chavannes's *Les Jeunes filles et la mort* (Young maidens and death), painted in 1872.

Provenance: artist's estate; to Hirschl & Adler Galleries, New York; to private collection.

Exhibited: St. Botolph Club, Boston, 1897, *An Exhibition of Paintings by Mrs. T. S. Perry*, no. 37 (note: also presented in this same exhibition was *Children Dancing, Sketch I,* no. 19); Pennsylvania Academy of Fine Arts, Philadelphia, 1898 (?), group show; Braus Galleries, New York, 1922, *An Exhibition of Paintings by Lilla Cabot Perry*, no. 25; Boston Art Club, Boston, 1933, *A Memorial Exhibition of Paintings by Lilla Cabot Perry*, no. 7 (as *Children Dancing*); Boston Athenaeum,

Boston, 1982, *Lilla Cabot Perry: Paintings*, no. 1 (as *Dancing Girls*); Santa Fe East Gallery, Santa Fe, 1983, *Lilla Cabot Perry: Days to Remember* (as *Dancing Girls*).

References: *Boston Evening Transcript*, November 11, 1897.
 Lisa M. Ward, "Lilla Cabot Perry and the Emergence of the Professional Woman Artist," Master's thesis, University of Texas, Austin, 1985.

27. *Playing by Heart* [Alice Perry] Pl. 20
1897
Oil on canvas, 35 1/2 × 28 1/2 in.
Private collection

Provenance: artist's family.

Exhibited: St. Botolph Club, Boston, 1897, *An Exhibition of Paintings by Mrs. T. S. Perry*, no. 20 (as *Playing by Heart [Unfinished]*).

References: *Boston Evening Transcript,* November 11, 1897.

28. *The Trio* [Alice, Edith and Margaret Perry] Pl. 21
ca. 1898–1900
Oil on canvas, 29 3/4 × 39 3/8 in.
Collection Fogg Art Museum, Harvard University, Cambridge, Massachusetts
Friends of the Fogg Art Museum Funds

Documentation: Although *The Trio* is not dated, Thomas Perry's correspondence from Tokyo confirms that chamber music concerts by his daughters were in full swing in 1899: "The children have their music & find an excellent teacher in Junker, a most enthusiastic & inspiring instructor, while Alice is going to have lessons [piano] from Dr. von Koebes, Professor of Philosophy at the Imperial University and a pupil of Rubinstein, who had meant to be a public player, but found himself too timid. . . . Margaret and Edith are to play on the 10th in a charity concert" (T. S. Perry to Mrs. Thomas Meteyard, January 1, 1899 — Special Collections, Colby College Library, Waterville, Maine).

Provenance: artist's estate; to John Castano Galleries, Boston; to Fogg Art Museum, Harvard University, Cambridge, Mass., Friends of the Fogg Art Museum Funds.

Exhibited: Boston Art Club, Boston, 1933, *A Memorial Exhibition of Paintings by Lilla Cabot Perry*, no. 29 (as *The Trio, Tokyo, Japan*); Olin Library, Wesleyan University, Middletown, Conn., 1937, no. 16; Brattleboro Free Library, Brattleboro, Vt., n.d., *Paintings by Lilla Cabot Perry*, no. 10 (as *The Trio, Tokyo, Japan*); John Castano Galleries, Boston, 1952, *Oil Paintings by Lilla Cabot Perry*; Hirschl & Adler, New York, 1969, *Lilla Cabot Perry: A Retrospective Exhibition*, no. 22 (as *The Trio, Tokyo*); The National Museum of Women in the Arts, Washington, D.C., 1987, *American Women Artists, 1830–1930*, no. 50 (as *The Trio, Tokyo, Japan*).

References: Dorothy Adlow, *Christian Science Monitor,* March 10, 1952.
 Amy Fine Collins, *American Impressionism*, (Greenwich, Conn.: Bison Books, 1989).
 Bernice Kramer Leader, "The Boston Lady as a Work of Art: Paintings by the Boston School at the Turn of the Century." Ph.D. dissertation, Columbia University, 1980.
 Eleanor Tufts, *American Women Artists: 1830–1930*, exhibition catalogue (Washington, D.C.: The National Museum of Women in the Arts, 1987).
 Lisa M. Ward, "Lilla Cabot Perry and the Emergence of the Professional Woman Artist," Master's thesis, University of Texas, Austin, 1985.

29. *Child in Kimono* [Alice Perry] Pl. 22
1898
Pastel, 36 × 26 in.
Signed (upper right), "L C Perry —"
Collection of Mrs. Lilla Cabot Levitt

Documentation: One of two variations in pastel.

Provenance: artist's family.

Exhibited: St. Botolph Club, Boston, 1911, *An Exhibition of Portraits and Other Pictures by Lilla Cabot Perry*, no. 16; Guild of Boston Artists, Boston, 1934, *A Memorial Exhibition of Paintings by Lilla Cabot Perry*, no. 13.

30. *Portrait of a Young Girl with an Orange* Pl. 23
1898–1901
Oil on canvas, 31 × 25 in.
Private collection

Provenance: artist's estate; to Hirschl & Adler Galleries, New York; to private collection.

Exhibited: Previous exhibitions, if any, unknown.

31. *In a Japanese Garden* Pl. 24
1898–1901
Oil on canvas, 31 × 25 in.
Signed (lower right), "L C Perry"
Collection Mr. and Mrs. Jay P. Moffat

Documentation: The model for this painting is Perry's Japanese maid, Tsune, with whom she kept up a warm friendship all her life. There is a thematic similarity between this work and La Farge's *The Waterfall in Our Garden,* which is reproduced in the original edition of his book *An Artist's Letters from Japan.*

Provenance: the artist's family.

Exhibited: Brooks Memorial Art Gallery, Memphis, Tenn., n.d., group exhibition.

32. *Mountain Village, Japan* Pl. 25
1898–1901
Oil on canvas, 22 × 18 in.
Collection Mrs. Lilla Cabot Levitt

Provenance: artist's family.

References: Lisa M. Ward, "Lilla Cabot Perry and the Emergence of the Professional Woman Artist," Master's thesis, University of Texas, Austin, 1985.

33. *Fuji* Fig. 15
1898–1901
Oil on canvas, 25 1/2 × 32 in.
Private collection

Documentation: Judging from a photograph taken at Perry's 1934 memorial exhibition at the Guild of Boston Artists, Boston, this view of Fuji is quite similar to *Kasa Fuji* (no. 18 in that show) with minor changes in the foreground.

Provenance: artist's family.

34. *Fuji from the Canal, Iwabuchi* Pl. 26
1898–1901

Oil on canvas, 25 1/2 × 31 1/2 in.
Signed and dated (lower left), "L. C. Perry, Japan 01"
Collection Mrs. Lilla Cabot Levitt

Documentation: A variation [of *Fuji from the Canal, Iwabuchi*] painted "at dawn," was exhibited at the Braus Galleries in New York in April 1924. Perry was not well enough to attend the event, but an admirer sent warm praise. "I fell in love with *Fuji at dawn*, with the straight canal, and the great mass of yellow primroses in the foreground. It seemed to knock a hole right through the wall and take me to the Nippon which I have never seen" (Mrs. Fanny MacVeagh to L. C. Perry on April 13, 1924. Perry Family Archives).

Provenance: artist's family.

Exhibited: Guild of Boston Artists, Boston, 1920, *An Exhibition of Paintings by Lilla Cabot Perry,* no. 12; Boston Art Club, Boston, 1933, *A Memorial Exhibition of Paintings by Lilla Cabot Perry,* no. 13 (as *Fuji from the Canal, Japan*); Olin Library, Wesleyan University, Middletown, Conn., 1937, solo exhibition, no. 31 (as *Fuji from Canal*).
References: Lisa M. Ward, "Lilla Cabot Perry and the Emergence of the Professional Woman Artist," Master's thesis, University of Texas, Austin, 1985.

35. *Fuji from Lava Beach* Pl. 27
ca. 1898–1901
Oil on canvas, 7 × 21 3/4 in.
Signed (lower right), "L. C. Perry"
Collection Mrs. Lilla Cabot Levitt

Documentation: Perry completed several views of Fuji executed at different hours of the day, beginning at 4 A.M. The narrow, elongated canvas used for this painting again demonstrates the strong influence that Japanese art had on Perry. Edmund Tarbell greatly admired this work when it was exhibited in 1920.

Provenance: artist's family.

Exhibited: Guild of Boston Artists, Boston, 1920, *An Exhibition of Paintings by Lilla Cabot Perry,* no. 4; Guild of Boston Artists, Boston, 1922, *An Exhibition of Paintings by Lilla Cabot Perry,* no. 14; Braus Galleries, New York, 1922, *An Exhibition of Paintings by Lilla Cabot Perry,* no. 32; Brattleboro Free Library, Brattleboro, Vt., n.d., *Paintings by Lilla Cabot Perry,* no. 17.

References: Undated press review, *Boston Evening Transcript,* November 30 (?), 1920.
 New York Morning Telegraph, November 5, 1922.

36. *Lotus Flowers* [Oya, Japan] Pl. 28
 ca. 1900
 Oil on canvas, 32 × 25 in.
 Private collection

Documentation: Three variations on the same theme are presently documented. A second, very similar variation from a private collection also was exhibited in 1922 at the Braus Galleries. A third view of the same lotus flowers seen from a distance is in another private collection, courtesy of Hirschl & Adler Galleries, New York.

Provenance: artist's family.

Exhibited: Braus Galleries, New York, 1922, *An Exhibition of Paintings by Lilla Cabot Perry,* two versions, nos. 1 and 2 (as *Lotus Flowers, Japan*) — catalogue reference, nos. 36 and 37.

37. *Water Lilies in a Bowl*
 ca. early 1900s
 Oil on canvas, 16 3/8 × 25 7/8 in.
 Private collection

Provenance: artist's estate; to Hirschl & Adler Galleries, New York; to private collection.

Exhibited: Previous exhibitions, if any, unknown.

38. *Portrait of Mrs. Joseph Clark Grew* [Alice Perry Grew]
 Pl. 29
 ca. 1903–04
 Oil on canvas, 40 × 30 in.
 Signed (lower left), "L. C. Perry"
 Collection Mr. and Mrs. T. Gordon Hutchinson

Documentation: Perry painted this portrait of her daughter Alice two years before her marriage to Joseph Grew, a brilliant young diplomat from one of Boston's prominent families who later became Ambassador to Japan. The Perrys were devoted to their son-in-law. His portrait by Perry, currently in a private collection, also was exhibited on several occasions.

Provenance: artist's family.

Exhibited: St. Louis, Mo., Universal Exposition of 1904, Louisiana Purchase Exposition (awarded bronze medal); Copley Gallery, Boston, 1911, *An Exhibition of Portraits and Other Pictures by Lilla Cabot Perry,* no. 17 (as *Portrait of Mrs. J. C. G.*); Guild of Boston Artists, Boston, 1915, *An Exhibition of Paintings by Lilla Cabot Perry,* no. 19 (as *Portrait of Mrs. J. C. Grew*); Boston Art Club, Boston, 1933, *A Memorial Exhibition of Paintings by Lilla Cabot Perry,* no. 3 (as *Portrait — 1903*); Guild of Boston Artists, 1942, *A Retrospective Exhibition . . . of the Guild of Boston Artists,* group show, no. 54 (as *Portrait of Mrs. J. C. G.*).

References: *Boston Evening Transcript,* January 4, 1911, 16.
 Boston Evening Transcript, February 25, 1915, 11.
 Christian Science Monitor (Boston), January 7, 1911, 12.
 R. H. Ives Gammell, introduction to *The Guild of Boston Artists, 1914–1942: A Retrospective Exhibition,* exhibition catalogue (Boston: Museum of Fine Arts, 1942).
 John Nutting, review in an unidentified Boston newspaper, *ca.* January 3, 1911 (Perry Family Archives).

39. *Alice in a White Hat* [Alice Perry Grew] Pl. 31
 ca. 1904
 Pastel on paper (laid on linen canvas), 31 1/2 × 25 1/2 in.
 Private collection

Provenance: artist's estate; to Hirschl & Adler Galleries, New York; to David Ramus Fine Art, New York and Atlanta; to private collection, Atlanta.

Exhibited: David Ramus Fine Art, New York and Atlanta, 1984, no. 4; High Museum of Art, Atlanta, 1989; Telfair Academy of Arts and Sciences, Savannah, Ga., 1989.

References: Shelby White Cave, ed., *Gallery Collections Fall-84* (Atlanta: David Ramus Fine Art, 1984).
 Kelly Morris, Amanda Woods, and Margaret Miller, eds. *Georgia Collects* (Atlanta: High Museum of Art, 1989).

40. *Portrait of Augustus Lowell Putnam* Pl. 30
 1905
 Oil on canvas, 35 × 17 in.
 Signed and dated (upper right), "L. C. Perry, 1905"
 Private collection

Documentation: Perry recorded the exact circumstances of her first meeting with Mrs. William Lowell Putnam, mother of Augustus, in a letter to her daughter Alice dated February 9, 1905: "My mind cure woman is teaching me how to sleep better and does me much good. Yesterday I went to her at a.m. then to [the] studio [Fenway], from studio to Dr. Grad, then home to meet Mrs. William Putnam who gave me an order to paint a head of her little boy, aged 5. Then as Aunt Helen [Perry's sister Helen Almy] had lent me her carriage, I went and made 14 calls! . . . Wasn't that a day!" The Putnam family desired their son to be outfitted in the costume of a Russian refugee, according to information supplied by the present owner.

Provenance: Commissioned by Mrs. William Lowell Putnam in 1905 and remained in the Putnam family.

Exhibited: Rowlands Gallery, Boston, 1905, *An Exhibition of Pictures by Mrs. T. S. Perry*, no. 28 (as *Portrait*).

41. *The White Bed Jacket* Fig. 16
ca. 1905
Pastel on tan paper, 25 1/2 × 31 1/2 in.
Signed (lower left), "L C Perry"
Courtesy Hirschl & Adler Galleries, Inc., New York

Documentation: Although the identity of the sitter is still a mystery, the sharp, vivid quality of this portrait and the informality of dress strongly suggest that the model was a close friend. Two pastels—of Elsa Tudor and Amy Wesselhoeft—with similar dimensions to this are documented in the 1933 Perry inventory but have yet to be identified with certainty. There are frequent allusions to the Tudor family in Perry correspondence, so Elsa Tudor is a strong possibility as the sitter. It is not Mrs. Goodhue, as indicated in a Hirschl & Adler reference, whose portrait by Perry (*Mrs. George W. Goodhue*) is hanging presently in the Hancock (N.H.) Public Library. A preliminary pastel sketch for this work exists in a private collection.

Provenance: artist's estate.

Exhibited: Santa Fe East Gallery, Santa Fe, 1983, *Lilla Cabot Perry: Days to Remember*; Hirschl & Adler Galleries, New York, 1987, *Painters in Pastel: A Survey of American Works*, group show, no. 57.

References: Suzanne Deats, "Whistler's Sister," *Santa Fe Re-porter,* April 20, 1983.
Alma S. King, *Lilla Cabot Perry: Days to Remember*, exhibition catalogue (Santa Fe: Santa Fe East Gallery, 1983).
Painters in Pastel: A Survey of American Works, exhibition catalogue (New York: Hirschl & Adler Galleries, 1987).

42. *Spring Landscape, Giverny — no. 1* Pl. 32
"Bridge — Willows — Early Spring" inscribed on back of stretcher
ca. 1906
Pastel on paper, 25 × 31 in.
Private collection

Documentation: This is one of three variations — all done in pastel, all with the same dimensions — documented in the 1933 Perry inventory and titled *Spring, Giverny* (nos. 146, 147 and 148). "Bridge — Willows — Early Spring" is inscribed on the stretcher of the canvas. A second variation is presently documented in the Inventory of American Paintings, National Museum of American Art, Smithsonian Institution, Washington, D.C. (no. 71330161: *Bridge and Willows in Early Spring,* Robert Rice Gallery, Inc., Houston, Tex.; Mrs. Ira. J. Jackson, 1977).

Provenance: artist's estate; to Hirschl & Adler Galleries, New York; to private collection.

Exhibited: Guild of Boston Artists, Boston, 1934, *A Memorial Exhibition of Paintings by Lilla Cabot Perry*, no. 4; Hirschl & Adler, New York, 1969, *Lilla Cabot Perry: A Retrospective Exhibition*, no. 26 (as *Bridge — Willows — Early Spring*).

References: Richard J. Boyle, *American Impressionism* (New York: New York Graphic Society, 1982).

43. *Late Afternoon — Giverny* Pl. 33
(Railway Embankment — Giverny; Normandy Landscape)
n.d.
Oil on canvas, 26 × 32 in.
Signed (lower left), "L. C. Perry"
Private collection

Documentation: Inventory records at the time of Perry's death in 1933 indicate there are two versions of this work: *Railway Embankment, Giverny* (no. 11) and *Railway Embankment — no. 2* (no. 150).

Provenance: artist's estate; to Hirschl & Adler Galleries, New York; to Santa Fe East Gallery, Santa Fe; to private collection.

Exhibited: Copley Gallery, Boston, 1911, *An Exhibition of Portraits and Other Pictures by Lilla Cabot Perry,* no. 25; Guild of Boston Artists, Boston, 1920, *An Exhibition of Paintings by Lilla Cabot Perry,* no. 13; Guild of Boston Artists, Boston, 1922, *An Exhibition of Paintings by Lilla Cabot Perry,* no. 4 (as *Railway Embankment, Giverny*); Hancock High School, Hancock, N.H., n.d., solo exhibition, no. 25 (as *Railway Embankment, Giverny, France*); Hirschl & Adler, New York, 1969, *Lilla Cabot Perry: A Retrospective Exhibition,* no. 35 (as *Normandy Landscape*); Santa Fe East Gallery, Santa Fe, 1983, *Lilla Cabot Perry: Days to Remember* (as *Normandy Landscape*).

44. *Giverny Landscape*
 n.d.
 Oil on canvas, 20 × 30 in.
 Signed (lower right), "Lilla Cabot Perry"
 Collection Felix L. Zambetti

Documentation: The similarity in signature, as well as a certain stylistic resemblance in the brushwork, strongly suggest that this landscape was painted during the same season as *Late Afternoon — Giverny.* Other versions of this view include *Midsummer Twilight* by Willard Metcalf and *In the Seine Valley* by John Breck.

Provenance: artist's estate; to Hirschl & Adler Galleries, New York; to private collection.

Exhibited: Hirschl & Adler, New York, 1969, *Lilla Cabot Perry: A Retrospective Exhibition,* no. 12.

45. *Autumn Afternoon, Giverny* Pl. 34
 Giverny, n.d.
 Oil on canvas, 25 3/4 × 31 3/4 in.
 Daniel J. Terra Collection
 Terra Museum of American Art, Chicago

Inscription (on reverse): "An Autumn Afternoon, Giverny, Lilla Cabot Perry."

Provenance: Berry-Hill Galleries, New York; to Daniel J. Terra Collection, Terra Museum of American Art, Chicago.

Exhibited: Braus Galleries, New York, 1922, *An Exhibition of Paintings by Lilla Cabot Perry,* no. 16.

46. *The Violoncellist* **[Edith Perry]** Pl. 35
 ca. 1906–07
 Oil on canvas, 21 × 25 in.
 Signed (lower left), "L. C. Perry"
 Private collection

Provenance: Berry-Hill Galleries, New York; to private collection.

Exhibited: Previous exhibitions, if any, unknown.

References: William H. Gerdts, *American Impressionism* (New York: Abbeville, 1984).

47. *Child in a Garden, Giverny* **[Lilla Cabot Grew?]** Pl. 36
 ca. 1909
 Oil on canvas, 32 × 12 3/4 in.
 Collection Mr. and Mrs. Lawrence Herbert

Documentation: The attribution of this painting to Perry is confirmed by Mrs. Lilla Cabot Levitt, Perry's granddaughter, who is an artist herself: "I feel sure that it was painted by Lilla Cabot Perry and that it was painted in Monet's garden. The child could be me" (letter dated July 7, 1989). The Grews spent the summer of 1909 in Giverny with the Perrys, and Lilla Grew was then two years old. The narrow, vertical format, an obvious allusion to Japanese prints, is unusual for Perry.

Provenance: artist's estate; to Hirschl & Adler Galleries, New York; to Mr. and Mrs. Lawrence Herbert.

Exhibited: Previous exhibitions, if any, unknown.

48. *Little Girl in a Lane, Giverny* Pl. 37
 ca. 1906–07
 Oil on canvas, 32 × 27 in.
 Signed (lower right), "L C Perry"
 Collection James M. B. Holsaert

Documentation: The model for this work is a little French girl. There is no reference to this charming painting in the

Perry inventory of 1933, at the time of the artist's death, which suggests that she gave it to her daughter Margaret prior to 1933. This reference in exhibition notices could possibly allude to the work: "A Lane, Giverny" (Guild of Boston Artists, 1920, *An Exhibition of Paintings by Lilla Cabot Perry,* no. 6). The reference could also refer to other works, such as *Alice in the Lane,* however.

Provenance: artist's family; to Miss Margaret Perry; to Miss Patricia Holsaert by bequest; to James M. B. Holsaert by inheritance.

Exhibited: see above.

49. ***Child in a Walled Garden, Giverny*** [Lilla Cabot Grew] Fig. 17
1909
Oil on canvas, 26 × 32 in.
Collection Sarah Moffat Srebro

Provenance: artist's family.

Exhibited: No prior exhibitions.

50. ***Dans un bâteau*** (**In a boat**) Pl. 38
1907
Oil on canvas, 45 × 35 in.
Signed and dated (lower left), "L C Perry, '07"
Private collection

Exhibited: Le Salon des Indépendants (Cours-la-Reine), Paris, 1908.

References: *La Revue Moderne,* April 15, 1908.

51. ***Le Paravent jaune*** (**The yellow screen**) Pl. 39
ca. 1907
Oil on canvas, 50 1/4 × 36 in. Signed (lower right), "L C Perry"
Collection T. Messina

Documentation: The sitter is a professional model. This work should not be confused with *The Gold Screen,* painted in Boston.

Provenance: Mongerson Gallery, Chicago; to private collection of T. Messina.

Exhibited: Le Salon des Indépédants (Cours-la-Reine), Paris, 1908; Mongerson Gallery, Chicago, 1984, *Lilla Cabot Perry* (as *La* [sic] *Paravent Jaune*).

References: *La Revue Moderne,* April 15, 1908.
Lisa M. Ward, "Lilla Cabot Perry and the Emergence of the Professional Woman Artist," Master's thesis, University of Texas, Austin, 1985.

52. ***Roses*** Pl. 40
(The Scent of Roses)
Prior to 1911
Oil on canvas, 39 1/2 × 29 1/2 in.
Collection Mr. and Mrs. Jeffrey A. Marcus

Provenance: artist's family; to Hirschl & Adler Galleries, New York; to Hall Galleries, Inc., Dallas, Tex.; to collection Mr. and Mrs. Jeffrey A. Marcus.

Exhibited: Copley Gallery, Boston, 1911, *An Exhibition of Portraits and Other Pictures by Lilla Cabot Perry,* no. 40 (as *Girl and Roses*); Guild of Boston Artists, Boston, 1931, *An Exhibition of Paintings by Lilla Cabot Perry,* no. 11; Guild of Boston Artists, Boston, 1934, *A Memorial Exhibition of Paintings by Lilla Cabot Perry,* no. 9 (as *Girl with Roses*).

References: A. J. Philpot, *Boston Globe,* March 1931.

53. ***The State House, Boston*** Pl. 43
1910
Oil on canvas, 18 1/4 × 22 1/2 in.
Signed (lower right), "L C Perry"
Private collection

Provenance: artist's family.

Exhibited: Copley Gallery, Boston, 1911, *An Exhibition of Portraits and Other Pictures by Lilla Cabot Perry,* no. 31; Guild of Boston Artists, Boston, 1917, solo *Paintings by Lilla Cabot Perry,* no. 1 (as *State House from Boylston Street*).

54. ***Lady with a Bowl of Violets*** Pl. 44
ca. 1910
Oil on canvas, 40 × 30 in.
Signed (lower right), "L C Perry"
Collection National Museum of Women in the Arts
Gift of Wallace and Wilhelmina Holladay

Documentation: As with so many of Perry's works, titles have simply been attributed in recent years, which, in this particular instance, has led to a total misrepresentation of the painting. The flowers depicted in a bowl in the upper left corner of the canvas are pansies, not violets. Pansies had a special meaning for Perry, which she later expressed in a poem: "Pansies, white pansies and purple ones/Deep as the love I gave to you, my flower" (from *The Jar of Dreams*). They were also Thomas Perry's favorite flower: "Pansies are, I think, my favorite flower, they have such a mischievous wink & their colours, especially the purple, touch my heart tho' at times I weary of the lavender & raw yellow" (quoted in Harlow, *Thomas Sergeant Perry*, 227). Thus the portrait has very personal overtones. The sitter is believed to be a professional model.

Provenance: artist's estate; to Hirschl & Adler Galleries, New York; to Santa Fe East Gallery, Santa Fe; to the Holladay Collection; to The National Museum of Women in the Arts by gift.

Exhibited: Copley Gallery, Boston, 1911, *An Exhibition of Portraits and Other Pictures by Lilla Cabot Perry,* no. 11 (as *Pansies*); Santa Fe East Gallery, Santa Fe, 1982, *Five American Women Impressionists;* The National Museum of Women in the Arts, Washington, D.C., 1987, *Selections from the Permanent Collection.*

References: *Antiques* (April 1982): 889.
　　Christian Science Monitor (Boston), January 7, 1911, 12.
　　Boston Evening Transcript, January 4, 1911, 16.
　　Alma S. King, *Five American Women Impressionists,* exhibition catalogue (Santa Fe: Santa Fe East Gallery, 1982).
　　John Nutting, review in an unidentified Boston newspaper, *ca.* January 3, 1911.
　　Lisa M. Ward, "Lilla Cabot Perry and the Emergence of the Professional Woman Artist." Master's thesis, University of Texas, Austin, 1985.
　　Krystyna Wasserman, "Lady with a Bowl of Violets by Lilla Cabot Perry," *Journal of the American Medical Association,* 253, no. 14 (April 1985).
　　Mary Louise Wood, "Lilla Cabot Perry," *National Museum of Women in the Arts,* collection catalogue (Washington, D.C.: The National Museum of Women in the Arts, 1987), 50, 51.

55. *Meditation* [Margaret Perry]　Pl. 41
　　Fenway Studio, Boston, n.d.
　　Oil on canvas, 24 × 20 in.
　　Private collection

Documentation: A photograph of Perry's Fenway studio includes a larger variation of this portrait of Margaret Perry painted after the Perrys' return to Boston in 1909. Margaret was the most intellectual of the three Perry daughters. She adored books, and published a selection of her own poetry.

Provenance: artist's family.

Exhibited: No prior exhibitions.

56. *Cherry Blossoms* [Hildegarde]　Pl. 42
　　1911
　　Oil on canvas, 31 3/4 × 25 1/2 in.
　　Signed and dated (lower left), "L C Perry, 1911"
　　Collection Elaine and Elliott Caplow

Documentation: the model is Hildegarde, who appears in many of Perry's portraits from 1911 and 1912.

Provenance: artist's estate; to Hirschl & Adler Galleries, New York; to De Ville Galleries, Los Angeles; to Elaine and Elliott Caplow

Exhibited: Twentieth Century Club, Boston, 1913, *Recent Portraits and Other Paintings by Lilla Cabot Perry,* no. 30; Hirschl & Adler, New York, 1969, *Lilla Cabot Perry: A Retrospective Exhibition,* no. 36.

57. *Lady in an Evening Dress*　Pl. 45
　　(Renée)
　　1911
　　Oil on canvas, 36 × 24 in.
　　Signed and dated (upper right), "L C Perry, '11"
　　Collection National Museum of Women in the Arts
　　Gift of Wallace and Wilhelmina Holladay

Provenance: Hirschl & Adler Galleries, New York; to the Holladay Collection; to The National Museum of Women in the Arts by gift.

Exhibited: Twentieth Century Club, Boston, 1913, *Recent Portraits and Other Paintings by Lilla Cabot Perry,* no. 26 (as *Renée*); Boston Athenaeum, Boston, 1982, *Lilla Cabot Perry: Paintings,* no. 8 (as *Lady in Evening Dress*).

58. *The Pearl* Fig. 22
ca. 1913
Oil on canvas, 35 1/2 × 25 1/2 in.
Collection Eleanor and Irv Welling

Provenance: artist's estate; to Hirschl & Adler Galleries, New York; to collection of Eleanor and Irv Welling.

Exhibited: Twentieth Century Club, Boston, 1913, *Recent Portraits and Other Paintings by Lilla Cabot Perry*, no. 3.

References: Robert Rosenblum, "Art: The Boston School of Painters," *Architectural Digest* 44 (May 1987).

59. *Portrait of William Dean Howells* Pl. 47
1912
Oil on canvas, 30 × 40 in.
Signed and dated (upper left), "Lilla Cabot Perry, 1912"
Special Collections, Colby College, Waterville, Maine
Gift of Margaret Perry

Provenance: artist's family; to Special Collections, Colby College, Waterville, Maine, gift of Margaret Perry.

Exhibited: Twentieth Century Club, Boston, 1913, *Recent Portraits and Other Paintings by Lilla Cabot Perry*, no. 9 (as *Portrait of W. D. Howells, Esq.*); MacDowell Art Colony, Peterborough, N.H., 1913 (as *Portrait of W. D. Howells*); Guild of Boston Artists, Boston, 1915, *An Exhibition of Paintings by Lilla Cabot Perry*, no. 16 (as *Portrait of W. D. Howells, Esq.*).

References: Richard Cary, "William Dean Howells and Thomas Sergeant Perry," *Colby Library Quarterly,* 8th ser., 4 (December 1969).
 Boston Evening Transcript, February 25, 1915.

60. *Portrait of Mrs. Henry Lyman* [Elizabeth Cabot Lyman] Pl. 48
(Lady with a Black Hat)
ca. 1910
Oil on canvas, 32 × 25 1/2 in.
Signed (upper left), "L. C. Perry"
Private collection

Documentation: This portrait is not to be confused with Perry's full-length composition, *The Black Hat,* 1914, The

Currier Gallery, Manchester, N.H. The sitter is Perry's niece, the daughter of Samuel Cabot. She was thirty years old when this portrait was painted. The tapestry in the background was probably brought back from France in 1909. After living in France and Japan, Perry reaffirms here her adherence to the Boston tradition in portraiture.

Provenance: artist's estate; to Hirschl & Adler Galleries, New York; to private collection.

Exhibited: Copley Gallery, Boston, 1911, *An Exhibition of Portraits and Other Pictures by Lilla Cabot Perry,* no. 23 (as *Portrait of Mrs. H. L.*).

References: *Boston Evening Transcript,* January 4, 1911.

61. *The Green Hat* [Edith Perry] Fig. 19
1913
Oil on canvas, 33 1/2 × 26 in.
Signed and dated (upper right), "L. C. Perry"
Collection Terra Museum of American Art, Chicago

Provenance: Hirschl & Adler Galleries, New York; to Grand Central Art Galleries, New York; to Terra Museum of American Art, Chicago.

Exhibited: Twentieth Century Club, Boston, 1913, *Recent Portraits and Other Paintings by Lilla Cabot Perry,* no. 2; Guild of Boston Artists, Boston, 1915, *An Exhibition of Paintings by Lilla Cabot Perry,* no. 21; Braus Galleries, New York, 1922, *An Exhibition of Paintings by Lilla Cabot Perry,* no. 14; Guild of Boston Artists, Boston, 1934, *A Memorial Exhibition of Paintings by Lilla Cabot Perry,* no. 5; Olin Library, Wesleyan University, Middletown, Conn., 1937, solo exhibition, no. 12; Mongerson Gallery, Chicago, 1984, *Lilla Cabot Perry*; Grand Central Art Galleries, New York, 1987, *The Genius of the Fair Muse,* group show, no. 43.

62. *Portrait of Edwin Arlington Robinson* Fig. 28
1916
Oil on canvas, 40 × 30 in.
Signed and dated (upper left), "Lilla Cabot Perry, 1916"
Special Collections, Colby College, Waterville, Maine
Gift of Margaret Perry

Documentation: Robinson spent seventeen days with the Perrys in Hancock, N.H., in July of 1916, followed by two

brief visits in September and October, which enabled Perry to complete this portrait of one of her dear friends.

Provenance: artist's family; to Special Collections, Colby College, Waterville, Maine, gift of Margaret Perry.

Exhibited: Guild of Boston Artists, Boston, 1917, *Paintings by Lilla Cabot Perry*, no. 26 (as *Portrait of Edwin Arlington Robinson, Esq.*); Milton Public Library, Milton, Mass., 1920, *An Exhibition of Paintings by Lilla Cabot Perry*, no. 14; Braus Galleries, New York, 1922, *An Exhibition of Paintings by Lilla Cabot Perry*, no. 18; Guild of Boston Artists, 1929, *An Exhibition of Paintings by Lilla Cabot Perry*, no. 9 (as *Edwin Arlington Robinson, Esq.*); Boston Art Club, Boston, 1933, *A Memorial Exhibition of Paintings by Lilla Cabot Perry*, no. 27 (as *Portrait of Edwin Arlington Robinson, Esq.*).

Note: At the time of the Boston Art Club exhibition, the Robinson portrait was at Dunster House, Harvard University, where it had been on loan since September 1930.

References: *Boston Herald,* November 1, 1933.
 Van Wyck Brooks, *New England: Indian Summer, 1865–1915* (New York: Dutton, 1940).
 Edwin Arlington Robinson, *Selections from the Letters of Thomas Sergeant Perry* (New York: Macmillan, 1929).

63. **Lady in Black**
 ca. 1914
 Pastel, 32 1/2 × 26 in.
 Collection Mr. and Mrs. Stuart A. Bernstein

Documentation: The sitter was possibly Amy Wesselhoeft, whose pastel portrait is documented in the Perry 1933 inventory (see documentation for *The White Bed Jacket,* cat. no. 41).

Provenance: artist's estate.

Exhibited: Santa Fe East Gallery, Santa Fe, 1982, *Five American Women Impressionists*; Mongerson Gallery, Chicago, 1984, *Lilla Cabot Perry*; Mongerson Gallery, Chicago, 1985, *Lilla Cabot Perry*.

Note: In 1915 Perry exhibited *Lady in Black* at the Guild of Boston Artists. The author believes, however that this reference pertains to *The Black Hat,* 1914, The Currier Gallery, Manchester, N.H.

References: Alma S. King, *Five American Women Impressionists,* (Santa Fe: Santa Fe East Gallery, 1982).

64. **Thomas Sergeant Perry Reading a Newspaper** Pl. 46
 1924
 Oil on canvas, 39 1/2 × 30 in.
 Collection Terra Museum of American Art, Chicago

Provenance: artist's estate; to Hirschl & Adler Galleries, New York; to Terra Museum of American Art, Chicago.

Exhibited: Previous exhibitions, if any, unknown.

65. **Road from Charleston to Savannah** Pl. 49
 1925
 Oil on canvas, 18 × 22 in.
 Collection Mrs. Lilla Cabot Levitt

Documentation: This work was painted in Charleston, S.C., where Perry was convalescing from a near-fatal case of diphtheria, as well as a deep depression brought on by her daughter Edith's mental breakdown and her granddaughter's death. It announces Perry's return to landscapes in the manner of the French Impressionists.

Provenance: artist's family.

Exhibited: Boston Art Club, Boston, 1933, *A Memorial Exhibition of Paintings by Lilla Cabot Perry,* no. 57 (as *Highway at Sunset, Charleston, S.C.,* lent by Mrs. J. Pierrepont Moffat).

66. **A Field, Late Afternoon, Charleston, S.C.**
 1925
 Oil on canvas, 12 × 14 in.
 Signed and dated (lower left), "L C Perry, Charleston, 1925"
 Collection Mrs. Lilla Cabot Levitt

Provenance: artist's family.

Exhibited: No prior exhibitions.

67. **A Peach Tree [Charleston, S.C.]** Pl. 50
 1925

Oil on canvas, 12 × 14 in.
Signed and dated (lower left), "L C Perry, Charleston, Jan. 1925"
Collection Alice Lyon

Documentation: Inscription (on back of frame), "Brooks Memorial Art Gallery, Memphis, Tennessee, returned to Fenway Studio, framed in D.C."

Provenance: artist's family.

Exhibited: Gordon Dunthorne Gallery, Washington, D.C., 1927, *An Exhibition of Oil Paintings by Lilla Cabot Perry*, no. 8; Brooks Memorial Art Gallery, Memphis, Tenn., n.d., group show.

68. *Harvest Moon*
 (Flagstones, Hancock, N.H.)
 1925
 Oil on canvas, 12 × 15 in.
 Private collection

Documentation: A very rare view of the Perrys' farm house in Hancock, N.H. Also the only extant nocturnal landscape discovered. The title may be a reference to "the famous harvest moon picnic," which was a "turning point" in Perry's life, as recorded in her memoirs. She was seventeen when the picnic took place, and experienced the first tremors of love, as well as "a longing to paint or do something spectacular." The Perrys did not acquire Flagstones until 1903, however.

Provenance: artist's family.

Exhibited: Boston Art Club, Boston, 1933, *A Memorial Exhibition of Paintings by Lilla Cabot Perry*, no. 28.

69. *After the First Snow*
 1926
 Oil on canvas, 29 3/8 × 30 3/8
 Signed and dated (lower left), "Lilla Cabot Perry, 1926"
 Gibbes Museum of Art, CAA Collection

Provenance: Mrs. Frances R. Morse (Boston); to Carolina Art Association, Charleston, S.C., by gift, 1927; to Gibbes Museum of Art, CAA Collection.

Exhibited: Guild of Boston Artists, Boston, 1927, *An Exhibition of Paintings by Lilla Cabot Perry*, no. 15 (as *After the First Snow — Hancock, N.H.*).

70. *A Snowy Monday* Pl. 51
 (The Cooperage, Hancock, N.H.)
 1926
 Oil on canvas, 25 × 28 in.
 Signed and dated (lower left), "Lilla Cabot Perry, December 1926"
 Private collection

Provenance: artist's family.

Exhibited: Guild of Boston Artists, Boston, 1927, *An Exhibition of Paintings by Lilla Cabot Perry*, no. 8 (as *A Snowy Monday — Hancock, N.H.*); Gordon Dunthorne Gallery, Washington, D.C., 1927, *An Exhibition of Oil Paintings by Lilla Cabot Perry*, no. 19; Boston Art Club, Boston, 1933, *A Memorial Exhibition of Paintings by Lilla Cabot Perry*, no. 31.

References: *The Washington Star*, February 6, 1927

71. *Autumn Leaves* [Hancock, N.H.]
 (Autumn Foliage)
 1926
 Oil canvas on board, 15 × 12 in.
 Collection Alfred and Ellen King

Documentation: Hirschl & Adler Galleries has a variation of *Autumn Leaves*, also small in size.

Provenance: artist's estate; to Hirschl & Adler Galleries, New York; to Santa Fe East Gallery, Santa Fe; to collection of Alfred and Ellen King, 1983.

Exhibited: Guild of Boston Artists, Boston, 1927, *An Exhibition of Paintings by Lilla Cabot Perry*, no. 24 (as *Autumn Leaves, Hancock, N.H.*); Santa Fe East Gallery, Santa Fe, 1983, *Lilla Cabot Perry: Days to Remember* (as *Autumn Foliage*).

References: *Boston Evening Transcript*, March 20, 1929.
 Alma S. King, *Lilla Cabot Perry: Days to Remember*, exhibition catalogue, (Santa Fe: Santa Fe East Gallery, 1983).

72. *Lakeside Reflections* Pl. 52
 ca. 1929–31
 Oil on canvas, 14 × 18 in.
 Private collection

Documentation: This lovely landscape probably represents a large pond in the area of Hancock, N.H., rather than a lake. It recalls Monet's early views of his Japanese pond at Giverny. Although the site has not been definitely identified, Perry's comments to Bernard Berenson in her letter dated August 23, 1929, possibly shed some light on the subject: "Tom was buried, at least his ashes were, up on the shores of beautiful Norway Pond with only some tall pines between him and Skatutakee Mountain, where is this house [Flagstones] which he lived in and loved" (Berenson Archive, Villa I Tatti, The Harvard Center for Italian Renaissance Studies).

Provenance: artist's estate; to Hirschl & Adler Galleries, New York; to private collection.

Exhibited: No prior exhibitions.

73. *Snow, Ice, Mist* [Hancock, N.H.] Pl. 53
 (Ice Storm)
 1929
 Oil on canvas, 18 × 22 in.
 Signed and dated (lower left), "Lilla Cabot Perry, Dec. 1929–"
 Private collection

Provenance: artist's estate; to Hirschl & Adler Galleries, New York; to private collection.

Exhibited: Brattleboro Free Library, Brattleboro, Vt., n.d., *Paintings by Lilla Cabot Perry,* no. 16.

Note: This work is not to be confused with *The Ice Storm,* exhibited at Hancock High School, Hancock, N.H., n.d. solo exhibition, no. 11.

74. *Mist on the Mountain* Pl. 54
 (Misty Weather)
 1931
 Oil on canvas, 12 × 15 in.
 Signed and dated (lower right), "Lilla Cabot Perry, 1931"
 Collection Easterly and Bayly

Documentation: Perry was eighty-three years old, yet undaunted by the cold and the frequent pain from arthritis in her wrists when she painted this "impression" of Monadnock Mountain. It has the quality of certain late Turners. Symbolically, it was the very last work exhibited during her lifetime, as far as can be presently determined.

Provenance: artist's estate; to Hirschl & Adler Galleries, New York; to collection of Easterly and Bayly, 1988.

Exhibited: The Guild of Boston artists, Boston, 1931, *An Exhibition of Paintings by Lilla Cabot Perry,* no. 27.

References: A. J. Philpot, *Boston Globe, ca.* March 10–11, 1931.

75. *Portrait of Lilla Cabot Perry* Fig. 29
 Frederick Bosley (1881–1942)
 1931
 Oil on canvas, 31 1/4 × 25 in.
 Signed, lower left
 Collection A. Everette James and family

Documentation: "My portrait is nearly done. Fred [Bosley] came down from his place in Maine 4 or 5 times. He came from Monday to Saturday but twice had to go back after 2 days on account of the terrific downpour of rain that made it dark even in the studio and he worked never less than 3 hours a day and often more. He worked unceasingly and anxiously and he and I (and Lilla [Perry's granddaughter Lilla Grew] who attempted a profile of me) were nearly melted as the damp heat ruled every day that it did not rain in torrents" (L.C. Perry to Alice Grew, Hancock, August 16, 1931). Alice Grew commissioned the portrait of her mother from Bosley, who refused any payment out of his deep friendship for the Perry family.

Provenance: artist's estate; to Hirschl & Adler Galleries, New York; to collection A. Everette James and family.

Exhibited: Santa Fe East Gallery, Santa Fe, 1983, *Lilla Cabot Perry: Days to Remember.*

References: Alma S. King, *Lilla Cabot Perry: Days to Remember,* exhibition catalogue (Santa Fe: Santa Fe East Gallery, 1983).

Selected Bibliography

Published Sources

Adhémar, Hélène, Anne Distel, and Sylvie Gache. *Hommage à Claude Monet*. Exhibition catalogue. Paris: Grand Palais, 1980.

Beaux, Cecilia. *Background with Figures*. Boston and New York: Houghton Mifflin Co., 1930.

Bedford, Faith Andrews, Susan C. Faxon, and Bruce W. Chambers. *Frank W. Benson: A Retrospective*. Exhibition catalogue. New York: Berry-Hill Galleries, Inc., 1989.

Beer, Thomas. *The Mauve Decade*. New York: Knopf, 1926.

Bell, Millicent. *Edith Wharton and Henry James*. New York: Braziller, 1965.

Birmingham, Doris. "The Black Hat by Lilla Cabot Perry." *The Currier Gallery of Art Bulletin* [Manchester, N.H.] (Fall 1986).

Birmingham, Peter. *Paintings and Sculpture in the Permanent Collection*. Tucson, Ariz.: The Univ. of Arizona Museum of Art, 1983.

Blanche, Jacques-Emile. *Mes Modèles*. 1928. Reprint. Paris: Stock, 1984.

————. *La Pêche aux souvenirs*. Paris: Flammarion, 1949.

————. *Propos de Peintre*. 1st, 2nd, & 3rd ser. Paris: Editions Emile-Paul frères, 1919–28.

Bortolatta, Luigi Rossi. *Tout l'œuvre peint de Monet, 1870–1889*. Paris: Flammarion, 1981.

de Bosqué, Andrée *Quentin Metsys*. Brussels: Arcade, 1975.

"Boston Artists and Sculptors: Lilla Cabot Perry." *Boston Herald*, 27 February 1921.

Boyle, Richard J. *American Impressionism*. New York: New York Graphic Society, 1982.

Bradley, Eleanor Cabot. *Stories from My Life*. Privately published, 1988.

Brawley-Hill, May. *Grez Days: Robert Vonnoh in France*. Exhibition catalogue. New York: Berry-Hill Galleries, Inc. 1987.

Brooks, Van Wyck. *New England: Indian Summer, 1865–1915*. New York: Dutton, 1940.

Byvanck, Willem G. C. *Un Hollandais à Paris en 1891: Sensations de litérature et d'art*. Paris: Perrin et Cie., 1892.

Carr, Carolyn Kinder. *Then and Now: American Portraits of the Past Century from the National Portrait Gallery*. Exhibition catalogue. Washington, D.C.: The National Portrait Gallery, Smithsonian Institution, 1987.

Chatelain, Jean, and Geneviève Monnier. *Autour de Lévy-Dhurmer: visionnaires et intimistes en 1900*. Exhibition catalogue. Paris: Editions des Musées Nationaux, 1973.

Charteris, The Hon. Evan. *John Sargent*. New York: Scribner, 1927.

Chernowitz, Maurice E. *Proust and Painting*. New York: International Univ. Press, 1945. Issued also as doctoral thesis, Columbia University.

Chisholm, Lawrence W. *Fenollosa: The Far East and American Culture*. New Haven, Conn.: Yale Univ. Press 1963.

Clark, Eliot. "The Art of Robert Vonnoh." *Art in America* 16, no. 5 (August, 1928).

Clement, Clara Erskine. *Women in the Fine Arts from the Seventh Century B.C. to the Twentieth Century A.D.* Boston: Houghton Mifflin Co., 1904.

Cochrane, Albert Franz. "The Art of Lilla Cabot Perry." *Boston Evening Transcript,* 28 October 1933.

Corbin, Kathryn. "John Leslie Breck, American Impressionist." *Antiques* 134 (November 1988).

d'Argencourt, Louise, Mark Steven Walker, et al. *William Bouguereau, 1825–1905*. Exhibition catalogue. Montréal: Le Musée des Beaux-Arts de Montréal, 1984.

Daulte, François, and Claude Richebé. *Monet et ses amis*. Paris: Musée Marmottan, 1981.

Deats, Suzanne. "Whistler's Sister." *Santa Fe Reporter,* 20 April 1983.

Dewhurst, Wynford. *Impressionist Painting: Its Genesis and Development*. London: Newnes, 1904.

Dorra, Henri. "Symbolist and Other Visionaries." In *Visionaries and Dreamers*. Exhibition catalogue. Washington, D.C.: Corcoran Gallery of Art, 1956.

Downes, William Howe. "Boston Painters and Paintings." *Atlantic Monthly* (October 1888).

————. "Impressionism in Painting." *New England Magazine* (July 1892).

————. *John Singer Sargent: His Life and Work*. Boston: Little, Brown and Co. 1925.

Drew, Joanne. *Camille Pissarro.* Exhibition catalogue. Arts Council of Great Britain, 1981.

Dryfhout, John. *The Work of Augustus Saint-Gaudens.* Hanover, N.H.: University Press of New England, 1982.

Edel, Leon. *Henry James: A Life.* New York: Harper & Row, 1985.

Edel, Leon, ed. *The Complete Tales of Henry James,* vol. 3, 1873–75. London: Rupert Hart-Davis, 1962–64

————. *The Selected Letters of Henry James.* New York: Ferrar, Straus and Cudahy, 1955.

Eitner, Lorenz. "The Open Window and the Storm-Tossed Boat: An Essay in the Iconography of Romanticism." *The Art Bulletin* 37 (December 1955).

Elder, Marc. *A Giverny chez Claude Monet.* Paris: Bernheim Jeune, 1924.

Eldridge, Charles. *American Introspectives after 1900.* New York: Grey Art Gallery and Study Center, New York University, 1979.

Emerson, Ralph Waldo. *The Conduct of Life, Nature and Other Essays.* Edited by Ernest Rhys. New York: Everyman's Library, Dutton, 1908.

————. *Essays* 1st and 2nd ser. New York: Everyman's Library, Dutton, 1908.

An Exhibition of the Work of John La Farge. New York: Blanchard Press for The Metropolitan Museum of Art, 1936.

Fairbrother, Trevor J. *The Bostonians: Painters of an Elegant Age, 1870–1930.* Exhibition catalogue. Boston: Museum of Fine Arts, 1986.

Fehrer, Catherine. *The Julian Academy, Paris, 1868–1939.* Exhibition catalogue. New York: Shepherd Gallery, 1989.

Feld, Stuart P. *Lilla Cabot Perry: A Retrospective Exhibition.* Exhibition catalogue. New York: Hirschl & Adler Galleries, Inc., 1969.

Fenollosa, Ernest F. "The Coming Fusion of East and West." *Harper's* (December 1898).

————. *Hokusai and His School.* Boston: Museum of Fine Arts, 1893.

————. *The Paintings of Hokusai.* Exhibition catalogue. Tokyo: Bunshichi Kobayashi, 1901.

————. "The Place in History of Mr. Whistler's Art." *Lotus Magazine* (December 1903).

————. "The Symbolism of the Lotus." *The Lotus* 60, no. 8 (February 1896).

Fernier, J. J. *Dessins Destins, Gustave Courbet et Gustave Courtois.* Exhibition catalogue. Ornans, France: Musée de la Maison Natale de G. Courbet, 1982.

Focillon, Henri. "John La Farge." *The American Magazine of Art* 29, no. 5 (May 1936).

Foucart, Jacques. *Puvis de Chavannes, 1824–1898.* Exhibition catalogue. Paris: Grand Palais, 1976.

Fourny-Dargère, Sophie, and Claire Joyes. *Les Artistes americains à Giverny.* Exhibition catalogue. Vernon, France: Musée Municipal A. G. Poulain, 1984.

Fraser, Mary Crawford. *A Diplomat's Wife in Japan: Sketches at the Turn of the Century.* Edited by Hugh Cortazzi. New York: Weatherhill, 1982.

Frazier, Kenneth. "Alfred Quentin Collins." *The Arts* 7, no. 4 (April 1925).

Frederick A. Bosley, A. N. A. (1881–1942): A Painter in the Boston School. Exhibition catalogue. Boston: Vose Galleries of Boston, 1984.

Frederick Frieseke 1874–1939. Exhibition catalogue. Savannah, Ga.: Telfair Academy of Arts and Sciences, 1974.

Fuld, Alice. "Lilla Cabot Perry: A Poet, Painter and a Friend of Monet." *The Keene Sentinel* [New Hampshire], 13 November 1984.

Gammell, R. H. Ives. *The Boston Painters 1900–1930.* Edited by Elizabeth Ives Hunter. Orleans, Mass.: Parnassus Imprints, 1986.

————. *The Guild of Boston Artists, 1914–1942: A Retrospective Exhibition.* Boston: Museum of Fine Arts, 1942.

Garland, Hamlin. *Crumbling Idols.* Cambridge, Mass.: Belknap Press, 1960.

————. *Roadside Meetings.* New York: MacMillan, 1930.

Geffroy, Gustave. *Claude Monet, sa vie, son temps, son œuvre,* 2 vols. Paris: G. Crès & Cie., 1924.

Gerdts, William H. *American Impressionism.* Exhibition catalogue. Seattle, Wash.: Henry Art Gallery, Univ. of Washington, 1980.

————. *American Impressionism.* Collector's edition. New York: Abbeville Press, 1984.

Ghéon, Henri. "Les Paysages d'eau de Claude Monet." *La Nouvelle revue française* 6 (1 July 1909).

Gide, André. "Prétextes." *Mercure de France* (1909). Publication of author's lecture "Les limites sur l'art," 1901.

Gillet, Louis. "L'Epilogue de l'Impressionisme." *La Revue hebdomadaire* (21 August 1909).

Gimpel, René. *Journal d'un collectionneur, marchand de tableaux.* Paris: Calmann-Lévy, 1963.

"Giverny, Little Norman Town, Much in Favor with Americans." *New York Herald,* 25 November 1923.

de Goncourt, Edmond, and Matthi Forrer. *Hokusai.* Paris: Flammarion, 1988. Reprint.

Gordon, Adina E. *Frederick William MacMonnies — Mary Fair-*

child MacMonnies. Exhibition catalogue. Vernon, France: Musée Municipal A. G. Poulain, 1988.

Gordon, Robert. "The Lily Pond at Giverny: The Changing Inspiration of Monet." *Connoisseur* (November 1973).

Guerin, Marcel, and Daniel Halévy. *Lettres de Degas.* Paris: Grasset, 1945.

Guillemet, Maurice. "Claude Monet." *Revue illustrée* (15 March 1898).

Gwynn, Stephen. "Claude Monet and His Garden." *Country Life* (London, 1934).

Hale, Philip L. *Jan Vermeer of Delft.* Boston: Small, Maynard and Co., 1913.

Harlow, Virginia. *Thomas Sergeant Perry: A Biography.* Durham, N.C.: Duke Univ. Press, 1950.

————. "Thomas Sergeant Perry and Henry James." *Boston Public Library Quarterly* (July 1949).

Harris, Ann Sutherland and Linda Nochlin. *Women Artists: 1550–1950.* New York: Knopf, 1976.

Harris, Leon A. *Only to God: The Extraordinary Life of Godfrey Lowell Cabot.* New York: Atheneum, 1967.

Harrington, Bev, ed. *The Figural Images of Theodore Robinson.* Exhibition catalogue. Oshkosh, Wis.: Paine Art Center and Arboretum, 1987.

Hess, Thomas B., and Elizabeth C. Baker. *Art and Sexual Politics: Women's Liberation, Women Artists, and Art History.* New York: Macmillan, 1973.

Hill, Frederick D. "Cecilia Beaux: The Grande Dame of American Portraiture." *Antiques* (January 1974).

Hobbs, Susan. "Elizabeth Platt Jenks by Thomas W. Dewing." In *Triptych.* San Francisco: San Francisco Fine Arts Museums, 1988.

Holmes, Oliver Wendell. "The Brahmin Caste of New England." In *Elsie Venner: A Romance of Destiny.* 1861. Reprint. Boston: Houghton Mifflin Co., 1889.

Hoschedé, Jean-Pierre. "The Art Colony at Giverny." In *Claude Monet and the Giverny Artists.* Exhibition catalogue. New York: Charles E. Slatkin Galleries, 1960.

————. *Claude Monet, ce mal connu: intimité familiale d'un demi-siècle à Giverny de 1883 à 1926.* Vols. 1, 2. Edited by Pierre Cailler. Geneva: P. Cailler, 1960.

Howard-Johnston, Paulette. "Une visite à Giverny en 1924." *L'Oeil* (March 1969).

Howells, William Dean. *Literary Friends and Acquaintances.* New York and London: Harper & Bros., 1901.

Huth, Hans. "Impressionism Comes to America." *Gazette des Beaux-Arts* (April 1946).

Hyslop, Jr., Francis E. "Berthe Morisot and Mary Cassatt." *College Art Journal* (Spring 1954).

James, Henry. "Madame De Mauves" (1874). In *Novels and Tales of Henry James.* Vol. 13. New York: Scribner, 1936.

————. *Notes of a Son & Brother.* New York: Scribner, 1914.

————. *The Painter's Eye: Notes and Essays on the Pictorial Arts.* London: Rupert Hart-Davis, 1956.

"Japan's Greatest Critic Tells of Japan's Art." *New York Times,* 20 March 1904.

Johnston, Sona. *Theodore Robinson, 1852–1896.* Exhibition catalogue. Baltimore: Baltimore Museum of Art, 1973.

Jowell, Francis S. "The Rediscovery of Frans Hals." In *Frans Hals.* Exhibition catalogue. Washington, D.C.: National Gallery of Art, 1989.

Joyes, Claire. *Monet at Giverny.* London: Mathews Miller Dunbar, 1975.

Kimbrough, Sara Dodge. *Drawn from Life.* Jackson, Miss.: University Press of Mississippi, 1976.

King, Alma S. *Five American Women Impressionists.* Exhibition catalogue. Santa Fe: Santa Fe East Gallery, 1982.

————. *Lilla Cabot Perry: Days to Remember.* Exhibition catalogue. Santa Fe: Santa Fe East Gallery, 1983.

Kirwin, Liza. "Regional Reports: Mid-Atlantic." *Archives of American Art Journal* 24, no. 1 (1984).

La Farge, Henri. *John La Farge.* Exhibition catalogue. New York: Kennedy Galleries, 1968.

La Farge, John. *An Artist's Letters from Japan.* 1897. Reprint. New York: Kennedy Graphics, 1970.

————. *Considerations on Painting.* New York: Macmillan, 1895.

————. *Great Masters.* New York: McClure, Phillips & Co., 1904.

Leader, Bernice Kramer. "Antifeminism in the Paintings of the Boston School." *Arts Magazine* (January 1982).

Levine, Steven Z. *Monet and His Critics.* New York: Garland Publishing, 1976.

————. "The Window Metaphor and Monet's Windows." *Arts Magazine* (November 1979).

Linden, Raymond. "Falaise à Etretat par Claude Monet." *Gazette des Beaux Arts* (March 1960).

Lloyd, Christopher. *Camille Pissarro.* New York: Rizzoli, 1981.

Love, Richard H. *Theodore Earl Butler: Emergence from Monet's Shadow.* Chicago: Haase-Mumm Pub. Co., 1985.

Low, Will. *A Chronicle of Friendships, 1873–1900.* New York: Scribner, 1908.

Lowell, James Russell. Selections from *The American Tradition in Literature*. 3rd ed. New York: Norton, 1956.

Lubbock, Percy, ed. *The Letters of Henry James*. Vols. 1, 2. London: Macmillan, 1920.

MacChesney, Clara. "Frederick Carl Frieseke: His Work and Suggestions for Painting from Nature." *Arts and Decoration,* no. 3 (November 1912).

Manet, Julie. *Journal, 1893–1899*. Paris: C. Klincksieck, 1979.

Mathews, Nancy Mowll. *Cassatt and Her Circle: Selected Letters*. New York: Abbeville, 1984.

———. *Mary Cassatt: The Color Prints*. New York: Abrams, 1987.

Matthiessen, F. O. *The James Family*. New York: Knopf, 1947.

Meadmore, W. S. *Lucien Pissarro: Un Coeur simple*. New York: Knopf, 1963.

Meixner, Laura L. *An International Episode: Millet, Monet, and Their North American Counterparts*. Exhibition catalogue. Memphis, Tenn.: The Dixon Gallery and Gardens, 1983.

Meyer, Annie Nathan. "The Women's Room at the World's Fair." *The International Studio* 59, no. 234 (1916).

Milner, John. *The Studios of Paris*. New Haven: Yale University Press, 1990.

Moore, Charles. "The Modern Art of Painting in France." *Atlantic Monthly* (December 1891).

Moore, George. *The Lake*. Boston: D. Appleton and Co., 1905.

———. *Modern Painting*. London: Walter Scott, Ltd., 1893.

———. *Hale and Farewell!* London: William Heinemann, Ltd., 1937.

Mordell, Albert, ed. *Discovery of a Genius: William Dean Howells and Henry James*. New York: Twayne Publishers, 1961.

Morse, John T. *Thomas Sergeant Perry: A Memoir*. Boston: Houghton Mifflin Co., 1929.

Mount, Charles Merrill. *John Singer Sargent: A Biography*. New York: Norton, 1955.

The New Painting: Impressionism, 1874–1886. Exhibition catalogue. San Francisco: San Francisco Fine Arts Museums, 1986.

Okakura, Kakuzo. *The Book of Tea*. Edited by Elise Grilli. Reprint. Rutland, Vt.: C. E. Tuttle, 1988.

"Okakura Kakuzo, 1862–1913." *Bulletin* [Museum of Fine Arts, Boston] (December 1913).

Ostini, Fritz von. *Uhde*. Bielefeld und Leipzig: Velhagen & Klasing, 1902.

Panama Pacific International Exposition. Exhibition catalogue. Paris: Libraire Centrale des Beaux-Arts, 1915.

Pearson, Hesketh. *The Man Whistler*. London: Methuen & Co., Ltd., 1952.

Pennell, Elizabeth and Joseph. *The Whistler Journal*. Philadelphia: Lippincott, 1921.

Perry, Lilla Cabot. "An Informal Talk Given by Mrs. T. S. Perry to the Boston Art Students' Association in the Life Class Room at the Museum of Fine Arts, Wednesday, Jan. 24, 1894." Boston Art Students' Association, 1894.

———. *From the Garden of Hellas*. Boston: Houghton Mifflin Co., 1891.

———. *The Heart of the Weed*. Boston: Houghton Mifflin Co., 1886.

———. *Impressions: A Book of Verse*. Boston: Copeland and Day, 1898.

———. *The Jar of Dreams*. Boston: and New York: Houghton Mifflin Co., 1923.

———. "Reminiscences of Claude Monet from 1889 to 1909." *American Magazine of Art* 18 (March 1927).

Perry, Thomas Sergeant (See Harlow, *Thomas Sargeant Perry,* for an extensive bibliography).

Perry, Thomas Sergeant. "Among the Paris Pictures." *Boston Post,* 30 June 1891.

———. "At the Greatest Show" (World's Columbian Exposition, Chicago). *Boston Evening Transcript,* 8 September 1893.

———. "Decadents and Symbolists." *Boston Post,* 7 August 1891.

———. "A Distinguished Private Citizen" (Henry Lee Higginson). *Yale Review* 6 (July 1922).

———. *English Literature in the Eighteenth Century*. 1883. Reprint. New York: Books for Libraries Press, 1972.

———. "The Golden Age of Boston." *Yale Review* 3 (July 1919).

———. "The Goncourt Academy." *Boston Evening Transcript,* 4 parts, 29 September; 6, 13, 29 October 1897.

———. "Helen Choate Bell." *Boston Evening Transcript,* 25 July 1918.

———. "Memories of the Golden Age." *Yale Review* 3 (April 1918).

———. "The New School in France." *Boston Post,* 18 August 1891.

———. "Russian Novels." *Scribner's* 1 (February 1887).

———. "A Small Boy and Others. By Henry James." *Yale Review* 3 (October 1913).

———. "Some Greek Portraits." *Scribner's* 2 (February 1889).

Philpot, A. J. "Saw Landscape with the Soul of a Poet." *Boston Globe,* 29 October 1933.

Pierce, Patricia Jobe. *Edmund C. Tarbell and the Boston School of Painting*. Edited by John Douglas Ingraham. Higham, Mass.: Pierce Galleries, 1980.

Pollock, Griselda. *Mary Cassatt*. New York: Harper & Row, 1980.

Potter, Henry Codman. "Centennial Commemoration of Washington's Inauguration, April 29, 1889." *The World's Great Classics*. Vol. 6, *American Orators*. New York: Colonial Press, 1909.

Preato, Robert R. *The Genius of the Fair Muse: Painting and Sculpture Celebrating American Women Artists, 1875–1945*. New York: Grand Central Art Galleries, 1987.

Preston, Stuart. "Letters from Paris: Monet and Carrière." *Apollo* (June 1980).

Quick, Michael. *Munich and American Realism in the 19th Century*. Exhibition catalogue. Sacramento, Calif.: E. B. Crocker Art Gallery, 1978.

Rewald, John. *Camille Pissarro: Letters to His Son, Lucien*. Translated by Lionel Abel. New York: Pantheon, 1943.

———. *The History of Impressionism*. New York: Museum of Modern Art, 1973.

Reynolds, Gary A. *Walter Gay: A Retrospective*. Exhibition catalogue. New York: Grey Art Gallery and Study Center, New York Univ., 1980.

Robinson, Edwin Arlington, ed. *Selections from the Letters of Thomas Sergeant Perry*. New York: Macmillan, 1929.

Robinson, Theodore. "Claude Monet." *Century Magazine* 44 (September 1892).

Roger-Marx, Claude. *Maîtres d'hier et d'aujourd'hui*. Paris: Calmann-Lévy, 1909.

Roque, Oswaldo Rodriguez. "American Impressionist Paintings in the Collection of Dr. and Mrs. John J. McDonough." *The Magazine Antiques* (November 1985).

Rosenberg, Charles E. "Sexuality, Class and Role in 19th-Century America." *American Quarterly* 25 (1973).

Rosenblum, Robert. "Art: The Boston School of Painters." *Architectural Digest* 44 (May 1987).

Rouart, Denis, ed. *The Correspondence of Berthe Morisot*. 1957. Reprint. London: Camden, 1986.

Samuels, Ernest. *Bernard Berenson: The Making of a Connoisseur*. Cambridge, Mass.: Belknap Press, 1979.

———. *Bernard Berenson: The Making of a Legend*. Cambridge, Mass.: Belknap Press, 1987.

Seitz, William C. *Claude Monet*. New York: Abrams, 1960.

———. "Monet and Abstract Painting." *College Art Journal* (Fall 1956).

Sellin, David. *Americans in Brittany and Normandy, 1860–1910*. Exhibition catalogue. Phoenix, Ariz.: Phoenix Art Museum, 1982.

Simpson, Colin. *Artful Partners: Bernard and Joseph Duveen*. New York: Macmillan, 1986.

Strouse, Jean. *Alice James: A Biography*. Boston: Houghton Mifflin Co., 1980.

Stuckey, Charles F., and William P. Scott. *Berthe Morisot: Impressionist*. Exhibition catalogue. New York: Hudson Hills Press, 1987.

Sugimoto, Etsu Inaguki. *A Daughter of the Samurai*. Rutland, Vt.: C. E. Tuttle, 1985.

Sweet, Frederick A. *Miss Mary Cassatt: Impressionist from Pennsylvania*. Norman, Okla.: Univ. of Oklahoma Press, 1967.

Tarbell, Edmund C. Introduction to *Memorial Exhibition of Paintings by Lilla Cabot Perry*. Boston: Boston Art Club, 1933.

Tazawa, Yutaka. *Biographical Dictionary of Japanese Art*. New York: Harper & Row, 1981.

"Thomas Sergeant Perry." *The Bookman* 7 (June 1898).

Thullier, Jacques. *Peut-on parler d'une peinture "Pompier?"* Paris: Presses Universitaires de France, 1984.

Toussaint, Hélène, Geneviève Monnier, and Martine Servot. *Hommage à Corot*. Exhibition catalogue. Paris: Editions des Musées nationaux, 1975.

Trapp, Frank Anderson. *American Landscapes in the Wake of French Impressionism*. Exhibition catalogue. Amherst, Mass.: Mead Art Museum, Amherst College, 1986.

Truffaut, Georges. "Le Jardin de Claude Monet." *Jardinage* (November 1924).

Tufts, Eleanor. *American Women Artists, 1830–1930*. Exhibition catalogue. Washington, D.C.: The National Museum of Women in the Arts, 1987.

Venturi, Lionello. *Sandro Botticelli*. New York: Oxford Univ. Press, 1937.

———. *Les Archives de l'Impressionisme*. Vols. 1, 2. New York: Durand-Ruel, 1939.

Waern, Cecelia. "Some Notes on French Impressionism." *Atlantic Monthly* (April 1892).

Ward, Lisa Michelle. Foreword to *Lilla Cabot Perry*. Exhibition catalogue. Chicago: Mongerson Gallery, 1984.

Wasserman, Krystyna. "Lady with a Bowl of Violets by Lilla Cabot Perry." *Journal of the American Medical Association* 253, no. 14 (April 1985).

Weinberg, Helene Barbara. "American Impressionism in a Cosmopolitan Context." *Arts Magazine* 55 (November 1980).

———. *The Decorative Work of John La Farge*. New York: Garland Publishing, 1977.

———. "John La Farge: The Relation of His Illustrations to His Ideal Art." *The American Art Journal* 5, no. 1 (May 1973).

———. "The Lure of Paris: Late Nineteenth-Century American Painters and Their French Training." In *A New World: Masterpieces of American Painting*. Exhibition catalogue. Boston: Museum of Fine Arts, 1983.

Weitzenhoffer, Frances. *The Havemeyers: Impressionism Comes to America*. New York: Abrams, 1987.

Wharton, Edith. *A Backward Glance*. 2nd ed. New York: Scribner, 1964.

———. *The Book of the Homeless*. New York: Scribner, 1916.

White, Nelson C. *Abbot Thayer: Painter and Naturalist*. Hartford, Conn.: Connecticut Printers, Inc., 1967.

Wildenstein, Daniel. *Claude Monet: Biographie et catalogue raisonné*. 4 vols. Paris and Lausanne: La Bibliothèque des Arts, 1974–85.

Wood, Mary Louise. "Lilla Cabot Perry." In *National Museum of Women in the Arts*. Exhibition catalogue. New York: Abrams, 1987.

Yamaguchi, Seiichi. "Fenollosa on Ukiyo-e: Considerations on Ukiyo-e History." *Ukiyo-e Art* 67 (1980).

Young, Andrew McLaren. *The Paintings of James McNeil Whistler*. Vols. 1, 2. Catalogue raisonné. New Haven, Conn.: Yale Univ. Press, 1980.

Young, Dorothy Weir. *The Life and Letters of J. Alden Weir*. New Haven, Conn.: Yale Univ. Press, 1960.

Unpublished Sources

Archives, Galleries and Libraries

Archives of American Art. Smithsonian Institution, Washington, D.C.

Bernard Berenson Foundation. Villa I Tatti, The Harvard Univ. Center for Italian Renaissance Studies, Florence, Italy.

The Boston Athenaeum.

Boston Public Library.

Frick Art Reference Library. The Frick Collection, New York.

Hirschl & Adler Galleries, Inc., New York.

The Houghton Library, Harvard University, Cambridge, Mass.

Joseph Clark Grew, personal files.

Reference Library, Museum of Fine Arts, Boston.

Library and Research Center, The National Museum of Women in the Arts, Washington, D.C.

New York Public Library, manuscript department.

Perry Family Archives.

Special Collections, Miller Library, Colby College, Waterville, Maine.

Dissertations, Theses and Manuscripts

Gammell, R. H. Ives. "Lilla Cabot Perry." Boston Athenaeum, 1960.

Hills, Patricia. "Lilla Cabot Perry and American Impressionism." Lecture presented at the Boston Athenaeum, 1982.

Lyon, Elizabeth S. "Memories of Lilla Cabot Perry by One Granddaughter," 1989 (Perry Family Archives).

Perry, Lilla Cabot. "Painting and Poetry," n.d. (Perry Family Archives).

———. "Memories of Age 17," *ca*. mid-1920s (Perry Family Archives).

———. Unpublished poems, n.d. (Perry Family Archives)

Ward, Lisa M. "Lilla Cabot Perry and the Emergence of the Professional Woman Artist." Master's thesis, University of Texas, Austin, 1985.

Dissertations, Theses and Archival Materials on Related Subjects

Buck, Stephanie Mary. "Sarah Choate Sears: Artist, Photographer, and Art Patron." Master's thesis, Syracuse University, 1985.

Dupont-Viau, Dominique. "Peintres et sculpteurs contemporaines sur la scène New Yorkaise." Thèse doctorat, Université de Paris VII, 1983.

Hale, Philip Leslie. Papers, Archives of American Art. Smithsonian Institution, Washington, D.C.

Laffont, Robert. "L'Oeuvre de Tony Robert-Fleury." Mémoire maîtrise, Université de Paris IV, 1980.

Leader, Bernice Kramer. "The Boston Lady as a Work of Art: Paintings by the Boston School at the Turn of the Century." Ph.D. dissertation, Columbia University, 1980.

Robinson, Theodore. "Diaries, 1892–1893." Frick Art Reference Library.

Stuckey, Charles E. "L'Art de Monet et la perception visuelle." Lecture presented at the Claude Monet Symposium, Institut de France, Paris, September 1981.